# PICASSO IN PARIS
## 1900-1907

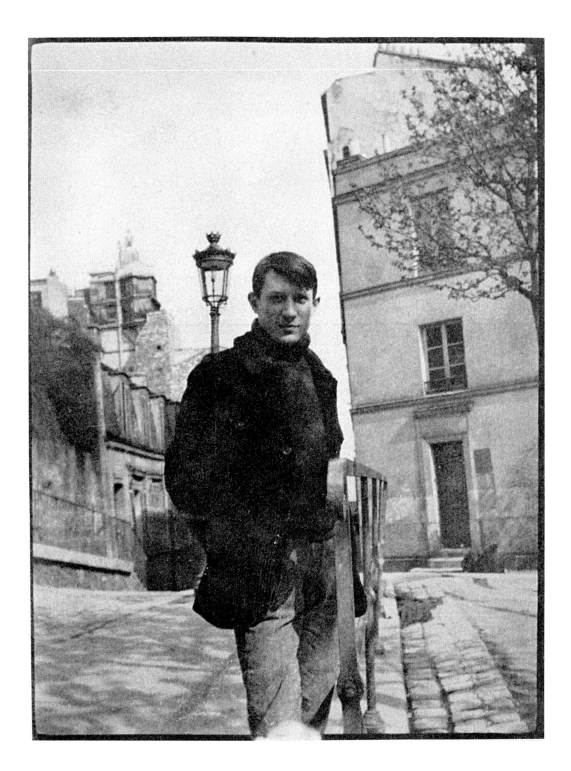

# PICASSO IN PARIS 1900-1907

Marilyn McCully

With contributions by
NIENKE BAKKER
ISABEL CENDOYA
PETER READ

Edited by
MICHAEL RAEBURN

In association with the Van Gogh Museum
and the Museu Picasso Barcelona

PUBLISHED ON THE OCCASION
OF THE EXHIBITION

## PICASSO IN PARIS, 1900-1907. EATING FIRE

Van Gogh Museum, Amsterdam
18 February - 29 May 2011

## DEVORAR PARÍS. PICASSO, 1900-1907

Museu Picasso, Barcelona
30 June - 15 October 2011

**Production**
Tijdsbeeld & Pièce Montée, Ghent
Ronny Gobyn (director)

**Head of Publications at the Museums**
Suzanne Bogman, Van Gogh Museum
Marta Jové, Museu Picasso

**Coordination**
Barbara Costermans, Tijdgeest, Ghent
Geri Klazema, Van Gogh Museum, Amsterdam
Ann Mestdag, Mercatorfonds, Brussels

**Editorial advice**
Nienke Bakker, Edwin Becker, Van Gogh Museum

**Translation**
Lynne Richards
(foreword and chapter 3)

**Picture research**
Linda Modderkolk, Anja Wisseborn, Van Gogh Museum
Isabel Cendoya, Museu Picasso

**Graphic design**
Janpieter Chielens, Tijdgeest

**Typesetting**
Yanne Devos, Tijdsbeeld & Pièce Montée

**Colour separations,
printing and binding**
Die Keure, Bruges

First published in the United Kingdom in 2011 by
Thames & Hudson Ltd, 181A High Holborn,
London WC1V 7QX

Original English edition *Picasso in Paris, 1900-1907. Eating Fire* published by Mercatorfonds, Brussels; Van Gogh Museum, Amsterdam; Institut de Cultura de Barcelona (Museu Picasso)

British Library Cataloguing-in-Publication Data
A catalogue record for this book is available from the British Library

ISBN:  978-0-500-09355-9

Printed and bound in Belgium

To find out about all our publications, please visit
**www.thamesandhudson.com.**
There you can subscribe to our e-newsletter, browse or download our current catalogue, and buy any titles that are in print.

ACKNOWLEDGEMENTS

The curator, the Museu Picasso, Barcelona, and the Van Gogh Museum would like to express their deepest gratitude to all the individuals and institutions who contributed to the realization of this exhibition and its catalogue.

In the first place, we would especially like to thank Cathy Hutin, for her contribution to this project. We are also greatly indebted to the Fundación Almine y Bernard Ruiz-Picasso para el Arte and to the Vincent van Gogh Foundation for the special collaboration they have given.

For their invaluable assistance and support of this project, the curator, the Museu Picasso, Barcelona, and the Van Gogh Museum would like to thank:

Béatrice André-Salvini, Jean-Paul Avice, Manuel Barbié, Tobia Bezzola, Beatriz Blanco, Robert Bowman, Lucía Cabezón, Domènec Casals, Migi Coyle, Richard Cyzer, Mirin Dajo, Susan Davidson, Dr Stephan Diederich, Maite van Dijk, Ignasi Domènech, Roland Doschka, M. and Mme André Fage, Evelyne Ferlay, Dr Hartwig Fischer, Joanna Foyster, Joan Gaspar i Farreras, Amanda Geitner, Marta Gil de Biedma, Gloria Groom, Florianne M. van Hees-Simons, Danielle Hodel, Geurt Imanse, Rafael Inglada, Montserrat Isern, Núria Isern, Nichola Johnson, Atsuko Kanazawa, Hélène Klein, Daniel Malingue, Jill McLennon, Cristina Mendoza Garriga, Natalia Mikiszko, Maria Luisa Pacelli, Mertxe París Leza, Florence Perez, Brooke Perrin, Marina Picasso, Christine Pinault, Kay Poludniowski, Eliza Rathbone, Peter Read, Tara Reddi, James Roundell, Salvador Salort-Pons, Helen Simpson, Jaume Socias, Benno Tempel, Louis van Tilborgh, Eduard Vallès, Neil Warnock, Ann S. Woolsey and Jessica Yakubowicz.

We are extremely grateful to the following museums, galleries and collectors, and to all those wishing to remain anonymous, who have generously lent their works of art.

The Edelweiss Trust

Merzbacher Kunststiftung

Collection Gabriele and Horst Siedle, Germany

**Aix-en-Provence**
Musée Granet (Bruno Ely)

**Albi**
Musée Toulouse-Lautrec (Danièle Devynck)

**Amsterdam**
Stedelijk Museum (Ann Goldstein)

**Barcelona**
Col·lecció Eusebi Isern Dalmau

**Basel**
Kunstmuseum Basel (Dr Bernhard Mendes Bürgi)

**Basel-Riehen**
Fondation Beyeler (Samuel Keller)

**Berlin**
Nationalgalerie/Museum Berggruen (Dr Kyllikki Zacharias)

**Bilbao**
Museo de Bellas Artes de Bilbao (Javier Viar)

**Brussels**
Pieter and Olga Dreesmann
Musée d'Ixelles (Claire Leblanc)

**Chicago**
The Art Institute of Chicago (James Cuno)

**Cologne**
Museum Ludwig (Prof. Kasper König)

**Copenhagen**
Ordrupgaard (Anne-Birgitte Fonsmark)

**Detroit**
Detroit Institute of Arts (Graham W. J. Beal)

**Fort Worth**
Kimbell Art Museum (Eric McCauley Lee)

**Geneva**
Petit Palais – Musée d'Art moderne (Prof. Claude Ghez)

**Ghent**
Museum voor Schone Kunsten (Robert Hoozee)

**London**
Tate (Sir Nicholas Serota, Caroline Collier)

**Madrid**
Museo Thyssen-Bornemisza (Guillermo Solana)

**Martigny**
Fondation Pierre Gianadda (Léonard Gianadda)

**Montreal**
François Odermatt

**New York**
The Metropolitan Museum of Art (Thomas P. Campbell)
Solomon R. Guggenheim Museum (Richard Armstrong)

**Nice**
Musée Matisse (Dominique Szymusiak)

**Norwich**
Sainsbury Centre for Visual Arts (Paul Greenhalgh)

**Oxford**
The Ashmolean Museum (Christopher Brown)

**Paris**
Musée du Louvre (Henri Loyrette)
Musée de l'Orangerie (Emmanuel Bréon)
Musée d'Orsay (Guy Cogeval)
MNAM/CCI Centre Pompidou (Alfred Pacquement)

**Philadelphia**
Philadelphia Museum of Art (Timothy Rub)

**Providence**
Museum of Art, Rhode Island School of Design (Hope Alswang)

**Richmond**
Virginia Museum of Fine Arts (Alex Nyerges)

**Rotterdam**
Hans Leijser
Museum Boijmans Van Beuningen (Sjarel Ex)

**Saint-Germain-en-Laye**
Musée d'Archéologie nationale (Patrick Périn)

**St Louis**
Mildred Lane Kemper Art Museum, Washington University (Sabine Eckmann)

**San Francisco**
Fine Arts Museums of San Francisco (John E. Buchanan)

**Sitges**
Museu del Cau Ferrat (Antoni Sella)

**Stuttgart**
Staatsgalerie Stuttgart (Sean Rainbird)

**Toronto**
Art Gallery of Ontario (Matthew Teitelbaum)

**Washington**
The Phillips Collection (Dorothy Kosinski)

**Zurich**
Kunsthaus Zurich (Christoph Becker)

# CONTENTS

# FOREWORD

The Van Gogh Museum in Amsterdam and the Museu Picasso in Barcelona are specialized centres, each devoted to the work of a single artist who has become part of the world's collective imagination: two essential figures in art history who have provided a visual reference for many generations.

In 2007 the Van Gogh Museum in Amsterdam presented the major exhibition *Barcelona 1900*, a tribute to the city and its art scene at the turn of the century, and invited the Museu Picasso to take part through the loan of key works. The two museums were struck by their evident similarities, the correspondence in their approaches to research and the wish to forge partnerships with other institutions. This realization led almost immediately to the joint organization of an ambitious exhibition tracing the development of Pablo Picasso following his arrival in Paris and immersion in the artistic life of the city. For the Van Gogh Museum the appeal lay in the fact that this period of Picasso's work relates so closely to the museum's collection, which contains works by Van Gogh and many other artists who were working in Montmartre towards the end of the nineteenth century and who inspired Picasso. In Barcelona the exhibition will also trace the parallels between Picasso and Van Gogh, whose sojourn in Paris profoundly influenced his artistic development. Right from the start we felt it was essential that Marilyn McCully, a leading expert on Picasso with a profound knowledge of the young artist's development, should be the person to curate the exhibition.

# FOREWORD

The Van Gogh Museum in Amsterdam and the Museu Picasso in Barcelona are specialized centres, each devoted to the work of a single artist who has become part of the world's collective imagination: two essential figures in art history who have provided a visual reference for many generations.

In 2007 the Van Gogh Museum in Amsterdam presented the major exhibition *Barcelona 1900*, a tribute to the city and its art scene at the turn of the century, and invited the Museu Picasso to take part through the loan of key works. The two museums were struck by their evident similarities, the correspondence in their approaches to research and the wish to forge partnerships with other institutions. This realization led almost immediately to the joint organization of an ambitious exhibition tracing the development of Pablo Picasso following his arrival in Paris and immersion in the artistic life of the city. For the Van Gogh Museum the appeal lay in the fact that this period of Picasso's work relates so closely to the museum's collection, which contains works by Van Gogh and many other artists who were working in Montmartre towards the end of the nineteenth century and who inspired Picasso. In Barcelona the exhibition will also trace the parallels between Picasso and Van Gogh, whose sojourn in Paris profoundly influenced his artistic development. Right from the start we felt it was essential that Marilyn McCully, a leading expert on Picasso with a profound knowledge of the young artist's development, should be the person to curate the exhibition.

We are delighted to say that the prestige of the curator, who first suggested the idea for this exhibition, and the solid premises of the project developed by our respective Exhibitions departments, have secured the loan of major works from institutions and private collectors around the world, enabling us to bring together an exceptional selection of pieces. Meanwhile, the desirability of our joint venture has made itself all the more evident by the presence of important works from our respective collections, with the Van Gogh Museum contributing a number of works by other artists who were active in Montmartre around 1900.

The exhibition takes as its starting point the attendance of the nineteen-year-old Picasso at the 1900 Exposition Universelle in Paris, the city where he first showed his paintings outside Spain. To begin with, he took his inspiration from the subjects and styles he saw in the work of other artists, but even then he always succeeded in transmuting these innumerable influences into an individual style of his own. In a very few years he was at the forefront of the avant garde and was breaking new ground, having absorbed everything that the French capital and the foreign artists who had been drawn to it – Van Gogh among them – could offer. The aim of this book is to chart Picasso's development step by step during those crucial years in Paris (1900-1907).

The presentation at the Van Gogh Museum places a special emphasis on works by Picasso, since this is the first major exhibition devoted to the artist's early years in Paris to be held in Holland, while the show in Barcelona focuses more on the context of Picasso in Paris and aims to enrich the line of research and exhibition production that the Barcelona museum has been pursuing for a number of years.

We must begin by expressing our immense gratitude to Marilyn McCully, guest curator and the main author of this book, for creating this unique exhibition and for devoting her great knowledge and expertise to obtaining loans and making this project a success. Her essays on Picasso explore and illuminate this crucial period of the artist's career. McCully's ideas for the exhibition proposal and the accompanying publication were developed in conjunction with her husband, Michael Raeburn, who has edited this book with extraordinary dedication. Co-authors Peter Read and Nienke Bakker respectively, provide fascinating insights into the literary aspects and the link between Van Gogh and Picasso, and Isabel Cendoya completes the volume with a valuable chronology.

Special thanks also go to colleagues in the two museums: the Van Gogh Museum's Head of Exhibitions, Edwin Becker, and former curator Benno Tempel, and the two project managers, Geeta Bruin at the Van Gogh Museum and Isabel Cendoya at the Museu Picasso, who initiated and coordinated the exhibition with great tenacity and commitment, and to Lluís Bagunyà, Fouad Kanaan and Martine Kilburn for their tremendous contribution to its realization.

We also thank Mercatorfonds in Brussels, led by director Jan Martens, for their collaboration and readiness to participate in this project. The publication process was supervised with the utmost professionalism by Ronny Gobyn and his colleagues at Tijdsbeeld & Pièce Montée in Ghent.

In conclusion we would like to express our heartfelt thanks to all those who so generously lent us their works. Here our special thanks go to the Vincent van Gogh Foundation for their generous contribution of important loans. Neither the exhibition nor this book would have been possible without the lenders' faith in our two museums and in this project. We were keenly aware that the works are highlights of the permanent displays in these museums, so we were particularly delighted that they were nonetheless willing to lend so many outstanding pieces.

For an exhibition of this kind financial support is also of crucial importance. We are grateful for the backing of SEACEX (Sociedad Estatal para la Acción Cultural Exterior), which acted as guarantor for part of the insurance and transportation costs, and in Amsterdam our immense gratitude goes to our sponsor, Citroën, which provided substantial assistance for this unique project.

We hope that the readers of this book and the visitors to the exhibition in both venues will come to appreciate Picasso not as the isolated genius he is sometimes thought to be, but as an artist who in his early years was receptive to other artists, and who was always seeking new and surprising paths.

PEPE SERRA  
Director  
Museu Picasso, Barcelona

AXEL RÜGER  
Director  
Van Gogh Museum, Amsterdam

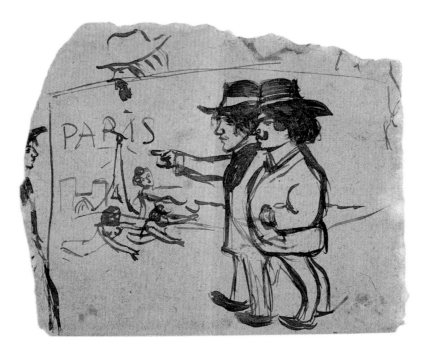

PL. 1   ***Picasso and Manuel Pallarès in Paris***
Paris, 1900
Pen and ink on paper, 8.8 x 11.1 cm
Museu Picasso, Barcelona

# PICASSO'S DISCOVERY OF PARIS

MARILYN McCULLY

Fresh from the critical success of his debut exhibition in Barcelona earlier in the year, the nineteen-year-old Pablo Ruiz Picasso, imbued both with confidence and with great expectations about his artistic future, set off for Paris in late October 1900. He travelled with his friend, the writer Carles Casagemas; both of them had been named as correspondents for the Barcelona journal *Catalunya artística,* to cover events at the Exposition Universelle, which was due to close on 12 November.[1] The occasion of the exhibition, with its ambitious building and cultural programmes, had over the course of the past months changed Paris, with the city becoming a destination for artists, performers, writers, curiosity seekers, and enthusiasts for all manner of artistic and ethnic manifestations, scientific demonstrations and the latest inventions, which could be discovered at the fair.

The fact that the whole of the exhibition was illuminated with electricity confirmed Paris's status as *la ville lumière* and, symbolically, announced the dawn of a new century. Moreover, for the aspiring young men and women who came to Paris in 1900, the new Mecca represented opportunity: what was possible – both technologically and artistically – was about to change.

The influx of artists from all over the world, which had begun in the late nineteenth century, was unparalleled in the history of Paris and marked a period of cultural immigration that would redefine the direction and artistic developments of the avant garde. In the beginning, the national groups tended to keep to themselves, speaking their own languages and relying on their already established countrymen for contacts and work. This was certainly the case for Picasso and his friends when

they arrived. At the same time, some of the Catalans who had settled or spent significant time in Paris in the 1890s had made connections with certain French artistic circles, which also gave the new arrivals a ready entrée.

The older generation of Barcelona artists and writers, who had themselves gone to the capital to study and to attend previous world exhibitions, tended to settle in the rather rough, cheap district of Montmartre high above the city. Ramon Casas and Santiago Rusiñol had actually lived above the celebrated Moulin de la Galette (see pl. 2), beginning in 1890 and, with their compatriot Miquel Utrillo, had immersed themselves in the artistic world around them. While Utrillo had lived the life of a shadow puppet producer and cabaret *assidué* – and had become involved with the French model Suzanne Valadon, whose child (Maurice Utrillo) he recognized – Rusiñol and Casas moved in somewhat more conventional artistic circles, exhibiting at the Salon of the Société Nationale des Beaux-Arts. Utrillo and Casas returned to Paris for the Exposition Universelle in 1900, and their presence is recorded in Casagemas's letters and in several drawings by Picasso.

Others, including Isidre Nonell and Ricard Canals, who were among the second wave of Catalan immigrants in the mid-1890s, also settled in Montmartre, and they built their professional careers in France primarily as painters of Spanish subjects. Their success depended to a large degree on their promotion by several Paris dealers, notably Le Barc de Boutteville, Ambroise Vollard, and later Durand-Ruel.[2] Another Catalan, Joaquim Sunyer, first established his reputation by collaborating with writers, for whom he produced illustrations, notably for Jehan Rictus's *Les Soliloques du pauvre* in 1897. His depictions of life on the margins followed the example of Théophile-Alexandre Steinlen in subject matter and, to some extent, in style (although Steinlen's own illustrations for Rictus came several years after those of Sunyer). Yet another painter who was already in Paris in 1900 and who would become close to Picasso over the years was Ramon Pichot, who originally came from Cadaquès. The well-to-do Pichot family eventually helped Ramon acquire the Maison Rose, a house in Montmartre, where he could set up a studio, and where his future wife Germaine would run a little bistrot on the ground floor.

In addition to the activities of the artists, the Catalan community also had the special political cachet of *fin-de-siècle* anarchism that set them apart from other national groups. The nineties had been a difficult time in Catalonia, and many anarchists or sympathizers who were suspected of fomenting anti-government activity had sought refuge in Paris. In comparison to the Germans, Russians or Italians, the Spanish community was relatively small, so the mixture of artists, writers and activists became a normal aspect of the 'exiled' group. Among them were also a number of Basques, and, like the Catalans, they held separatist views when it came to the political situation in Spain. As a general rule, they all tended to have as their headquarters certain cafés and cabarets, where they outspokenly professed their political views.[3] At the same time, the French police kept tabs on their movements, and even Picasso turns out to have had a police file.[4]

As soon as they had arrived, Picasso and Casagemas learned from the Catalan network that a studio in Montmartre was about to be vacated by their well known compatriot Nonell, whose show at Vollard's had closed in April. The place on rue Gabrielle was large enough

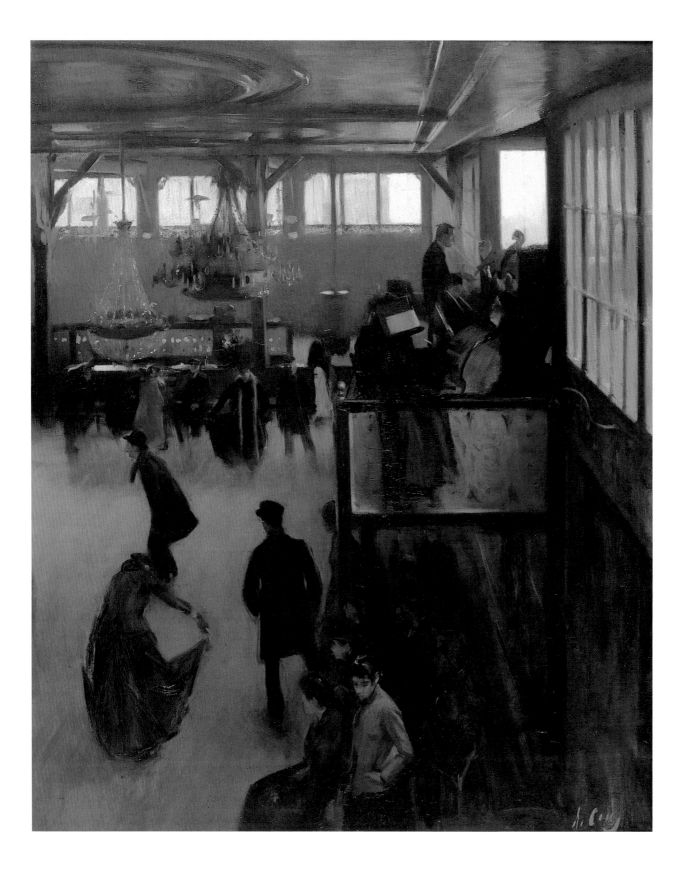

**RAMON CASAS**
*Dance at the Moulin de la Galette*
1890
Oil on canvas, 100 x 81.4 cm
Museu Cau Ferrat, Sitges

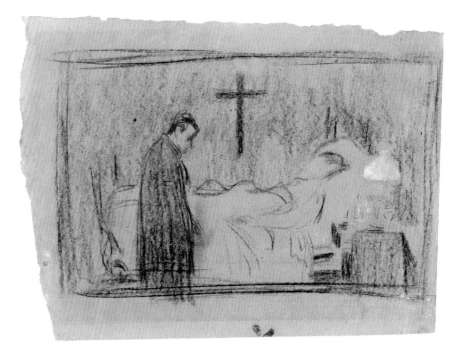

FIG. 1    **Study for *Last Moments***
Barcelona, 1899-1900
Charcoal, chalk and black pencil on paper,
30 x 39.8 cm
Museu Picasso, Barcelona

to set up studios – Casagemas also had ambitions to become a painter – even to sleep six! Another painter friend, Manuel Pallarès, arrived from Barcelona a few days later (pl. 1), and soon the three companions were joined by three artist's models, Germaine Gargallo (aka Laure Florentin), her sister Antoinette (later Fornerod), and another girl by the name of Odette (aka Louise Lenoir), who took up with Picasso. Casagemas wrote letters back to Barcelona describing their new, liberated arrangement: 'We've decided that we've been getting up too late and eating at improper hours and that everything was beginning to go wrong. On top of this [...] Odette was starting to become raucous because of [her] good habit of getting drunk every night. So we have arrived at the conclusion that neither [the women] nor we will go to bed later than midnight, and every day we'll finish lunch by one. After lunch we'll dedicate ourselves to our paintings and they'll do women's work – that is, sew, clean up, kiss us and let themselves be "fondled". Well, this is a kind of Eden or dirty Arcadia.'[5]

Apart from his nominal reporting job, Picasso also had a personal reason for attending the Exposition: his painting *Last Moments* had been selected to hang in the Spanish section in the Grand Palais. This large canvas, showing the visit of a priest to a dying woman, had also been featured in Picasso's show in Barcelona in February. One French reviewer mentioned the painting among those that stood out, observing that 'there is a true sense of grief in Ruiz Picasso's *Derniers moments*.'[6] The fact that *Last Moments* had been chosen to represent the latest

**_Leaving the Exposition Universelle_**
Paris, 1900
Charcoal, coloured crayons and pencil
on paper, 47.6 x 62 cm
Private collection, Switzerland. Courtesy of E & R Cyzer Gallery, London
Odette, Picasso, Pichot, Utrillo, Casagemas and Germaine in front
of the main entrance to the Exposition.

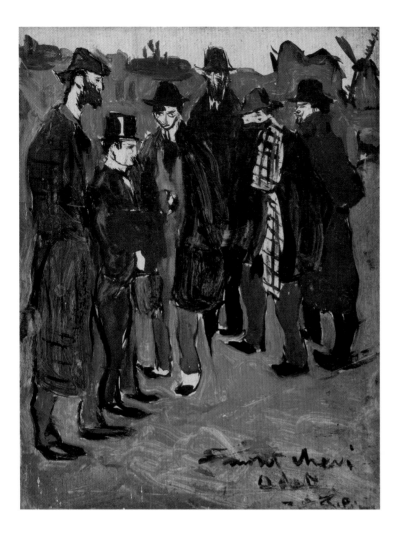

FIG. 2 **Group of Catalans in Montmartre: Pichot, Mañach, Casagemas, Brossa, Picasso and Gener**
Paris, 1900
Oil on panel, 24.1 x 18.7 cm
The Barnes Foundation, Merion, Pa.

Spanish painting over works by established Barcelona artists,[7] was significant in bringing the young Picasso's name to the forefront, at least in terms of his reputation in his native country. But that limited recognition, too, was about to change.

One of the initial contacts who helped Picasso in Paris was Pere Mañach, a Catalan who had already acquired a reputation both as something of a stylish dandy and also as a runner for some of the dealers in Montmartre.[8] The son of a Barcelona locksmith, Mañach had originally gone to Paris in the early 1890s to pursue the family trade,[9] but he gave up his course of study and, instead, set up a little shop where he bought and sold antiques. When the opportunity presented itself, he also promoted young, preferably Spanish, artists, including many of the Catalans who had arrived in the late 1890s.[10] Casagemas wrote about Mañach's first visit to their Montmartre studio on 19 November 1900 in a letter sent back to their friend Reventós in Barcelona: 'The man we were waiting for has just left. He has a junk shop nearby, where I've seen paintings, and it's certain that he is going to buy some from us. Now we are waiting for an answer and the money if he purchases any. This runner is a guy called Mañac and he takes *only* 20%.'[11]

In addition, Mañach is reported to have offered Picasso a contract, paying him 150 francs a month for his artistic output.[12] As Casagemas also says in his letter that they were scheming how to avoid paying the rent of the rue Gabrielle studio for lack of funds, the promise of some income must have given them a little security for the time

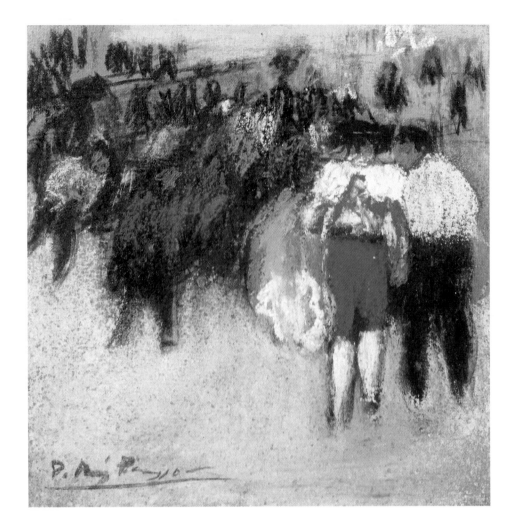

FIG. 3  **Bullfight**
Barcelona, 1900
Pastel on paper, 28 x 28 cm
Private collection, Paris

being. Mañach appears in a drawing that Picasso did of his Spanish friends on the hillside in Montmartre (fig. 2): on the left is Pichot next to Mañach, with Casagemas and Picasso standing in front of the Barcelona writers Jaume Brossa and Pompeu Gener.[13]

Mañach was responsible for introducing Picasso to potential buyers, among whom were the Spanish consul Emmanuel Virenque, who bought *The Blue Dancer* (1900; Private collection), a cabaret performance at the Divan Japonais showing a Pierrot and a female dancer dressed in blue, and a bullfight composition entitled *Entrance to the Bullring* (1900; Museum of Modern Art, Toyama).[14] Another collector was the government official Olivier Sainsère, who reportedly acquired a painting of a child in white.[15] The dealer Berthe Weill, who, with Mañach's

help, had just opened a little gallery at 25 rue Victor-Massé,[16] came to Picasso's studio and bought three bullfight pastels (fig. 3), which she immediately sold on to the drama critic and editor-in-chief of *Les Annales politiques et littéraires,* Adolphe Brisson.[17]

Picasso had begun to explore the medium of pastel back in Barcelona, but once in Paris he shifted from doing Spanish themes, like the ones Weill acquired, to Parisian ones, including some sketches of French fashion that he recorded in a tiny carnet. Among the larger pastel drawings that were not immediately sold are *The Embrace* (pl. 5)[18] and *In the Dressing Room* (pl. 7). These compositions provide a good idea of how he had changed from the vibrant, sun-lit bullfight scenes, with their dashes of different pastel tones to give movement

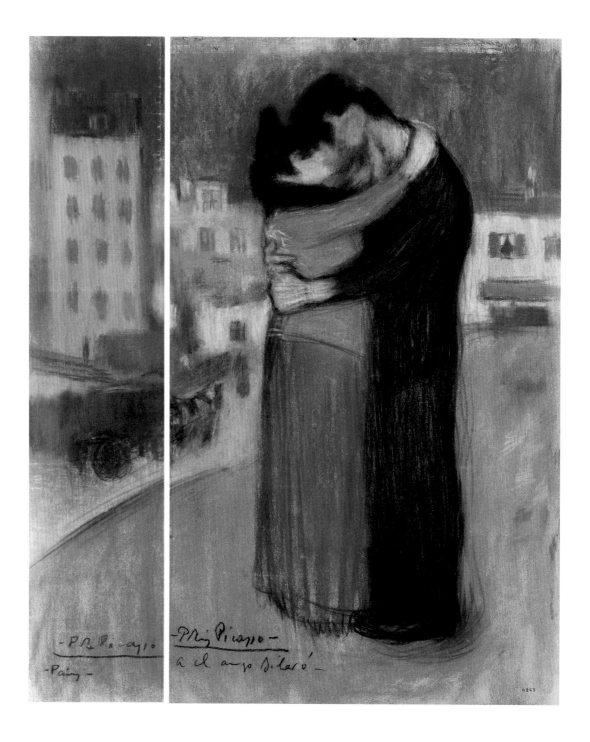

PL. 4    **House and Street in Paris**
Paris, 1900
Pastel on paper, 59 x 12.6 cm
Private collection

PL. 5    **The Embrace**
Paris, 1900
Pastel on paper, 59 x 35 cm
Museu Picasso, Barcelona

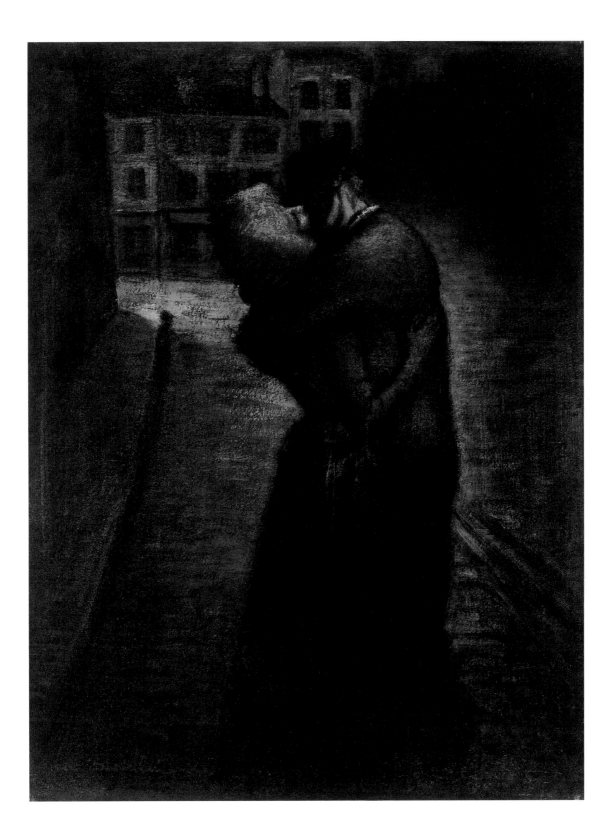

**THÉOPHILE-ALEXANDRE STEINLEN**
*The Embrace*
1895
Oil on cardboard, 65 x 50 cm
Association des Amis du Petit Palais, Geneva

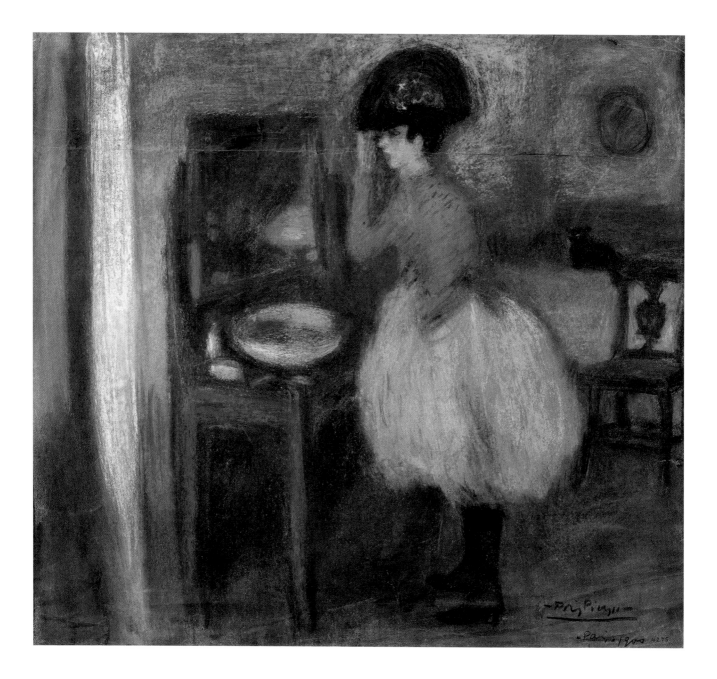

PL. 7    ***In the Dressing Room***
Paris, 1900
Pastel on paper, 47.5 x 52.5 cm
Museu Picasso, Barcelona

and local colour to the event, to the dark, almost saturated, areas of pastel used to convey the underside of life that he observed in the French capital. In these works, Picasso's handling of the medium is quite confident, with a rich application of pastel defining the space and with colour giving expression to the figures. As for his choice of French subject matter, Picasso must have been struck by seeing embracing figures in the street, and a strong parallel can be drawn between his *Embrace* and similar depictions by Steinlen (pl. 6). Although Steinlen, too, was a foreigner, the Swiss artist had made his reputation in Paris and exerted an enormous influence, principally through journal illustrations, on the graphic art of Picasso and his generation.

Through Weill, Picasso also sold his most ambitious painting done in the rue Gabrielle studio, *Le Moulin de la Galette* (pl. 8), to the newspaper publisher (*La Dépêche de Toulouse*) and collector Arthur Huc. This composition, which echoed celebrated depictions by other well-known, artists of the dancehall that had come to be synonymous with a view of modern life,[19] was clearly a means for the young Spaniard to associate his name with theirs. Rather than portray his scene as a light-filled, colourful party out of doors, as Renoir had done (*Bal au Moulin de la Galette*, 1876, Musée d'Orsay, Paris), the mood of Picasso's interior is very different. The sharp effects of lighting turn the painted faces of the women into configurations that resemble masks, and, in this respect, the composition is reminiscent of certain paintings by Toulouse-Lautrec, including *At the Moulin Rouge* (fig. 4), where the greenish face of the woman at the right reflects an upward beam of electric light. In Picasso's *Moulin de la Galette*, the close-up view of the dancers, cut off at the edges, which brings an immediacy to the scene and invites us as viewers to become part of the spectacle, is a device one finds not only in Toulouse-Lautrec but also in works by Degas.

A striking comparison can be made between Picasso's composition and another foreigner's depiction of a similar French scene, Van Gogh's *Dance Hall at Arles*, 1888 (fig. 5). Although done over a decade earlier and in the south of France, Van Gogh's view of the occasion, illuminated with lanterns that punctuate the scene, has some of the same evocative elements that Picasso later chose to portray. In both compositions the dancers are shown as a mass – individuals joined together in the throes of their dance. While Van Gogh's scene celebrates the gaiety of a provincial festivity, Picasso's setting is Parisian. In his composition, emphasis is given to the harshly made-up faces of the women, and the central male dancer, like the one cut off at the right, is shown from the back. There is the tempting possibility that Picasso knew Van Gogh's canvas first-hand, since it was likely to have been in the possession of Vollard in 1900, but there is no record of Picasso visiting Vollard's gallery on his first Paris trip.[20]

Picasso's discovery of Paris parallels in many ways Van Gogh's early experiences in the French capital some fourteen years earlier. Both initially settled in the Bohemian district of Montmartre high above the city, and each of them had a swift introduction into the world of art dealers and galleries – Van Gogh through his brother Theo, and Picasso through the Catalan Mañach. As far as their artistic responses were concerned, there are also parallels in their work. The face of Paris, which had been undergoing rapid changes during these years, provided new material for their compositions. Van Gogh

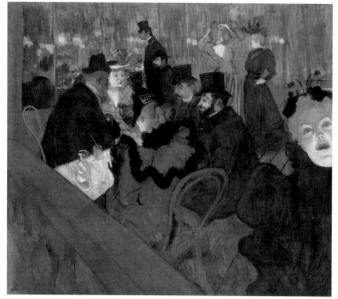

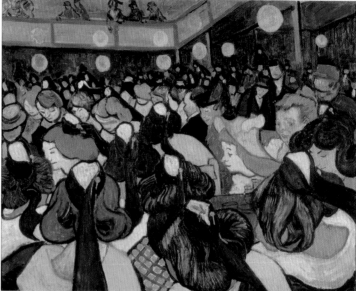

concentrated primarily (but not exclusively) on landscape, painting light-filled views of the hillsides of Montmartre and outlying areas beyond the city limits (pls. 9, 10, 11). For his part, Picasso focused on the urban inhabitants, and he turned his attention principally to the life that he observed on the street and also to the ways of Paris at night. Although it is difficult to ascertain precisely which works by the Dutch artist Picasso might have seen once in Paris, the vibrancy of his own palette and the energetic brushstroke that he employed, especially in 1901, reflect an awareness of Van Gogh's work at an early date.

Casagemas, unlike Picasso, seems not to have had much luck in Paris either with his painting or with romance. He became extremely despondent over his failed love affair with Germaine Gargallo, which prompted Picasso to bring him back to Spain for Christmas. When Casagemas

decided to return alone to the French capital in early February 1901, he occupied the studio on the boulevard de Clichy that Pallarès had moved into after the two of them had left in December.[21] In the meantime, Picasso had chosen to go Madrid, where he worked as art editor for a new journal called *Arte Joven*. While he was in the Spanish capital, he learned from mutual friends the story of Casagemas's death. His friend had arranged a lunch party in a restaurant near the studio and had pulled out a gun and aimed a shot (which missed) at Germaine. Casagemas then turned the gun fatally on himself. His suicide jolted Picasso at a moment when he was in a quandary about his future plans. *Arte Joven* was not proving a success, and lack of money meant that any other artistic ventures in Madrid did not look promising. Mañach was pestering Picasso to send him

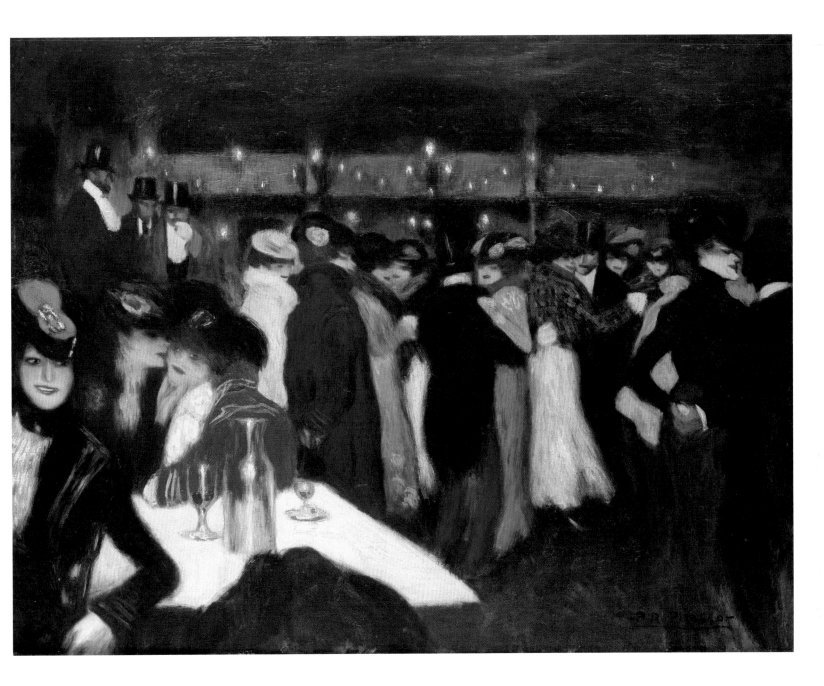

PL. 8    *Le Moulin de la Galette*
Paris, 1900
Oil on canvas, 88.2 x 115.5 cm
Solomon R. Guggenheim Museum, New York
Thannhauser Collection, Gift, Justin K. Thannhauser, 1978

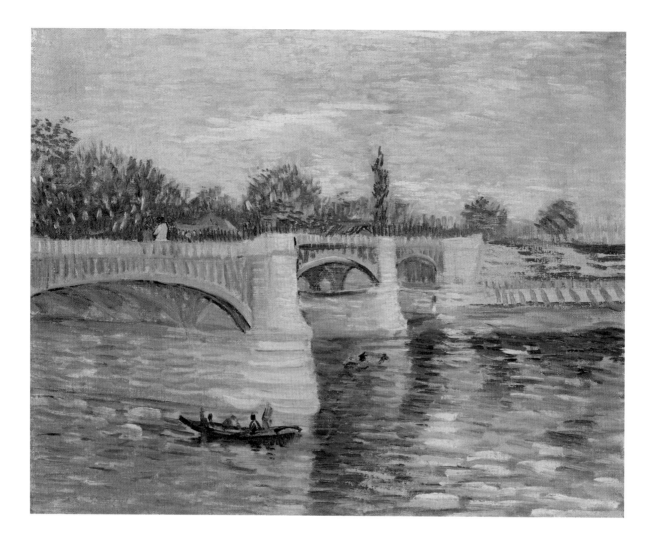

PL. 9  **VINCENT VAN GOGH**
*The Bridge of Courbevoie*
Paris, 1887
Oil on canvas, 32 x 40 cm
Van Gogh Museum, Amsterdam
(Vincent van Gogh Foundation)

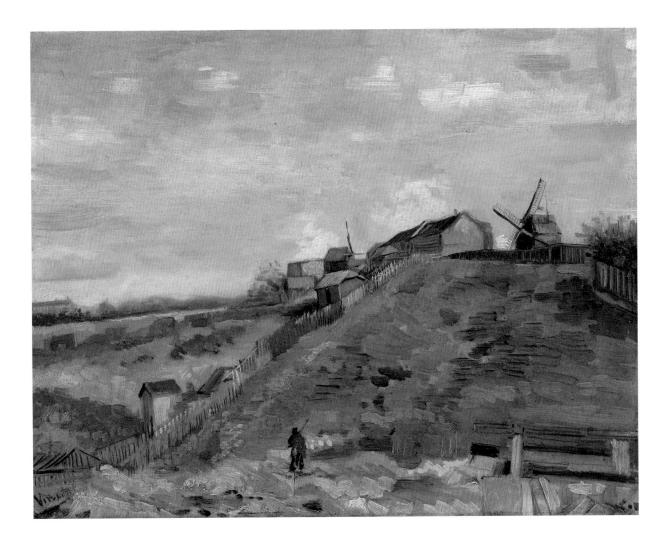

PL. 10　**VINCENT VAN GOGH**
***The Hill of Montmartre with Stone Quarry***
Paris, 1886
Oil on canvas, 32 x 41 cm
Van Gogh Museum, Amsterdam
(Vincent van Gogh Foundation)

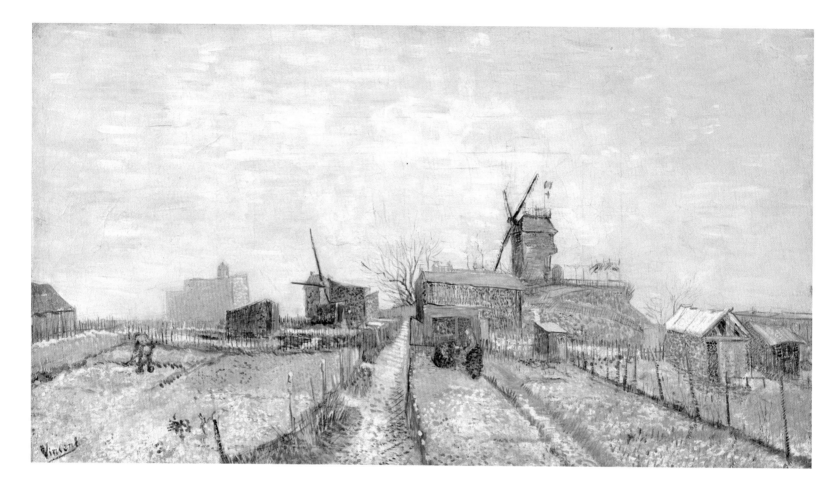

PL. 11    **VINCENT VAN GOGH**
*Montmartre: Mills and Vegetable Gardens*
Paris, 1887
Oil on canvas, 44.8 x 81 cm
Van Gogh Museum, Amsterdam
(Vincent van Gogh Foundation)

FIG. 6

**RAMON CASAS**
**Portrait of Picasso for *Pèl & Ploma***
1901
Charcoal and conté crayon with pastel on
paper, 69 x 44.5 cm
MNAC, Museu Nacional d'Art de Catalunya,
Barcelona

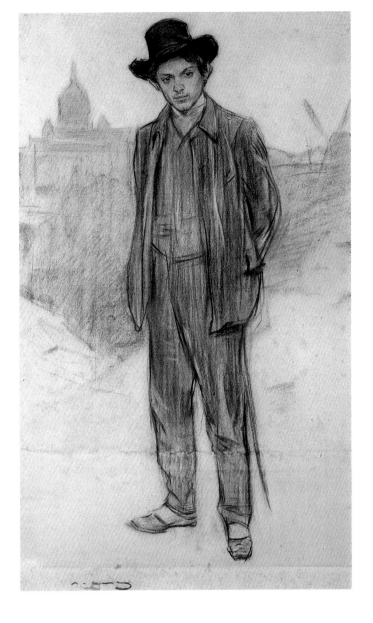

work to fulfil the obligations of his contract, so the artist decided in late spring that the best course of action would be to return to Paris.

On his way, he spent about ten days at home in Barcelona, and during that period he assembled a small group of pastels that he had brought with him from Madrid for an exhibition scheduled to open in the middle of the month at the Sala Parés gallery there. To coincide with the show, an article about him appeared in the journal *Pèl & Ploma*, and the text by Miquel Utrillo expressed the recognition on the part of Barcelona artists that the Benjamin of their group was about to make it big in Paris. The article was accompanied by a portrait of Picasso by Casas (fig. 6), showing him standing in front of the Moulin de la Galette. Utrillo concentrates on his Spanish formation, noting that the pastels in the Sala Parés exhibition represented 'only one aspect of Picasso's talent, which will be very much discussed, but no less appreciated'.[22]

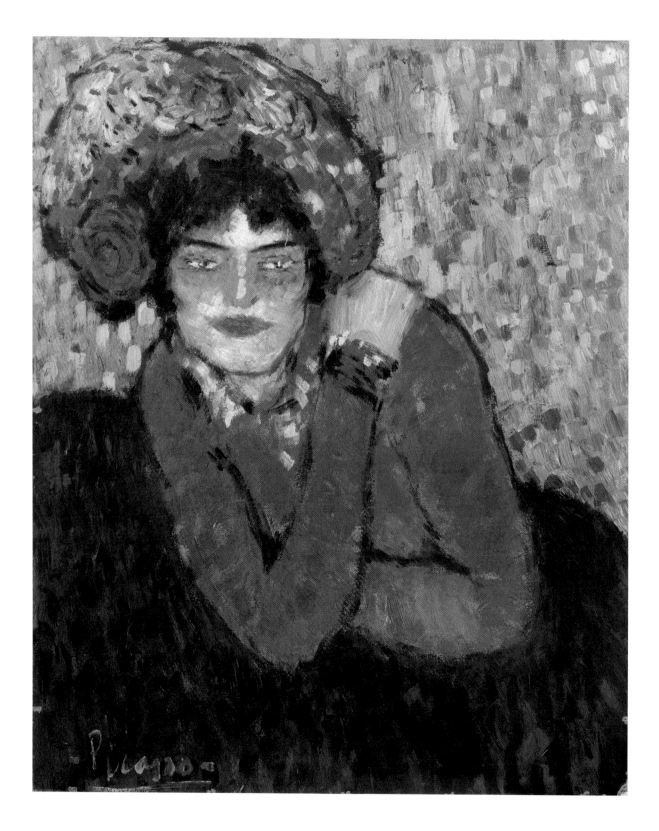

PL. 12    ***Waiting (Margot)***
Paris, 1901
Oil on cardboard, 68.5 x 56 cm
Museu Picasso, Barcelona

# THE 1901 VOLLARD SHOW

MARILYN McCULLY

Since Picasso had been away, Mañach had been looking for a suitable space to hold a large exhibition of his work,[1] and, since Weill's place was too small, Vollard's gallery seemed the obvious choice. Vollard was keen to show Spanish artists – the work of Nonell and Canals had been well received – so Mañach arranged for an introduction, which took place at the rue Laffitte gallery.[2] For his part, Picasso welcomed the possibility of a show, but he was equally delighted with the opportunity to see some of Vollard's celebrated stock, including canvases by Cézanne, Redon, Gauguin and Van Gogh.[3] Following the positive critical reception of previous 'Spanish' shows, Vollard decided to feature the Andalusian along with another Spaniard, the Basque Francisco Iturrino, in a joint exhibition, which was due to open on 25 June. The participation of the writer Gustave Coquiot was secured for the catalogue, in which he contrasted the Hispagnolism of the older Iturrino with the 'youthful, plentiful and varied "Parisian" character' of Picasso's contribution.[4]

Iturrino was one of the first Spaniards in Paris that Picasso and Casagemas had met the previous October.[5] Known both as a painter and as a printmaker, the Basque had studied and lived for several years in Brussels before moving to Paris in 1895. His studio on the boulevard de Clichy was only a few doors down from Picasso's in 1901. Iturrino's image as *The Spaniard in Paris* (pl. 13) had been made famous – at least among fellow artists – by the Belgian painter Henri Evenepoel, who showed the portrait at the Salon in Ghent in 1899 and at the Exposition Universelle in 1900.[6] Iturrino's contribution to the Vollard show comprised 35 paintings, including

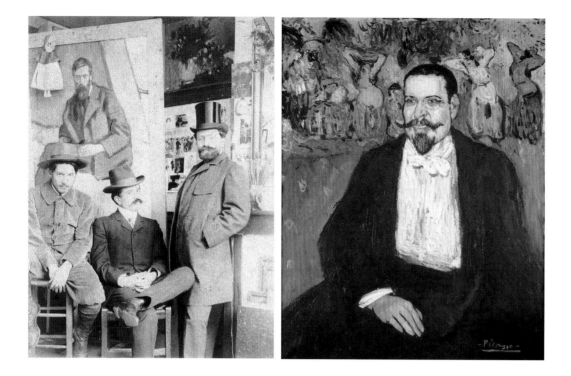

the subject of gypsies (for which he was widely known) as well as some Paris scenes and an unspecified number of drawings.[7]

For his part, Picasso needed to work fast to produce the required number of paintings to fill his section of the gallery walls. Apart from a few things he had brought with him from Spain,[8] Picasso worked on the majority of compositions in the studio on the boulevard de Clichy that had previously been occupied by Casagemas and the Catalan sculptor and mischief-maker Manolo Hugué.[9] Picasso and Mañach had taken over the two-room apartment, with Picasso occupying the larger space, where he could work. While Mañach concerned himself with organizing various aspects of the exhibition, including contacting potential buyers and reviewers,[10] Picasso set about to paint. For him, the Vollard show

offered the chance to make a big name for himself on the French scene. However, the work that he prepared would not be typically Spanish, as Vollard might have anticipated, but decidedly French in inspiration.

With time at a premium and available cash at a minimum, Picasso chose to work principally on a group of cardboard supports of several different formats, and he painted with oils directly on them without any particular preparation (avoiding the normal gesso stage when working on canvas). He reportedly completed up to three paintings in a day,[11] and, in some cases, he painted on both sides of the board.[12] In addition, he did several oil on canvas portraits depicting his promoters, Mañach, Coquiot and Vollard,[13] as well as his fellow exhibitor Iturrino (fig. 7), although this work was later relegated to the back of another composition and painted over.[14]

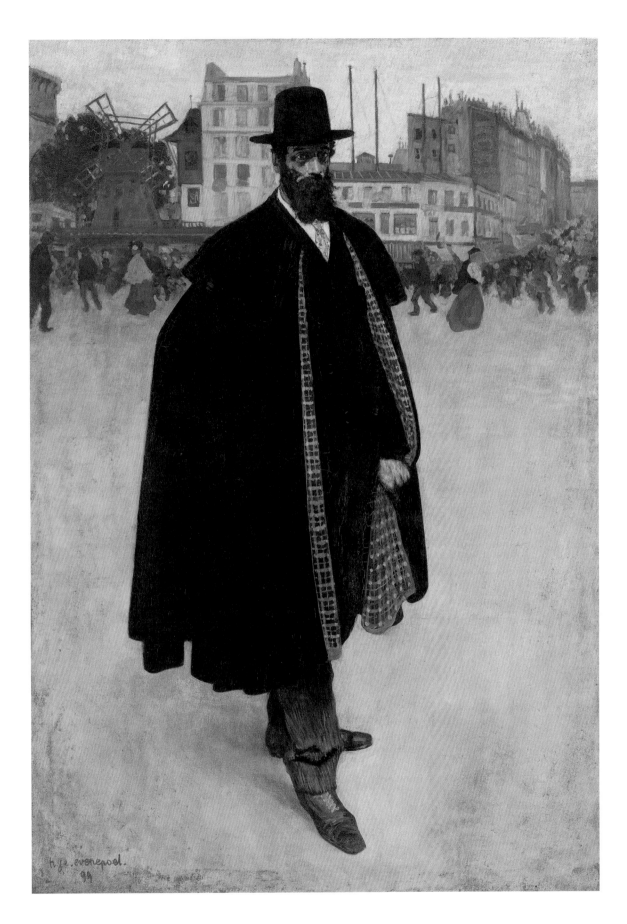

PL. 13 **HENRI EVENEPOEL**
***The Spaniard in Paris (Portrait of Francisco Iturrino)***
1899
Oil on canvas, 217 x 152 cm
Museum voor Schone Kunsten, Ghent

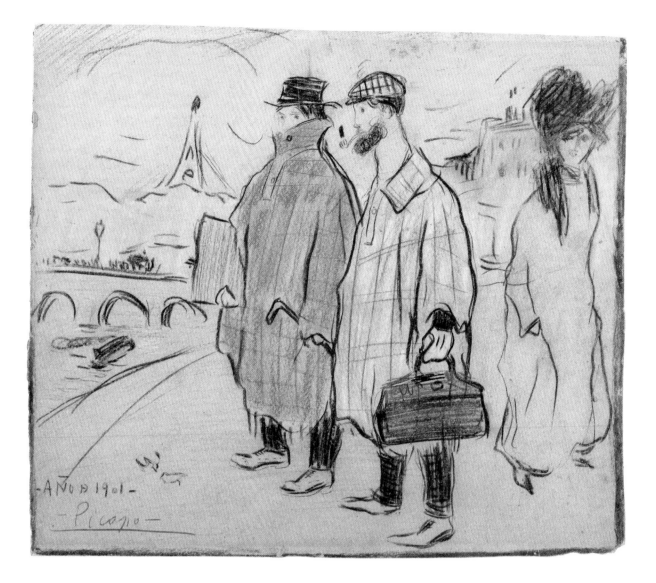

PL. 14    ***Picasso and Jaumandreu Bonsoms Arriving in Paris***
Paris, 1901
Coloured pencils on paper, 33 x 38 cm
Staatliche Museen zu Berlin, Nationalgalerie,
Museum Berggruen, Berlin
Bonsoms, a friend of Casagemas, accompanied Picasso on his
second trip to Paris.

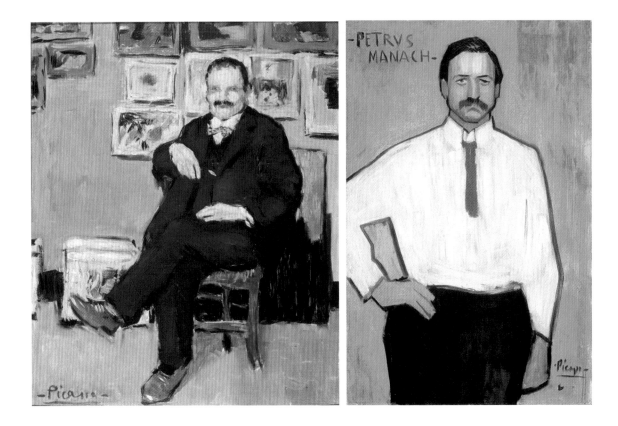

FIG. 9     **Portrait of Ambroise Vollard**
Paris, 1901
Oil on cardboard, 46 x 38 cm
Stiftung Sammlung E.G. Bührle, Zurich

FIG. 10     **Portrait of Pere Mañach**
Paris, 1901
Oil on canvas, 105.5 x 70.2 cm
National Gallery of Art, Washington DC.
Chester Dale Collection

In the case of Coquiot (fig. 8), Picasso portrayed him against the backdrop of Parisian nightlife, with exotic dancers writhing in the background. The rendering of the central band of space behind the figure and below the dancers as an essentially flat plane, with patches of colour, is reminiscent of a similar compositional device in paintings by Gauguin and also by Van Gogh.[15] The portrait of Vollard (fig. 9) shows him seated in his gallery, with paintings by Picasso on the walls – two that can be identified in the catalogue list are no. 41 'La Bête (appartient à Mme K. Kollwitz artiste-peintre à Berlin)' and no. 50 'Rochers',[16] which is also shown on the wall of Picasso's studio in *The Blue Room* (pl. 56) – and stacked against the walls behind him. For Mañach (fig. 10), Picasso began by depicting him in a bullfighter's pose and costume, but he changed the composition as he developed

the image.[17] In his final version, he painted over most of the traditional suit of lights, preferring to show him simply with a white shirt and the bullfighter's scarlet tie and the hint of a cummerbund.

When it came to doing a *Self-Portrait* for the show (fig. 11), there was no doubt in Picasso's mind that he would present himself not as a Spanish type – as he had done for Mañach – but as a confident and modern young man, on the brink of success on the international stage and a great career. The bravura strokes of paint and the bright palette that he chose are French in inspiration (rather than sombre, monochromatic, Spanish ones) and the deliberate execution conveys a determined and forceful personality. While he shows himself at the easel in the act of painting, this is obscured in the composition by the emphasis given to his bright red neckscarf, with

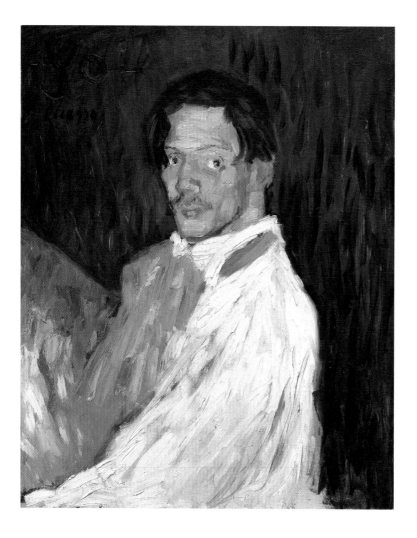

FIG. 11    ***Self-Portrait ('Yo, Picasso')***
Paris, 1901
Oil on canvas, 73.5 x 60.5 cm
Private collection

yellow highlights, which are echoed in the area of the easel, and the rhythms of thick strokes of white paint that define the artist's billowing white shirt.

Although the catalogue lists works by title, not all of the 64 compositions (and an unspecified number of drawings) that were shown have been precisely identified.[18] Nonetheless, given the type of support and the change in Picasso's signature, from '– *Pablo Ruiz Picasso* –' (or, '– *P R Picasso* –') to '– *Picasso* –', we can identify quite a few works that were undoubtedly done in preparation for the show. We can also gain from the catalogue titles a fairly clear idea of the subjects that Picasso concentrated on – women, Parisian daily life (pls. 17, 46, 50), the city (pl. 45, fig. 16), entertainments (pl. 38), etc. – and these, again, reflect a desire to present himself primarily as an observer of modern French life rather than just as a painter of bullfights and gypsies, although these subjects, as well as a number of flower pieces (pl. 20), were represented in the show.[19] An alternative exhibition title – at least for many of the works by Picasso in the Vollard show – might have been 'Paris: jour et nuit', since a large number of them reflected those aspects of the life that he himself observed and lived in Paris.

A large number of compositions listed in the catalogue refer to depictions of women: some of them are café clientele, some are shop girls, while others are dancers or singers in performance, and others again prostitutes hanging out in seedier locales. The *Woman at a Café* (pl. 15) features a fashionable woman, with a large, splendid hat matching her dress. Apart from a wine glass on the table, the absence of anecdotal details or companions reveals her to be on her own and the type

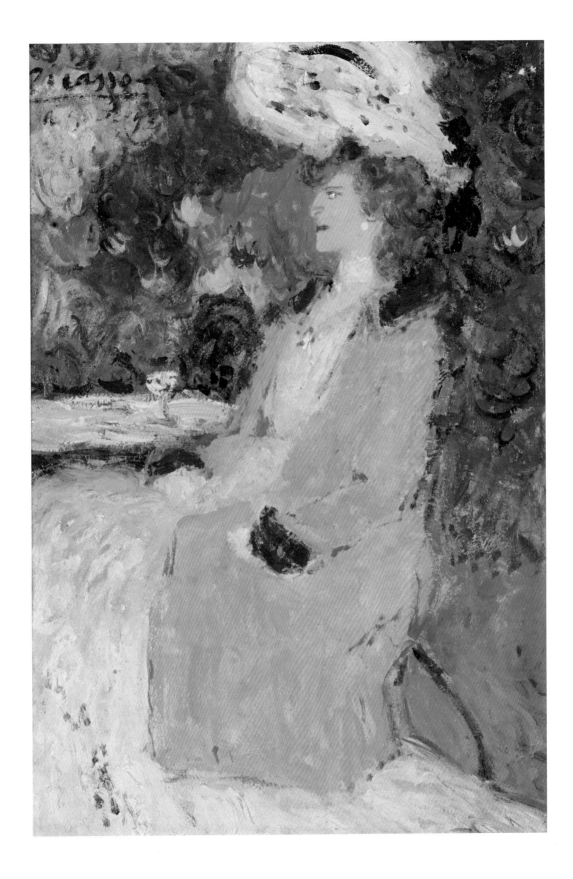

PL. 15    ***Woman at a Café***
Paris, 1901
Oil on paper pasted on panel, 53.5 x 35 cm
Museum Boijmans Van Beuningen, Rotterdam

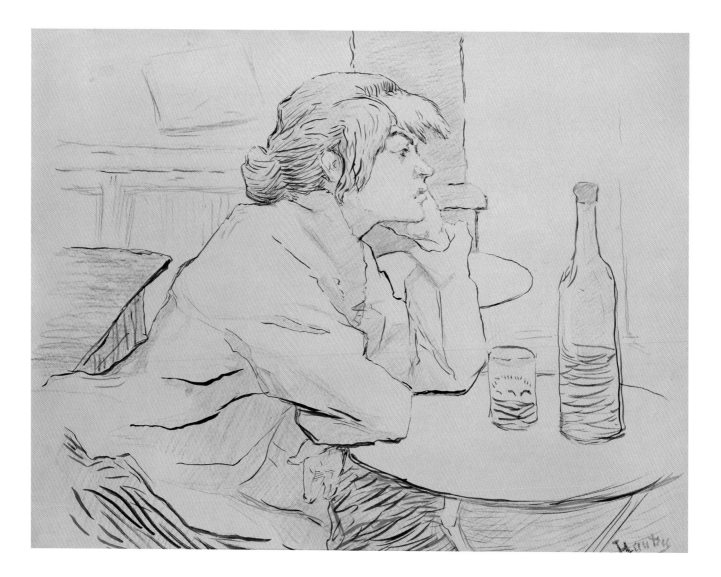

**HENRI DE TOULOUSE-LAUTREC**
*The Drinker* or *Hangover* (Suzanne Valadon)
1889
Black ink and crayon on paper, 49 x 63 cm
Musée Toulouse-Lautrec, Albi

PL. 17 **_Dinner in a Restaurant_**
Paris, 1901
Pastel and watercolour on paper, 28.5 x 39 cm

PL. 18    *Still Life*
Paris, 1901
Oil on canvas, 61 x 82 cm
Museu Picasso, Barcelona

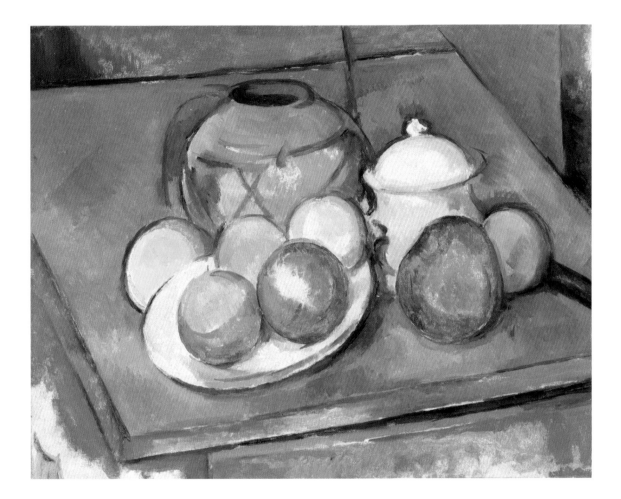

PAUL CÉZANNE
*Ginger Jar, Sugar Bowl and Apples*
1890-3
Oil on canvas, 36 x 46 cm
Musée de l'Orangerie, Paris

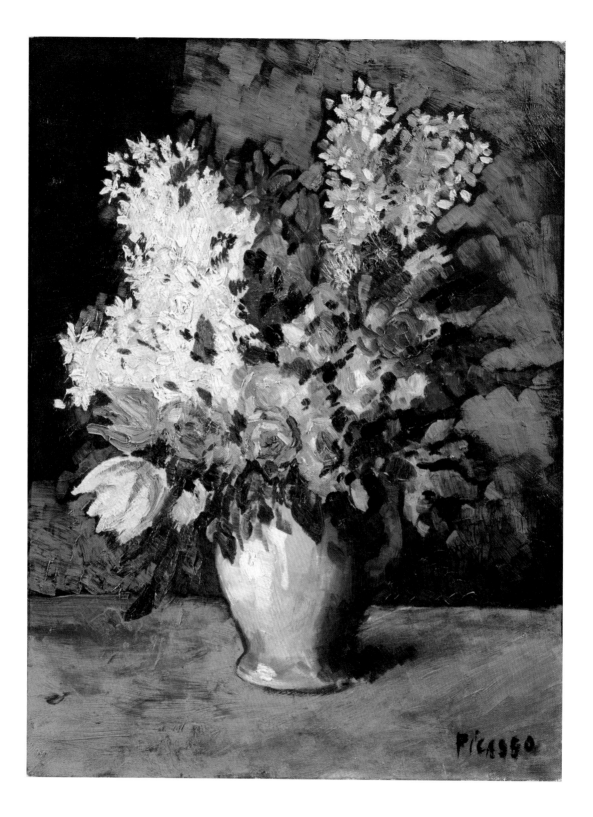

PL. 20   **Flowers**
Paris, 1901
Oil on canvas, 65.1 x 48.9 cm
Tate, London

of French woman, so unlike her less liberated Spanish equivalent, that Picasso would have observed from a distance in a Paris café. By contrast, *Waiting*, the painting of an unknown woman called Margot (pl. 12) is a close-up view, and the directness of her gaze suggests that she was sitting across a table from the artist. Picasso emphasizes her lipstick by using his paint as if he were applying the make-up himself. The overall treatment of Margot's dress and hat, as well as the table and space around her, is done with short, lively brushstrokes laden with colours, probably applied right from the tube. The overall shrillness of the colours that he chose both for her face and the setting suggests that she might be a call girl seated in a cabaret, seen under the harsh glare of electric lights.

For amusement and in search of subjects for their art, Picasso and his friends regularly frequented dancehalls and cabarets, going to places like L'Enfer, La Fin du Monde, the Moulin de la Galette and the Moulin Rouge. In the case of the *Dwarf-Dancer (La Nana)* (pl. 21), Picasso shows the dwarf performer on stage, with the brightness of the lights that illuminate her from below emphasized by the vivid palette. The abbreviated type of brushwork and choice of colours that are evident here (as in the portrait of Margot), are fairly new in Picasso's oeuvre. His reviewers, including Félicien Fagus (*nom de plume* of the poet Georges Faillet) in *La Revue Blanche*, pointed to a wide range of sources of artistic influence to account for this new, painterly approach: 'It is easy to discern, apart from the great artists of the past, many likely influences – Delacroix, Manet (obviously, whose painting owes something to the Spanish masters), Monet, Van Gogh, Pissarro, Toulouse-Lautrec, Degas, Forain, Rops perhaps... Each influence is transitory, no sooner

picked up than it vanishes into the air: He is evidently hot-headed, and this has allowed him no time to forge a personal style; his personality lies in this hot-headedness (it is said that he is not yet twenty and that he paints as many as three canvases a day). The danger for him lies in this very impetuousness, which could easily lead to facile virtuosity and easy success. To be prolific is not the same as being productive, nor is violence the same as energy. That would be a great pity in someone of such outstanding virility.'[20]

Concerning the origins of this painterly approach, it should be noted that there is some dispute among Picasso specialists as to where – Madrid, Barcelona or Paris – the paintings of *Waiting (Margot)*, the *Dwarf-Dancer* and the *Old Woman* (1901; Philadelphia Museum of Art) were actually carried out.[21] One suggestion is that some of them were done in Madrid. However, the use of the paint-laden brushstrokes and the bright palette that we find in these compositions is not characteristic of other paintings done there, which tend to be Spanish in inspiration. The largest painting that Picasso did in Madrid, *Woman in Blue* (fig. 12), which he showed in the capital at the Exposición de Bellas Artes that year, owes a large debt to Velázquez and Goya, and in terms both of colour and technique it is quite different from the works in question. We know that Picasso disliked sending or transporting his work, and he had already taken a group of pastels from Madrid to show in Barcelona, so it is highly unlikely that he brought unfinished canvases from Madrid to complete in Paris; this would not have been his normal practice, nor is there any technical evidence (i.e., underpainting revealed in x-rays or examination of paint layers) to substantiate this claim.[22] As far as Barcelona

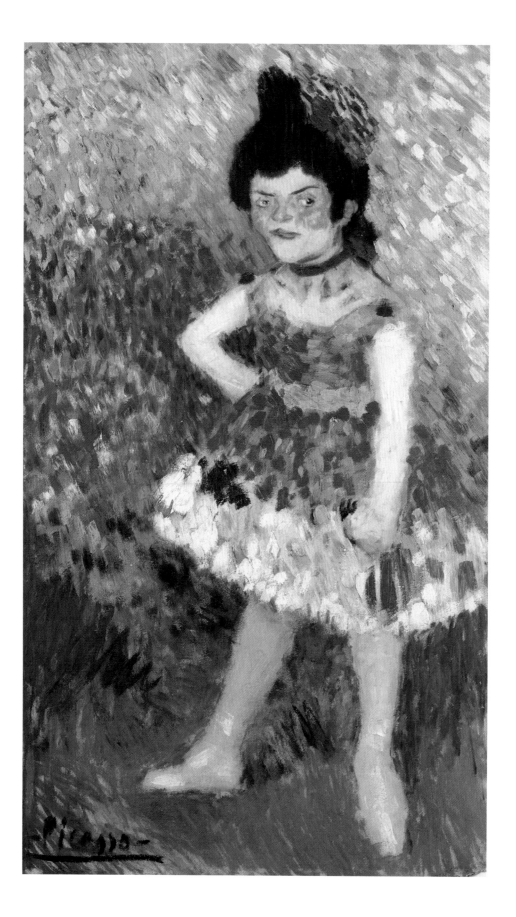

PL. 21     **Dwarf-Dancer (La Nana)**
Paris, 1901
Oil on cardboard, 105 x 60 cm
Museu Picasso, Barcelona

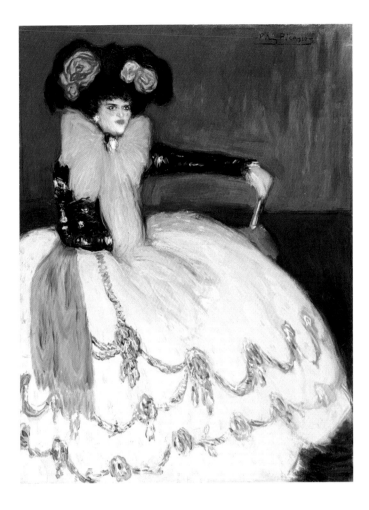

FIG. 12  **Woman in Blue**
Madrid, 1901
Oil on canvas, 133 x 100 cm
Museo Nacional Centro de Arte Reina Sofia,
Madrid

is concerned, several paintings, seemingly done in and around the city in the short time he was there in May, are much closer in technique and support (cardboard) to the depictions of entertainers. However, it is likely that the compositions featuring harlots and performers, including those mentioned above, were carried out in Paris, where Picasso's fresh painterly approach would be understood by visitors to his exhibition, as Fagus pointed out, in the context of late nineteenth-century French painting rather than in the light of Spanish tradition.

The response that Picasso had to the art that he discovered in Paris on his first two visits was shaped in part by the interests of his artist and writer friends. The focus in the work of Nonell, Canals and Sunyer, for instance, was on the depiction of the deprivations and social conditions of the life that they observed in the city.

The concept of Naturalism was still widely favoured, as exemplified in the work of Zola, and the themes of his novels – poverty and social alienation – were also taken up by many graphic artists, including Steinlen.[23] At the same time, Picasso was keen to see first-hand the works of the French painters whose techniques were considered advanced and about whom he had also heard a great deal from his friends.[24] Picasso was able to see a vast number of works in 1900 at the Grand Palais at the Exposition, and he also made a point of seeing the Impressionist rooms in the Luxembourg and visiting galleries to see works by, among others, the Nabis, including Bonnard, and Symbolists Redon and Gauguin. For Picasso's circle of friends, who came from the background of narrative Symbolism that was practised back home, the idea that painting could be considered, in the first

place, an arrangement of colours in a certain order on a flat surface,[25] and that this in itself could be evocative, represented something completely new.

Without a doubt, the combination of influences that he discovered in Paris, whether from the point of view of subject matter or the change in approach in terms of technique, made an impact on Picasso from the start. But the nature of what we might call 'influence' is not in his case simply a matter of imitation. What becomes clear – and this was something that would remain an aspect of his practice throughout his career – is that Picasso was able to absorb – and steal, if necessary – whatever he needed from the work of other artists in order to reinvent the art that he saw around him in his own terms. Picasso later recalled, 'They said when I began in Paris that I copied Toulouse-Lautrec and Steinlen. Possible, but never was a painting by Toulouse-Lautrec or Steinlen taken for mine. It is better to copy a drawing or painting than to try to be inspired by it, to make something similar. In that case, one risks painting only the faults of his model.'[26]

The darker side of Paris, especially the world of prostitutes who lived on the fringes of mainstream life in the city, became a subject of particular fascination for Picasso: a subject with erotic potential, to which he would return, especially in many prints, at the end of his life. The early scenes not only reflect the young man's personal discovery of Paris brothels – the one on the rue de Londres in the 6th district seems to have been a favourite[27] – but they also reveal the way in which he responded to the handling of similar subjects by other artists. A striking comparison of subject matter can be made, for instance,

between Picasso's *Nude with Red Stockings* (pl. 23), a bright painting of a woman (wearing only stockings) leaning back on a divan, with Bonnard's *Nude with Black Stockings* (pl. 24), done a year earlier. Bonnard conveys a certain coy modesty in his portrayal of the woman, who is seated on a bed in a darkened interior, by obscuring her face (and identity) as she removes her clothing from over her head. Picasso's depiction, by contrast, emphasizes in its frontality and bright palette the forthright, brazen quality of the naked woman's attitude towards her profession and her surroundings.

Another painting of a naked woman, who may or may not be a prostitute, is the disturbing *Madwoman with Cats* (pl. 25), which must be the work listed in the Vollard catalogue as no. 17. The crouching attitude and strangeness of the woman's compressed, small body, combined with her anxious facial expression, suggest that she is actually mad. Close examination of the surface shows that while he was working, Picasso changed this composition, painting over much of the interior setting surrounding the figure with a thick layer of white. At the same time, this process of covering up allowed for the emergence of the black cats from the layer of paint beneath. Rafael Inglada believes that this particular woman was someone that Mañach actually knew,[28] and it might be that he arranged for her to pose for Picasso.

A fortuitous result of the Vollard show of great importance to Picasso was that he was introduced to Max Jacob, whom Mañach had invited to the exhibition in the poet's capacity as critic. The entertaining and inquisitive man from Brittany would become one of

PL. 22    *Le Divan Japonais*
Paris, 1901
Gouache and watercolour on paper, 35 x 53 cm
Collection Gabriele and Horst Siedle, Germany

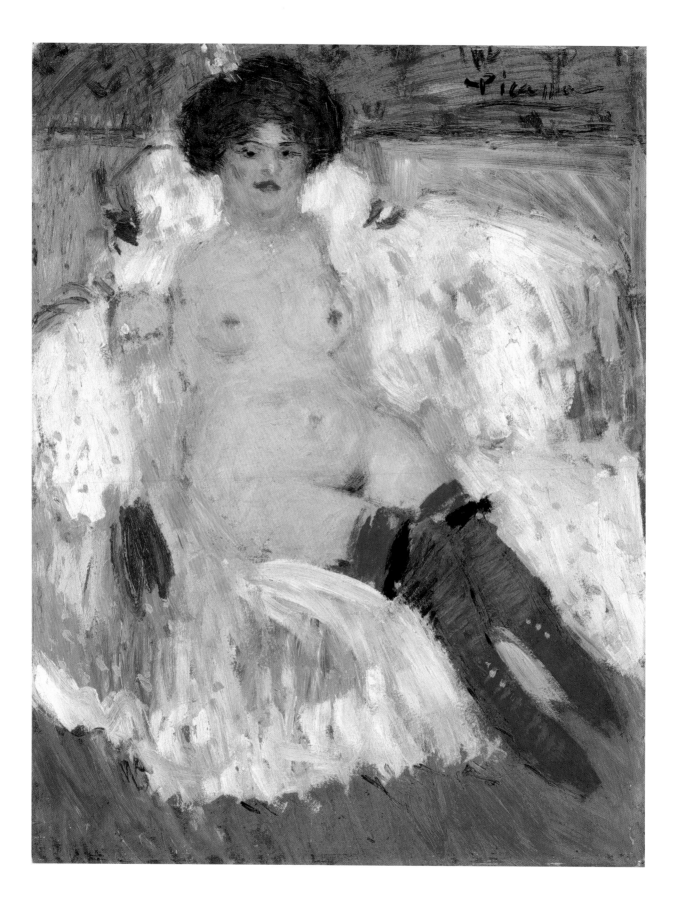

PL. 23 **Nude with Red Stockings**
Paris, 1901
Oil on cardboard, 67 x 51.5 cm
Musée des Beaux-Arts de Lyon

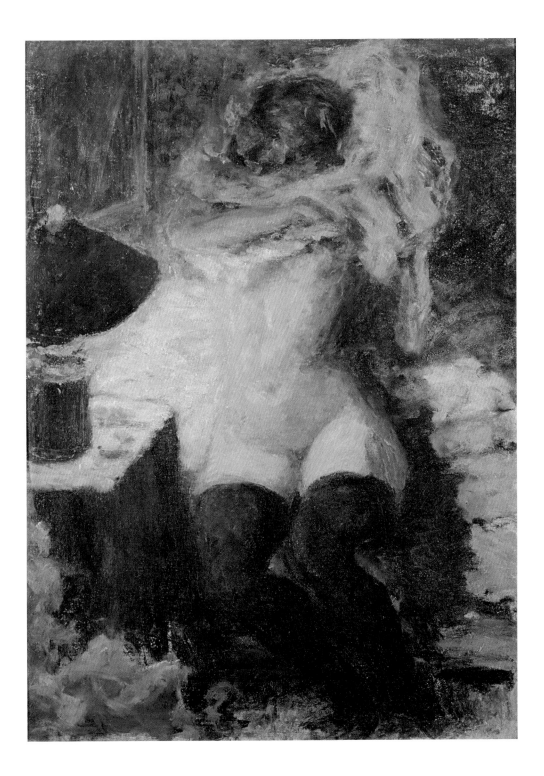

**PIERRE BONNARD**
*Nude with Black Stockings*
1900
Oil on canvas, 59 x 43 cm
Private collection

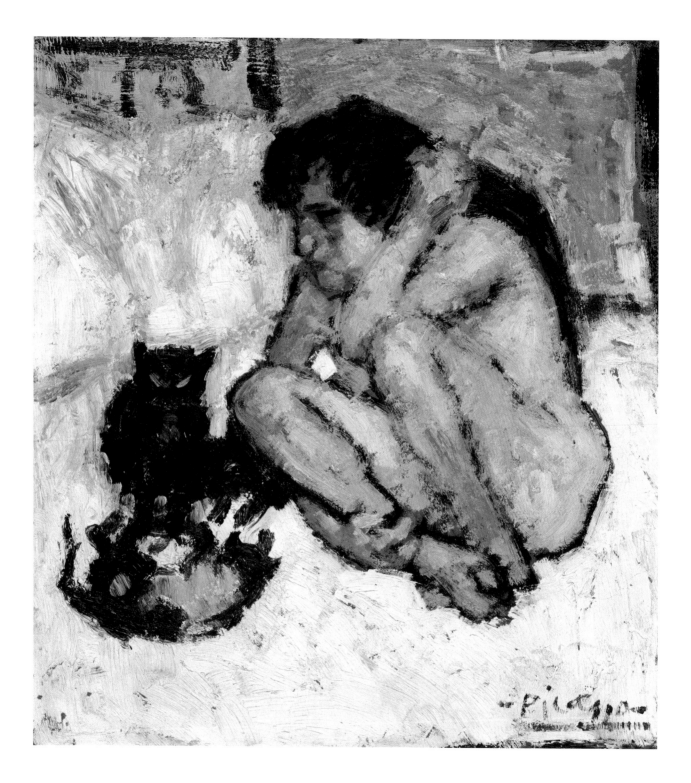

PL. 25    **_Madwoman with Cats_**
Paris, 1901
Oil on cardboard, 45.1 x 40.8 cm
The Art Institute of Chicago, Amy McCormick
Memorial Collection

Picasso's closest friends. Not only did he help him learn to speak French, but he also introduced him to the world of French literature and new, sometimes arcane, ideas.[29] Jacob remembered their first meeting in Picasso's studio with great fondness: 'I went to see them, Mañach and Picasso, I spent a day looking at piles and piles of paintings! He was making one or two each day or night, and selling them for 150 francs on the rue Laffitte. Picasso spoke no more French than I did Spanish, but we looked at each other and we shook hands enthusiastically. This happened in a large studio in the place Clichy, where some Spaniards were sitting on the floor, eating and conversing gaily. [...] They came the following morning to my place, and Picasso painted on a huge canvas, which has since been lost or covered over, my portrait seated on the floor among my books in front of a large fire.'[30]

In spite of the promise of sales, during the weeks of heated preparation for the Vollard show Picasso was struggling to make ends meet. Mañach was supposed to pay him a monthly stipend, but rent for the studio may well have been deducted from that amount. The Catalan musician Ricard Viñes, who had been resident in Paris since 1897 and was, with his brother Pepe, an art collector, reports that Picasso came to him asking for help in July of 1901.[31] The pianist loaned him money in exchange for the promise of three works, which Picasso gave him and his brother in the following year. Among them was *Head of a Woman* (1901; Philadelphia Museum of Art), and *Woman with Jewelled Collar* (pl. 52), which he painted some time after the Vollard show had opened in late June.[32]

The artist also took on other jobs to make pocket money, including doing illustrations for Paris journals, notably *Le Frou-Frou* in 1901.[33] The role that illustrated publications, such as *Le Frou-Frou, Gil Blas Illustré* and *L'Assiette au Beurre*, played in the life of so many foreign artists in Paris in the early years of the century was enormous. Principally, this casual work provided artists with a means to make a little money, but the activity also put them in touch with one another and made them familiar with newsworthy topics, including political and social issues, which their drawings accompanied. Illustrations by many of Picasso's friends and acquaintances – from the Catalan Xavier Gosé (pl. 28) to the Italian Ardengo Soffici, the Greek Démétrius Galanis, the Dutch Kees van Dongen (pl. 29) and, later, Picasso's countryman Juan Gris (pl. 31) – can be found on the pages of a wide range of French journals in the early years of the century.[34] In addition to the standard, linear cartoon-type of drawing, often incorporating silhouettes, a fairly recognizable graphic style emerged among artists, who were influenced, in particular, by Steinlen, with emphasis given to a sketchy, charcoal or lithographic crayon technique. The Frenchman Paul Iribe (pl. 30) and, later, Gris, both developed a different and quite original approach, based on an understanding of the potential of printers' tints to render certain areas flat and with varying tones in their drawings for publication.

The style of illustration of the drawings Picasso had previously (early 1901) contributed to the Madrid journal *Arte Joven*, was probably closer to Steinlen than most of the illustrations he subsequently produced in Paris. The

PL. 26   *Lures for Men*
Paris, 1901
Reproduced in *Le Frou-Frou*, 31 August 1901
Private collection, London

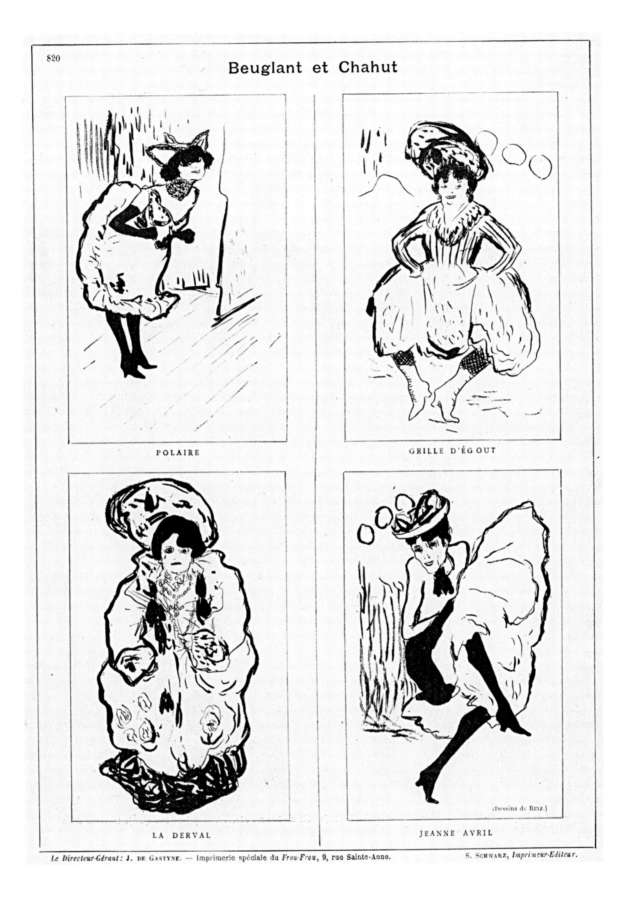

PL. 28     **XAVIER GOSÉ**
*Foreign Adventurers*
Cover of *L'Assiette au Beurre*, 4 July 1903
Private collection, London

PL. 29     **KEES VAN DONGEN**
*Short Story for Children Small and Large*
Cover of *L'Assiette au Beurre*, 26 October 1901
Private collection

— ...Indépendamment de cela, je peins avec mon âme...

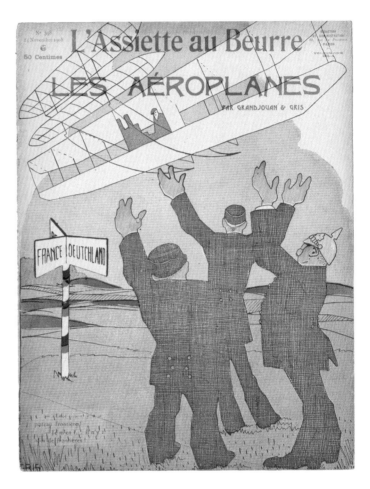

**PAUL IRIBE**
*Woman Artist*
Caricature from his 'Esthètes' issue of *L'Assiette au Beurre*,
25 April 1903
Private collection, London

**JUAN GRIS**
*Aeroplanes*
Cover of *L'Assiette au Beurre*, 24 November 1908
Private collection, London

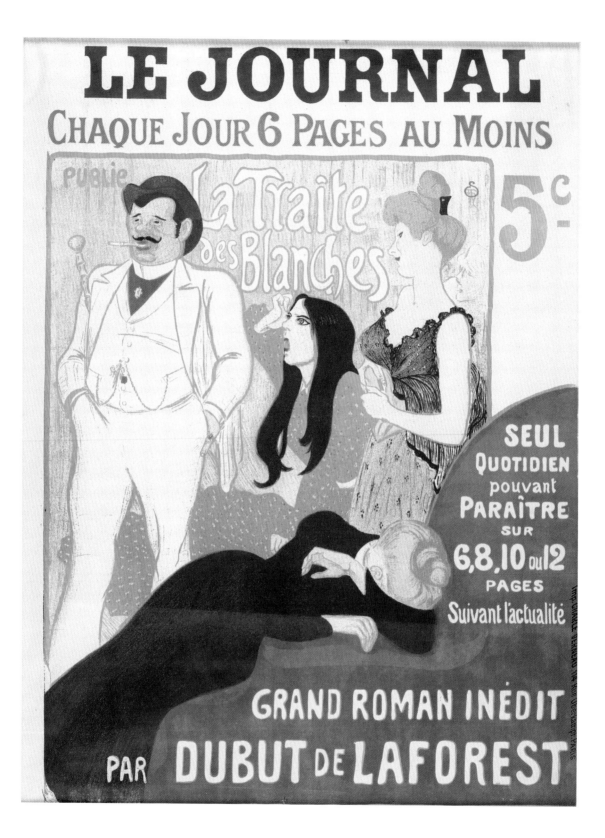

PL. 32    **THÉOPHILE-ALEXANDRE STEINLEN**
*White Slavery* **(censored version)**
1899
Colour lithographic poster, 80.5 x 60 cm
Musée d'Ixelles, Brussels

PL. 33  **HENRI DE TOULOUSE-LAUTREC**
*May Milton*
1895
Colour lithographic poster, 79 x 60 cm
Musée d'Ixelles, Brussels

pen and ink drawings that appeared in *Le Frou-Frou*, which were always signed '– *Ruiz* –' [in a circle], stand out for their differences rather than for their similarities with the conventions of accepted graphic modes. All of the subjects of Picasso's illustrations that appeared in *Le Frou-Frou* (and in the *Almanach de Frou-Frou*) featured well-known Paris entertainers, including Toulouse-Lautrec's favourite Jane Avril, the can-can dancer known as Grille d'Egout, the old singer Marie Derval and the actress Polaire, among others (pl. 27). By boldly employing pen and ink, Picasso was able, in the manner of an accomplished caricaturist, to capture their instantly recognizable physical features as well as their trademark costumes. For the most part, he probably worked from photographs rather than from life, but some drawings suggest that there were exceptions. Although not done for publication, the little sketch of the red-haired performer Yvette Guilbert (pl. 39) has an immediacy that suggests it was done from life, probably at one of her performances.

A few years later, at a time when Picasso was yet again desperately low on funds, he was asked to do a series of illustrations for the satirical magazine *L'Assiette au Beurre*. He was offered what represented at the time the significant amount of 800 francs for a whole number. While this sum could have been used to pay for paint supplies, the rent, and even food, he declined, preferring instead to push ahead with his plans to become self-sufficient as a painter, and one who would be true to his aims and ambitions at that.[35]

Another contact for the Barcelona group was the Catalan impresario Josep Oller, who occasionally gave Picasso and his friends free passes to his establishments, notably the Moulin Rouge. Although Oller had grown up in Paris and spent practically his whole life there, he was proud of his Catalan origins, and he cultivated all kinds of Barcelona emigrés, including artists, writers and businessmen, who came to the French capital. Among his own close circle of friends were the writers Pompeu Gener and Jaume Brossa, both of whom were anarchist sympathizers, as well as the pianist Joaquim Nin (father of Anaïs Nin) and the painter Ricard Canals. Oller's many establishments included the Grande Piscine Rochechouart in Montmartre (which recycled the water used to drive the *funiculaire*), the Nouveau Cirque on rue Saint-Honoré, the celebrated Olympia theatre on the boulevard des Capucines, and the Jardin de Paris near the Petit Palais. But, as Sunyer recalled, the Moulin Rouge was the Catalan artists' regular gathering place: 'We went often. The owner Oller [...] introduced us to the doormen, and on entering all we had to do was to signal them. Often I went accompanied by the critic Gustave Coquiot and the painter Bottini. I never spoke with Toulouse-Lautrec, although I saw him there on many occasions.'[36]

It was probably at Oller's instigation that Picasso did a poster design (never printed) for the Jardin de Paris (pl. 35), which, as an image, stands out as an homage to Toulouse-Lautrec. The watercolour features a group of can-can dancers, which Picasso placed in the upper part of the sheet, along with the name of the establishment, while he left much of the space below empty for his signature.[37] The repetition and seemingly random placement of the black stockings of the dancers' kicking legs reflects the vigour of the dance and, in this way, animates the graphic design in a manner that recalls celebrated posters by Toulouse-Lautrec (pls. 34, 36, 37).

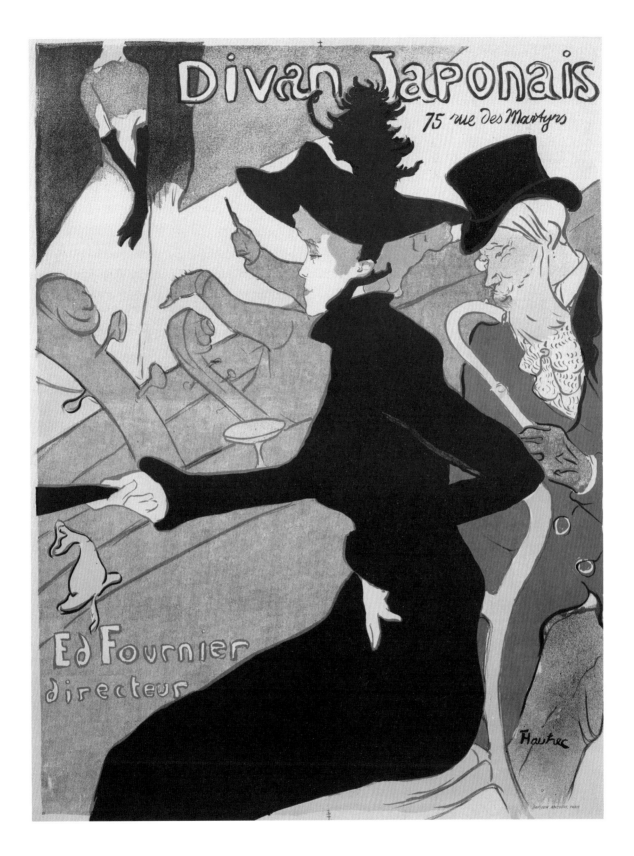

PL. 34 **HENRI DE TOULOUSE-LAUTREC**
*Divan Japonais*
1893
Colour lithographic poster, 82 x 57.5 cm
Van Gogh Museum, Amsterdam
(Vincent van Gogh Foundation)

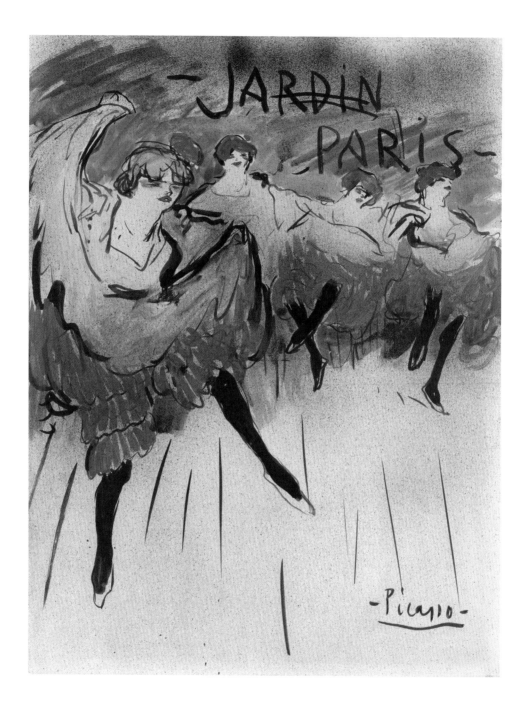

PL. 35  **Jardin de Paris**
Paris, 1901
Ink and watercolour on paper, 64.8 x 49.5 cm
The Metropolitan Museum of Art, New York.
Gift of Raymonde Paul, in memory of her brother,
C. Michael Paul, 1982

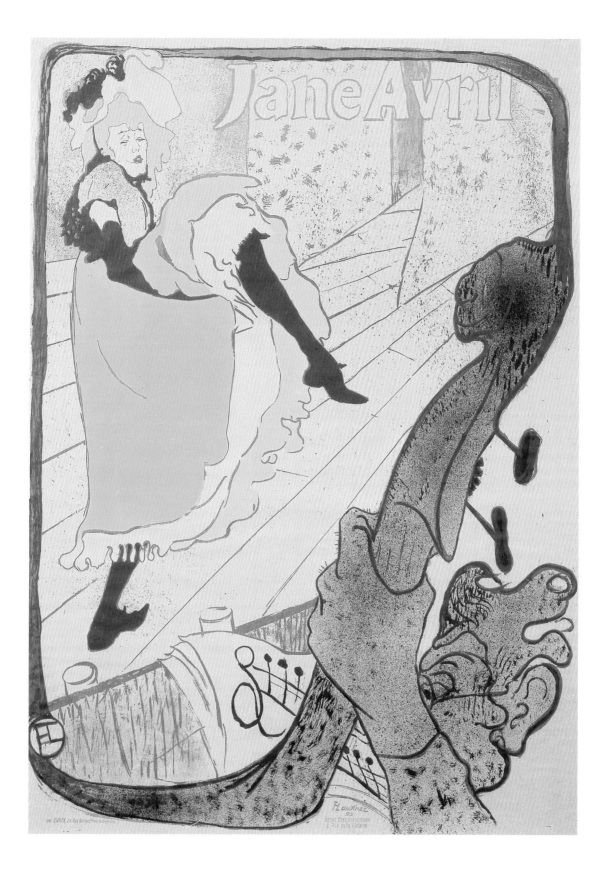

PL. 36   **HENRI DE TOULOUSE-LAUTREC**
*Jane Avril*
1893
Colour lithographic poster, 124 x 91.5 cm
Musée d'Ixelles, Brussels

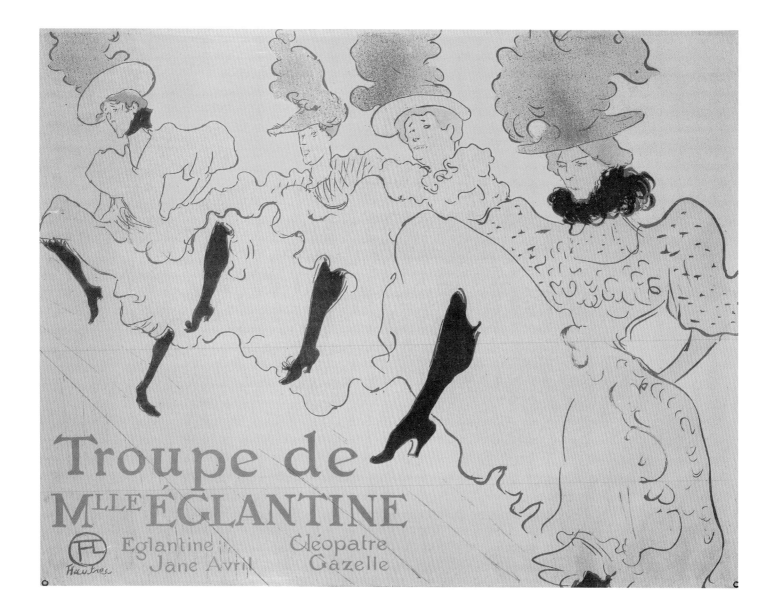

PL. 37    **HENRI DE TOULOUSE-LAUTREC**
*Mademoiselle Eglantine's Troupe*
1896
Colour lithographic poster, 61.7 x 78.9 cm
Musée d'Ixelles, Brussels

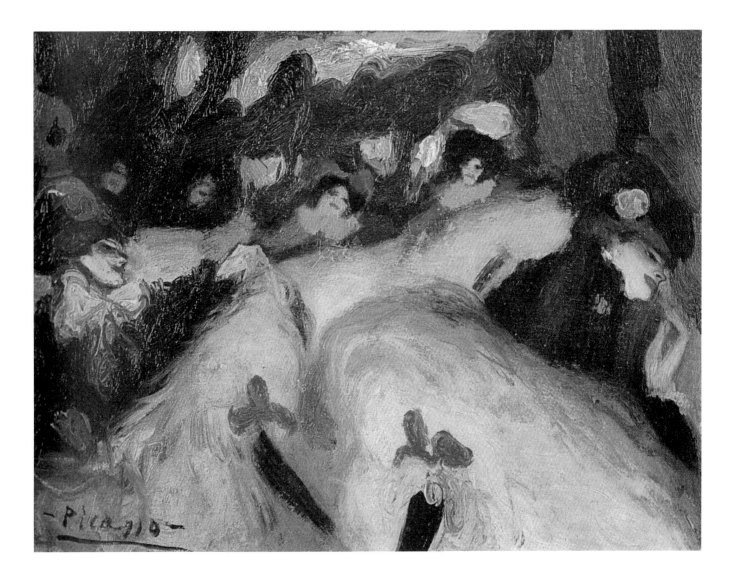

PL. 38  *French Can-Can*
Paris, 1900
Oil on canvas, 46 x 61 cm
Hiroshima Museum of Art

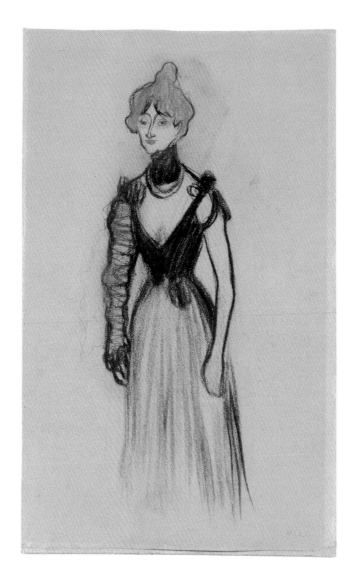

PL. 39   ***Café-Concert Singer* (Yvette Guilbert)**
Paris, 1901
Charcoal and coloured pencils on paper, 21 x 12.5 cm
Museu Picasso, Barcelona

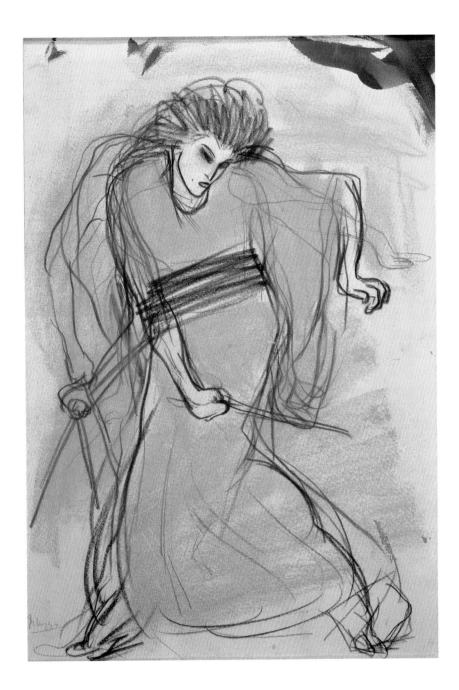

PL. 40   *Sada Yacco*
Paris, 1901
Pastel and ink on paper, 37.1 x 25.5 cm
Collection Pieter and Olga Dreesmann, Brussels

PL. 41    **VINCENT VAN GOGH**
*Courtesan (after Eisen)*
Paris, 1887
Oil on canvas, 105.5 x 60.5 cm
Van Gogh Museum, Amsterdam
(Vincent van Gogh Foundation)

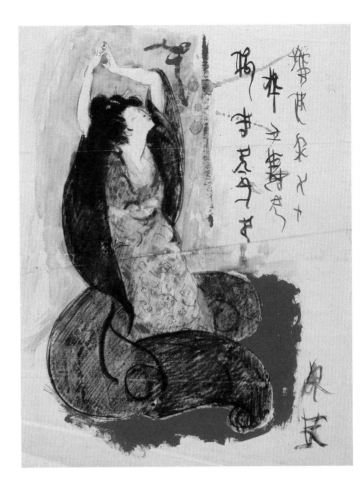

Picasso also made sketches of the Japanese actress Sada Yacco (pl. 40, fig. 13). He and his friends had probably seen her perform at the Exposition Universelle in Loïe Fuller's pavilion (and she later, in May 1902, travelled with her husband's troupe of actors to Barcelona, where Casas would do her portrait). The circumstances of what was likely a commission to produce a poster for her in Paris are unknown, but Picasso did several drawings that must have been done with some kind of advertisement in mind. In one of these, Sada Yacco displays her exotic theatrical movements, while invented Japanese characters are placed vertically along the side. Curiously, this composition is reminiscent of a painting by Van Gogh that Picasso could not have known, the

*Courtesan (after Eisen)* (pl. 41), which was done on a much larger scale some years earlier (1887). In both cases, the elaborately patterned costumes and the unfamiliar nature of the performance reflect the attraction of foreign entertainers to the Western painter's eye.

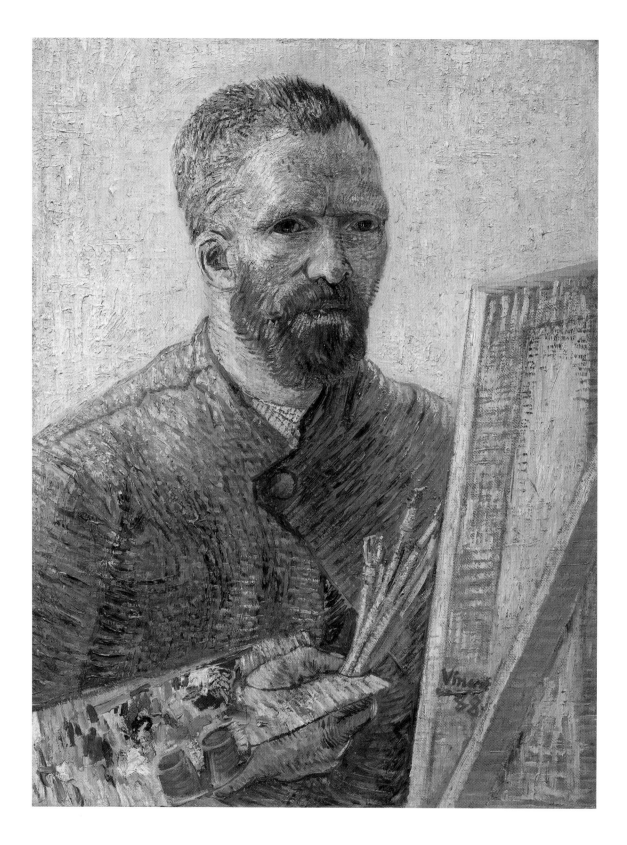

PL. 42    **VINCENT VAN GOGH**
*Self-Portrait as Painter*
Paris, 1888
Oil on canvas, 65.2 x 50.2 cm
Van Gogh Museum, Amsterdam
(Vincent van Gogh Foundation)

# THE REPUTATION OF VINCENT VAN GOGH IN PARIS AROUND 1900

NIENKE BAKKER

Picasso often entered into a dialogue with the great masters of art history in his work. He took what he could use from their oeuvres and exploited it for his own ends.[1] He did this with Vincent van Gogh, one of the few painters for whom he openly expressed his admiration and respect. At the end of his life he went so far as to call the Dutchman 'the greatest of them all', and he had a special affinity for him – in the words of Picasso's wife Jacqueline: 'Cézanne he admired; Van Gogh he loved.'[2] His intriguing statement, 'People don't understand that *I'm* Van Gogh', dates from the same period.[3] In the conversations recorded in the 1960s by the author Hélène Parmelin, a close friend of Picasso's, Van Gogh is repeatedly described as a groundbreaking artist and exemplar: '"We have been talking painting as if this were a competition," Picasso says. "The winner is the one who

'goes the farthest'. But what does 'the farthest' mean?... When it's a question of painting, what does it mean to break the sound barrier with a canvas? Does it mean painting nothing on it? Or painting any old thing? Or does it mean being Van Gogh?"'[4] This profound identification with the artist was typical of Picasso, who at an early age had already identified quite literally with a great painter like El Greco by signing his name on his sketches.[5] From the outset his aim was to surpass all his predecessors – 'In art one must kill one's father,' as he once said.[6]

Picasso's fascination with Van Gogh in the fifties and sixties was wholly bound up in the artist's fame, which soared to unprecedented heights at this time. By then Van Gogh had long been acknowledged as one of the pioneers of modern art, but in the mid-fifties his paintings started to fetch more than Cézanne's and his

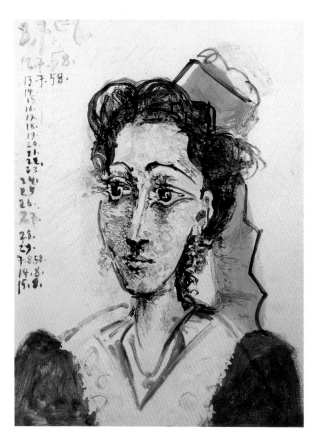

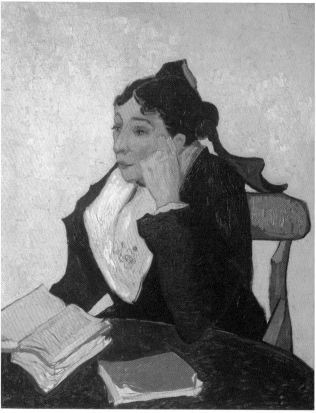

FIG. 14    **The Arlésienne (Jacqueline)**
Cannes, 1958
Oil on canvas, 61 x 41 cm
Private collection

FIG. 15    **VINCENT VAN GOGH**
**The Arlésienne (Madame Ginoux)**
Arles, 1888
Oil on canvas, 91.4 x 73.7 cm
The Metropolitan Museum of Art, New York. Bequest of
Sam A. Lewisohn, 1951

image as a tragic hero elevated him to true star status. The 1956 film version of Irving Stone's biography *Lust for Life* (1934) with Kirk Douglas in the leading role, the publication of the monumental edition of the collected letters in 1952-4, which were translated all over the world,[7] and the celebrations to mark the centenary of Van Gogh's birth in 1953, all conspired to make him the focus of attention as never before. Like so many, Picasso was fascinated not just by the tragic life of the Dutch artist but by his views on art and on being an artist. 'Picasso talks about Van Gogh all the time, and thinks about him all the time,' wrote Parmelin in the early sixties. 'For him, Van Gogh is the one painter whose life was exemplary, up to and including his

death.'[8] Picasso was reflecting on art history in his work of this period, and so in 1958 he painted *The Arlésienne (Jacqueline)* (fig. 14), inspired by Van Gogh's *Arlésiennes* (fig 15).[9] When he was living in Vallauris, he seized the opportunity to see the major Van Gogh exhibition staged in nearby Arles in 1953. The painter's great-nephew, Johan van Gogh, related how he met Picasso there: 'He came to see those Van Gogh paintings. And then we took one painting, but I can't remember which one [...] off the wall, and he wanted to look at it outside.'[10] It is a wonderful image: the 72-year-old Picasso taking Van Gogh's painting outside to look at it in the Provençal light, in the very place where Van Gogh painted his masterpieces more than half a century before.

But let us turn to the question of the impact Van Gogh had on the *young* Picasso in those crucial early years in Paris. Picasso himself once said that Van Gogh had been a greater influence on him at that time than any other painter, but the comment dates from the fifties, when he was only too keen to establish a link between his own early work and the oeuvre of his illustrious predecessor.[11] It is often assumed – perhaps on the grounds of Picasso's remark – that Van Gogh did indeed play an important role in his early years, but this is not as clear-cut as it might seem. For a nuanced picture we must first examine Van Gogh's reputation around 1900, and also establish which of his works Picasso could actually have seen.

The modest reputation Van Gogh had acquired in French avant-garde circles during his lifetime grew steadily after his suicide in July 1890. Some months earlier, Albert Aurier – the first critic to do so – had devoted an article to his work, 'Les Isolés: Vincent van Gogh', which was published in the Symbolist magazine *Mercure de France*. Van Gogh himself read it with mixed feelings, but it would prove to be very influential in creating an image of the visionary painter whose art was the expression of a tortured mind.[12] In researching his article, Aurier had drawn on letters from Van Gogh that his brother Theo and the artist Emile Bernard had shown him, and he had looked at the paintings that were stored with Theo and the artists' colourman Julien 'Père' Tanguy. Octave Mirbeau – another of Theo's acquaintances – also wrote an influential article on Van Gogh. This piece appeared in *L'Echo de Paris* in March 1891 on the occasion of the Salon des Indépendants, where there were ten of Van Gogh's paintings.[13] Emile Bernard, who appointed himself Van Gogh's champion after his friend's death,

recorded his memories of him in various short essays and published extracts from his letters in *Mercure de France* between 1893 and 1897.[14]

Aurier held Van Gogh up as the prototype of 'l'artiste isolé', retreating into nature to create new art, while Mirbeau laid greater emphasis on the spiritual quality of his art and the close link between his temperament and his painting style. Bernard, who knew Van Gogh well and drew on the correspondence between them, presented him not as a solitary figure but as a highly intelligent, socially engaged artist with a visionary eye that sprang from genius, not mental illness. His oeuvre, argued Bernard, had 'a cohesion which, in the long run shows that he is very balanced, very logical and very lucid. Some saw madness in his final pictures. But when it emerges as it does in the present form, what is that if not genius?'[15] These critics created a heroic image of a struggling, suffering artist who sacrificed himself for his work. The paintings and drawings could no longer be seen uncoloured by the dramatic life story and the letters.[16]

The early publications focused chiefly on Van Gogh's personality and views. His reputation as an original thinker anticipated a really searching examination of the oeuvre, in part because in the first years after his death relatively little of Van Gogh's work was shown in Paris. When Vincent's brother Theo died in January 1891, Theo's widow, Jo van Gogh-Bonger, took the collection back to the Netherlands with her. There had been work by Van Gogh at the exhibitions of the Indépendants in previous years, but aside from a modest show in 1892 it was not until 1895 that his work could be seen in Paris again – at the exhibition to mark the opening of Ambroise Vollard's

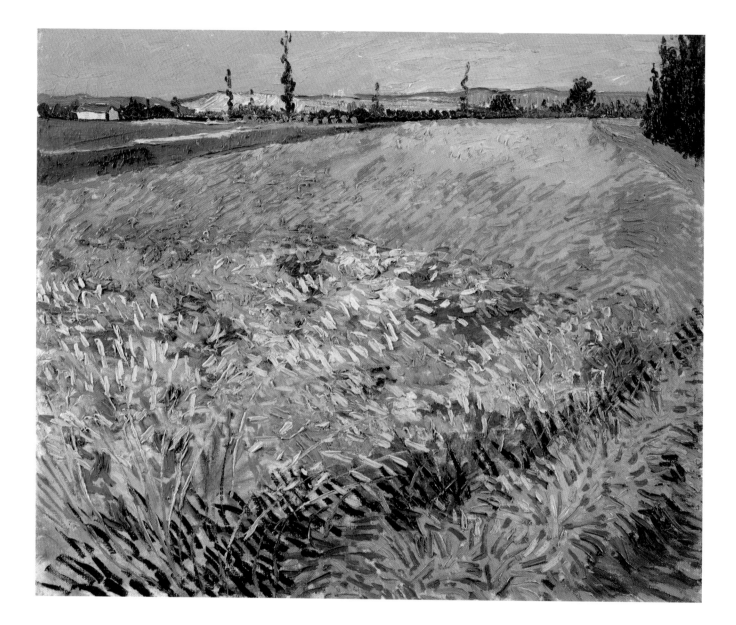

PL. 43  **VINCENT VAN GOGH**
*Wheatfield*
Arles, 1888
Oil on canvas, 54 x 65 cm
Van Gogh Museum, Amsterdam
(Vincent van Gogh Foundation)

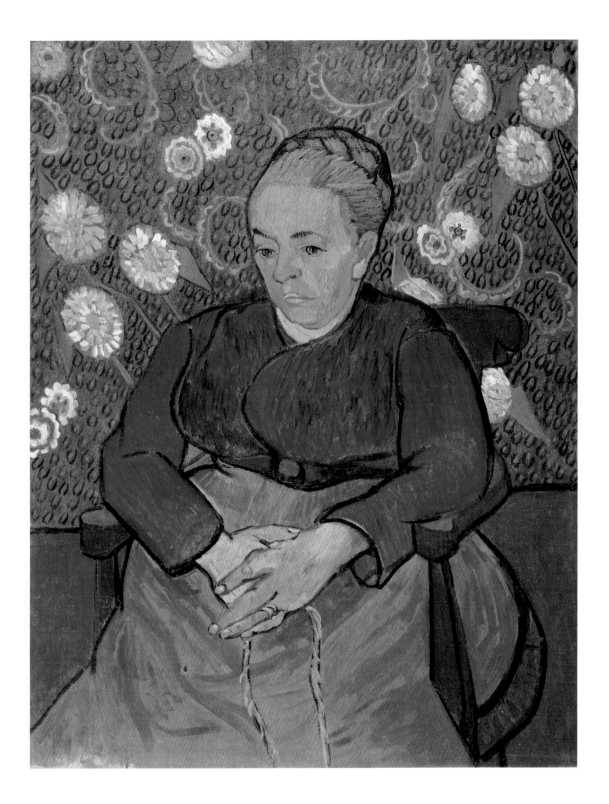

PL. 44    **VINCENT VAN GOGH**
*La Berceuse (Madame Roulin)*
Arles, 1889
Oil on canvas, 91 x 72 cm
Stedelijk Museum, Amsterdam

gallery in rue Laffitte.[17] Vollard had brought together a few – probably no more than twenty – paintings from Van Gogh's French period (1886-90).[18] There were positive reviews in *La Revue Blanche* and *L'Art et les Lettres*, although with the caveat that there were not enough works on show to give a good overview. A year later Vollard staged a second exhibition, this time presenting a representative selection from the whole oeuvre: 56 paintings and 54 drawings from Jo van Gogh-Bonger's holdings.[19] The exhibition was not, though, as successful as Vollard had hoped and expected, and he noted that 'except for the young painters, the public showed little enthusiasm. The time was not ripe'.[20] Vollard managed to sell only a few works, and virtually nothing was written about the exhibition, so he decided not to push Van Gogh's work any more.[21]

This was the state of affairs in October 1900, when the writer Julien Leclercq conceived a plan to mount an exhibition at the Bernheim Jeune gallery in Paris that would do justice to the artist and make his name once and for all. It was the right moment, he wrote to Jo van Gogh-Bonger, asking her for her help: 'Vincent's ambition was to make a place for himself amongst the painters belonging to the group of great French Impressionists and he is still just about the only one who has not yet got the reputation he deserves. [...] The presentation of Vincent's work at Vollard's has always been deplorable. [...] In a few months, we can create the right sort of fuss about Vincent's name.'[22]

The exhibition ran from 15 to 31 March 1901 and contained 65 paintings and 6 drawings. The foreword to the catalogue, written by Leclercq, gave a brief account of Van Gogh's life and work and was larded with quotes from the letters.[23] Leclercq wrote that it was the combination of mental illness and genius that made Van Gogh a visionary. 'His physical sufferings, which were real and brought with them passing turmoil, never jeopardized his artist's conscience. They stimulated it, as has been the case with others who had the essence of genius in them; whilst it is true that they sublimated his faculties by wearing out his body, they also made a visionary of him.'[24] He summed up the Dutch work – of which there was very little at the exhibition – in a single paragraph, before expounding at length on the French oeuvre and according Van Gogh his rightful place in the annals of French painting. 'In three years [...] he had a prodigious career and one so personal that he takes a very special place amongst the masters who spurred him on [...] This name [Vincent] will evoke ideas brilliant with colour.'[25]

Leclercq's instinct that Van Gogh's time had come was proved right. The new generation of young artists was beginning to lean towards bright colours and an expressive style, and Van Gogh's work captured this mood. The show at Bernheim Jeune came as a revelation to artists like Henri Matisse, Maurice de Vlaminck and André Derain. They were the first to judge Van Gogh solely on his artistic merits, to study his work out of interest in his use of colour and brushstroke – quite divorced even from subject and symbolism – and to follow the trail he had blazed. The life story was of less relevance to them, and all they would have known about the letters were the extracts Leclercq printed in the catalogue.[26]

It was not only the men who later became known as the Fauves on whom the Bernheim Jeune exhibition in 1901 made a deep impression. Van Gogh was widely covered by the press, and Mirbeau wrote a lyrical essay that ended

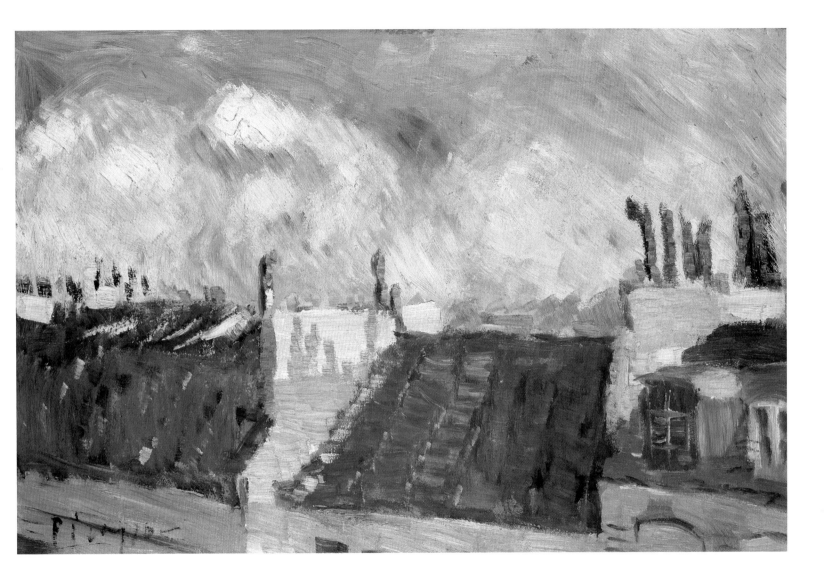

PL. 45   *Blue Roofs*
Paris, 1901
Oil on cardboard, 39 x 57.7 cm
The Ashmolean Museum, Oxford. Bequeathed by
Frank Hindley Smith, 1939

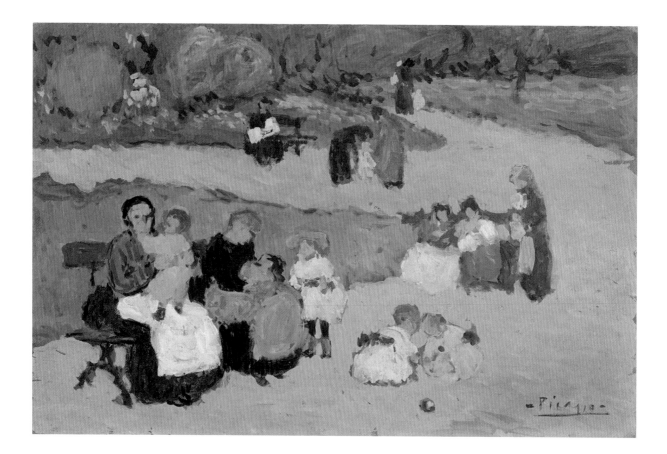

PL. 46    *Children in a Park*
Paris, 1901
Oil on cardboard, 32 x 47 cm
Private collection, Rotterdam
(on loan to Van Gogh Museum)

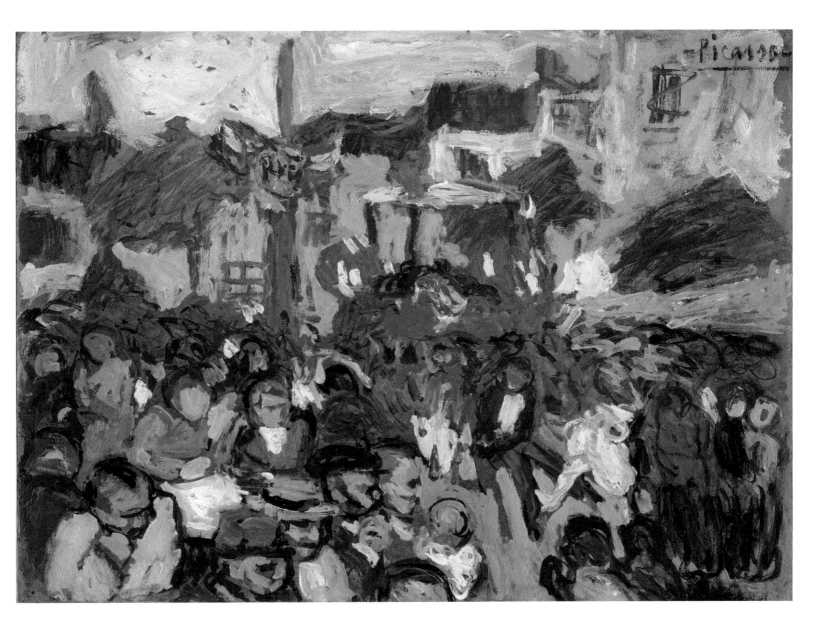

*The Fourteenth of July*
Paris, 1901
Oil on cardboard mounted on canvas, 48 x 62.9 cm
Solomon R. Guggenheim Museum, New York.
Thannhauser Collection, Gift, Justin K. Thannhauser, 1978

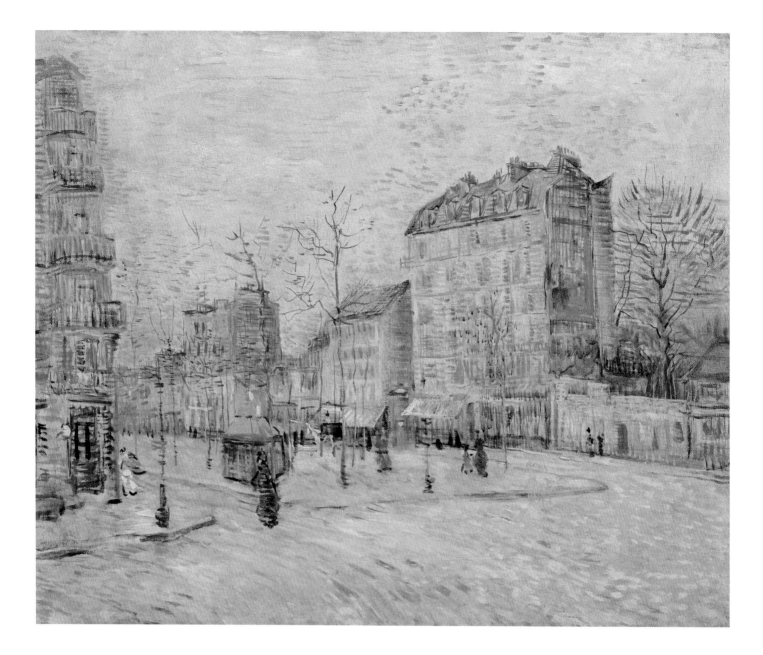

PL. 48    **VINCENT VAN GOGH**
*The Boulevard de Clichy*
Paris, 1887
Oil on canvas, 46.5 x 55 cm
Van Gogh Museum, Amsterdam
(Vincent van Gogh Foundation)

**Boulevard de Clichy**
Paris, 1901
Oil on canvas, 61.6 x 46.4 cm
Private collection

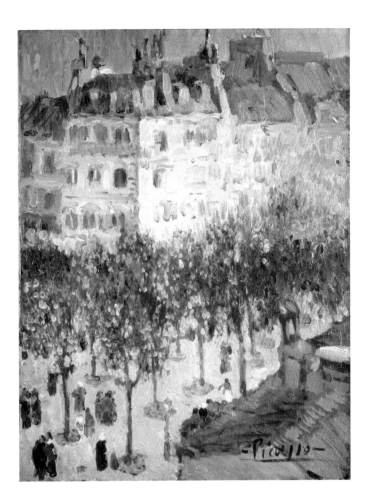

with the words 'We have to love Vincent van Gogh and treasure his memory for ever because that one, he really was a great and pure artist ...'[27] We may safely assume that Van Gogh was a frequent subject of conversation in artistic circles. Picasso, who returned to Paris in May 1901 – too late for the Van Gogh exhibition – must have heard all about it from other artists and dealers (he did not get to know Matisse and the other Fauves until 1905).

It has been suggested that Picasso had heard about Van Gogh even before the autumn of 1900, in Barcelona, but there is no evidence of this.[28] His first encounter with Van Gogh's work must be dated to 1901. Judging by the letter from Leclercq to Jo van Gogh-Bonger quoted above, in 1900 things were generally quiet where Van Gogh was concerned, and it is unlikely that Picasso would have seen any work by him then – although he did go to the modern

art galleries in rue Laffitte, including Bernheim Jeune, as soon as he got to Paris.[29] True, Leclercq was making preparations for his exhibition at that time and Bernheim Jeune owned some works by Van Gogh, but there is little chance that Picasso saw them.[30] The likeness, often remarked upon, between his *Moulin de la Galette* (pl. 8), the first major work he painted in Paris, and Van Gogh's *Dance Hall at Arles* (fig. 5) is almost certainly coincidental. At the time Van Gogh's painting was probably with Vollard, but he was renowned for his reluctance to show his stock.[31] It was not until May 1901 that Picasso had any personal contact with the dealer, who at that point was holding twenty or so works – chiefly portraits – by Van Gogh, such as a version of *La Berceuse (Madame Roulin)*.[32]

It is therefore far more likely that Picasso, with his curiosity piqued by the general interest in Van Gogh after

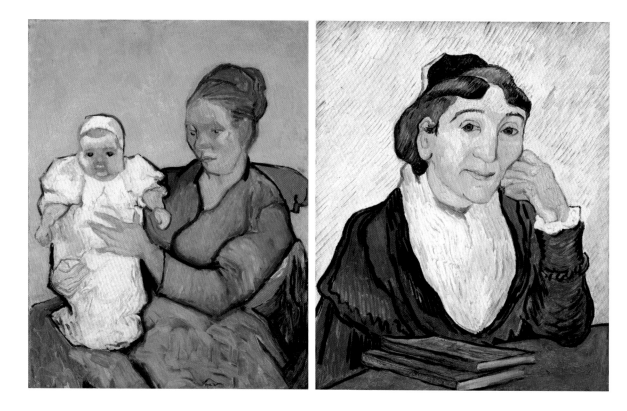

FIG. 17    **VINCENT VAN GOGH**
*Portrait of Madame Augustine Roulin and
Baby Marcelle*
Arles, 1888
Oil on canvas, 92.4 x 73.5 cm
Philadelphia Museum of Art. Bequest of Lisa Norris
Elkins, 1950

FIG. 18    **VINCENT VAN GOGH**
*The Arlésienne (Madame Ginoux)*
Saint-Rémy, 1890
Oil on canvas, 60 x 50 cm
Galleria Nazionale d'Arte Moderna, Rome. Courtesy of the
Ministero Beni e Att. Culturali

the Bernheim Jeune exhibition, studied the Van Goghs at Vollard's during the preparations for his own exhibition there in the summer of 1901. He had to produce a considerable number of saleable works in a short time and deftly exploited the new predilection for bright colours and loose handling – qualities praised in Van Gogh's work. The fact that he had had a good look at other artists, including Van Gogh, did not go unnoticed,[33] and Max Jacob later recalled that Picasso 'was accused of imitating Steinlen, Lautrec, Vuillard, Van Gogh etc., but everyone recognized that he had a fire, a real brilliance, a painter's eye.'[34]

The powerful brushstroke with impasto, the sharp outlines and the bright colours of the works Picasso painted during his second stay in Paris (e.g. pls. 45, 46, 47) do indeed show some kinship with Van Gogh. We have

to be cautious in looking for parallels, because it is impossible to say for sure exactly which works Picasso knew, but the hard contours and the yellow backgrounds in his portraits of this time, like the one of Mañach (fig. 10), are very reminiscent of portraits by Van Gogh that Vollard had then (fig. 17).[35] Gauguin's *At the Café (Madame Ginoux)* (1888, Pushkin Museum, Moscow) has been identified as the inspiration for Picasso's portraits of women at a table of 1901,[36] but Van Gogh's *Arlésienne* (fig. 18) – based on Gauguin's preliminary drawing (pl. 49) – was also with Vollard during this period.[37]

There was no longer any question of a stylistic similarity to Van Gogh after 1901 – not even when, four years later, the Dutch artist was again the focus of attention for the Parisian avant garde. The Salon des Indépendants

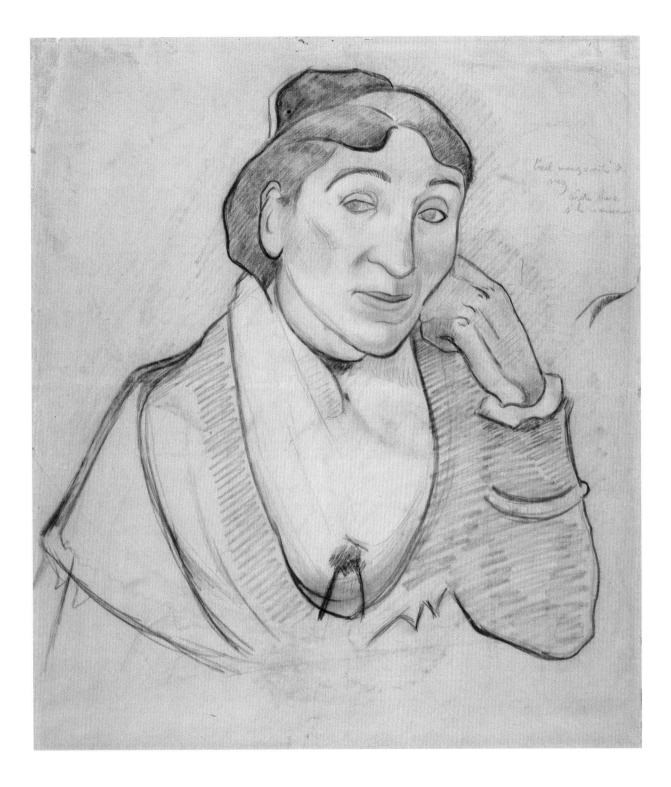

PL. 49 **PAUL GAUGUIN**
*The Arlésienne (Madame Ginoux)*
1888
White and coloured chalks and charcoal on paper,
56.1 x 49.2 cm
Fine Arts Museums of San Francisco. Memorial gift
from Dr. T. Edward and Tullah Hanley, Bradford, Pa.

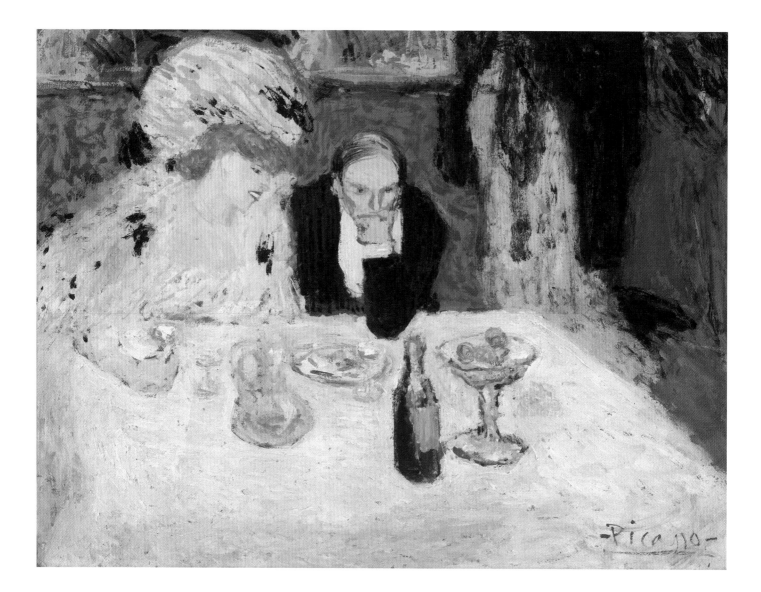

PL. 50    *The Diners*
Paris, 1901
Oil on cardboard, 47 x 62.2 cm
Museum of Art, Rhode Island School of Design, Providence.
Bequest of George Metcalf

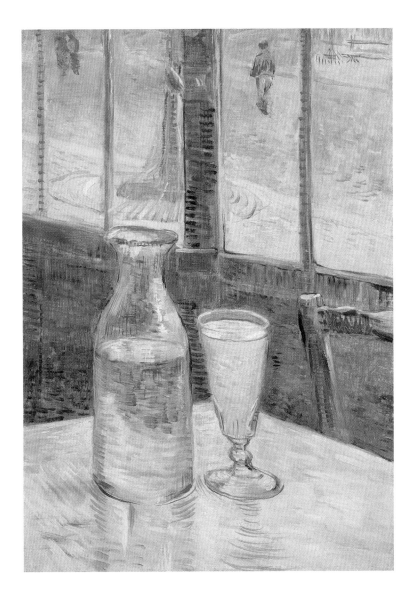

PL. 51 **VINCENT VAN GOGH**
***Café Table with Absinthe***
Paris, 1887
Oil on canvas, 46.2 x 33.3 cm
Van Gogh Museum, Amsterdam
(Vincent van Gogh Foundation)

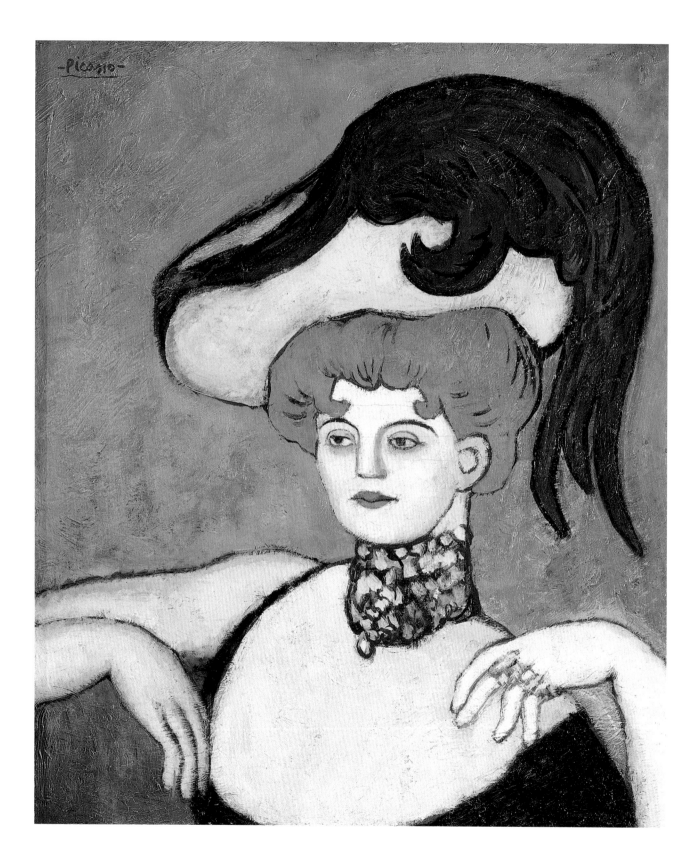

PL. 52    **_Woman with Jewelled Collar_**
Paris, 1901
Oil on canvas, 65.3 x 54.5 cm
Pinacoteca Giovanni e Marella Agnelli, Turin

honoured Van Gogh with his first official one-man show, which Picasso undoubtedly saw.[38] This exhibition had an even greater impact than the 1901 show on Derain, Vlaminck and, above all, Matisse, who as secretary of the Indépendants was involved in organizing it and had ample opportunity to study the paintings. The unconventional colours, extreme deformations and expressive handling of the paintings they presented at the Salon d'Automne that same year – particularly Matisse's *Woman with a Hat* (fig. 19), which would indeed have been inconceivable without Van Gogh's example – provoked an unprecedented scandal and led to their being labelled 'Les Fauves' by their critics.[39] In the meantime, however, Picasso had gone in a different direction; he was in his Rose Period and no longer interested in Van Gogh. He now had a greater affinity with the late work of Gauguin, who had died in 1903, and the

modern classicism of Puvis de Chavannes than with the expressive work of the Dutchman. Unlike the Fauves, who concentrated on colour in the footsteps of Van Gogh and Delacroix, Picasso was more in sympathy with Delacroix's polar opposite, Ingres, the master of line.[40] We know from Fernande Olivier, Picasso's companion, that at this time he admired Ingres more than any other painter and often went to look at his work in the Louvre.[41] The change in his attitude may also account for the fact that in the summer of 1905, when he was on holiday in the Dutch seaside resort of Schoorl, he did not stay long enough to see the major Van Gogh exhibition in Amsterdam.[42]

In other words, Picasso's interest in Van Gogh in his early years in Paris was probably based much more on what Van Gogh signified as a brilliant, innovative artist than on the appeal of the works themselves. Given Van

PL. 53    **VINCENT VAN GOGH**
*Worn Out*
The Hague, 1882
Pencil on watercolour paper, 50.4 x 31.6 cm
Van Gogh Museum, Amsterdam
(Vincent van Gogh Foundation)

Gogh's importance as an example for young painters in the wake of the Bernheim Jeune exhibition, Picasso had to rate himself against him, just as he did with other artists. Powerful self-portraits like *'Yo Picasso'* (fig. 11) can be seen in this light. The boundless ambition of the nineteen-year-old artist resonates in the self-assured look and the signature 'Yo Picasso' (I, Picasso), which challenge the viewer 'to question his right to be the new messiah of art', in the words of his biographer John Richardson.[43]

The young, brash Picasso must have recognized himself immediately in the prevailing image of Van Gogh as a visionary artist and genius on a solitary pinnacle, who sacrificed everything for his art. Or, as he said of himself, speaking to Françoise Gilot half a century later: 'Everybody has the same energy potential. The average person wastes his in a dozen little ways. I bring mine to bear on one thing only: my painting, and everything else is sacrificed to it – you and everyone else, myself included.'[44] He saw this same all-consuming dedication in Van Gogh, who wrote a few days before his death in 1890: 'I risk my life for my own work and my reason has half foundered in it.'[45] But that is where the similarity ends, for, unlike Picasso, Van Gogh certainly did not want to be a new messiah, even though the role was foisted on him after his death.

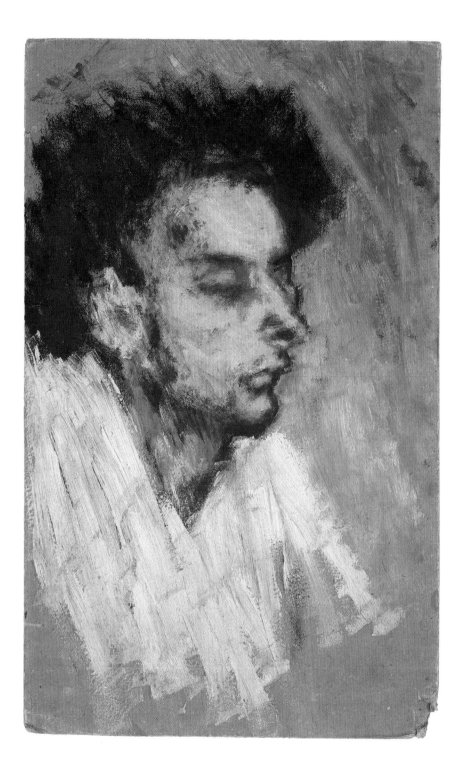

PL. 54 **Head of the Dead Casagemas**
Paris, 1901
Oil on cardboard, 52 x 34 cm
Private collection, Courtesy of Fundación Almine y Bernard
Ruiz-Picasso para el Arte

# FRENCH ORIGINS OF THE BLUE PERIOD

MARILYN McCULLY

The arrival in Paris of Picasso's close friend Jaime Sabartés, in late autumn 1901, coincided with a perceptible change in the artist's work, both in terms of subject matter and in his approach to form and colour. The flashy dancers and café types, painted with quick, loose brushstrokes and a bright palette, with which Picasso had introduced himself at Vollard's, gave way to subjects of greater introspection and a quite different, more probing, attitude towards composition and technique. Sabartés recalled that a few days after he had settled into a little hotel on the left bank, Picasso painted his portrait, known as *Le Bock* (fig. 21), in this manner, having observed him sitting in a bar with a glass of beer in his hand: 'Regarding myself for the first time in that marvellous blue mirror which to me is like a vast lake whose waters contain something of myself – not only because they hold my own reflection, but because I have watched it since its beginnings – I perceived a new aspect of Picasso's art which seemed to me like the glimmer of a new horizon. Even though "Le Bock" is among Picasso's first blue pictures, it bears a characteristic stamp – or sobriety – a characteristic which, not following the pattern of his other periods, becomes more and more unmistakable in the course of this period. The line which encloses the idea, eloquent in its simplicity, fixes a gesture wholly suggestive of the artist's compassion upon surprising his friend in his solitude.'[1]

Sabartés went on to describe the manner in which Picasso worked at this time: 'As a rule the palette was on the floor; white, heaped in the centre, constituted the basis of that type of mixture which he prepared especially with blue. The other colours brightened the contours. I do

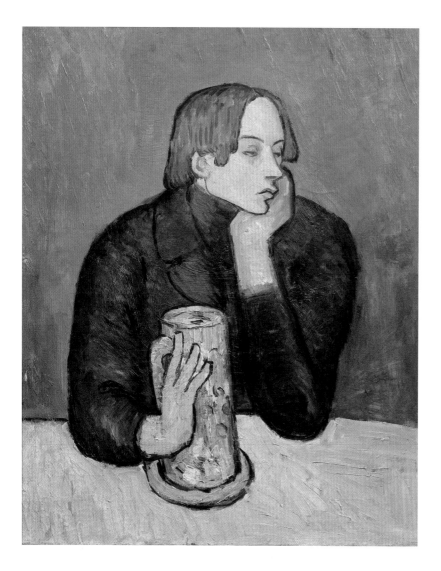

FIG. 21 **_Portrait of the Poet Jaime Sabartés (Le Bock)_**
Paris, 1901
Oil on canvas, 82 x 66 cm
Pushkin State Museum of Fine Arts, Moscow

not recall ever having seen Picasso holding the palette in his hand. He assures me that sometimes he does, just like everyone else. It may be so, but I have always seen him preparing his colours by leaning over a table, a chair or the floor.'[2]

In the paintings Picasso did after the Vollard show, it becomes evident that it was not just his choice of colours that was changing, but that he was rethinking the whole direction of his art. In *The Blue Room (Le Tub)* (pl. 56), for example, he focused his attention on what would become his life-long preferred subject, the model in the artist's studio – that is, art about art. While still acknowledging in the composition the importance for him of Toulouse-Lautrec, by including Lautrec's

May Milton poster on the wall (pl. 33), and of Degas, by showing the model bathing in the studio, this canvas is remarkably different from the works he had painted on cardboard so quickly just months before.[3] Here, the composition is worked out deliberately and carefully, with particular attention being given to the spatial element – for example, in the area of the patterned, tipped-up carpet – and to the resulting effects of flattening and compression of space in the various parts of the scene. The smaller and tighter brushstrokes and the predominance of blue and white paints that are used for the nude also suggest that Picasso was beginning to consider how he might come up with a new approach to the figure, based on modelling in paint.

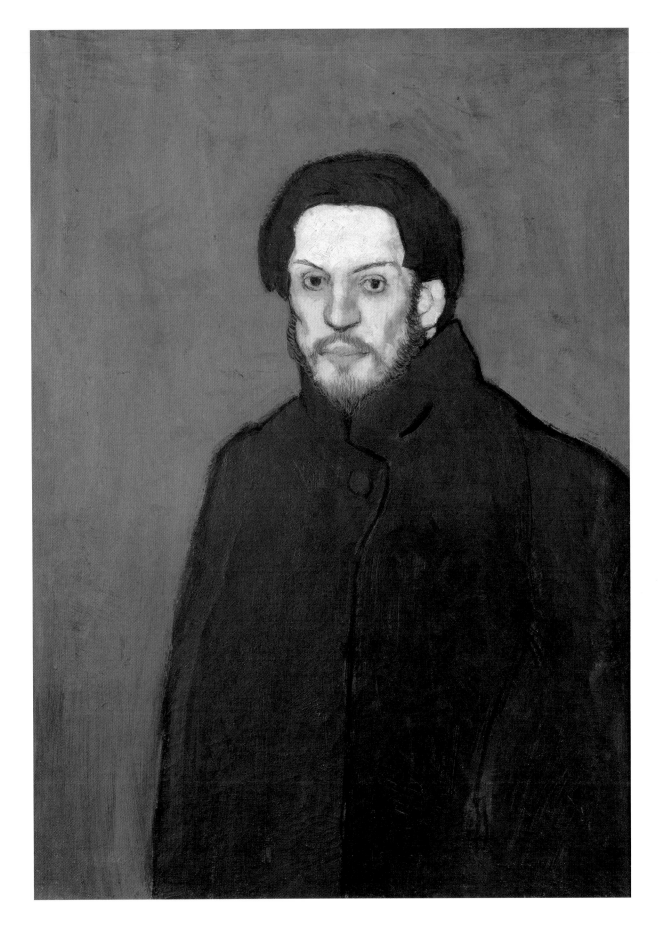

PL. 55    *Self-Portrait*
Paris, 1901
Oil on canvas, 81 x 60 cm
Musée national Picasso, Paris

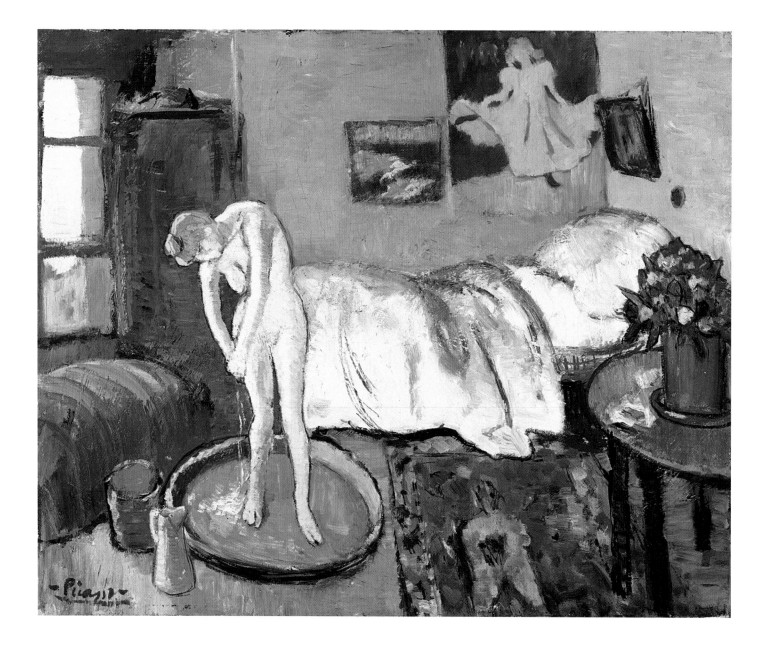

PL. 56    *The Blue Room (Le Tub)*
Paris, 1901
Oil on canvas, 50.5 x 61.6 cm
The Phillips Collection, Washington DC

FIG. 22 **_The Greedy Child_**
Paris, 1901
Oil on canvas, 92.8 x 68.3 cm
National Gallery of Art, Washington DC.
Chester Dale Collection

FIG. 23 THÉOPHILE-ALEXANDRE STEINLEN
**_Lait pur stérilisé de la Vingeanne_**
1894
Colour lithographic poster, 130 x 100 cm
Bibliothèque nationale de France, Paris

Another work, *The Greedy Child* (fig. 22), reflects a comparable change of technique and the use of a similar palette, based primarily on whites and blues.[4] The stylization of the image may be indebted to a surprising source in advertising: Steinlen's poster for sterilized milk, *Lait pur stérilisé de la Vingeanne* (fig. 23), features a similar blonde little girl sipping milk from a bowl. While missing from the Picasso are the anecdotal cats and other graphic details, emphasis in his composition is given to a sculptural approach to the figure, which is not dissimilar from the treatment of the nude in *The Blue Room*.[5] A strong rhythmic line follows the tablecloth, bowl, dress and head of the girl, and is echoed in the division of space behind her. This enclosing line is what Sabartés had referred to when he talked about the means with which Picasso now conveyed ideas in his compositions.

No other painting stands out so clearly as a manifesto of Picasso's new attitude towards himself and his art as his decidedly blue *Self-Portrait* (pl. 55), which was painted at the end of 1901. In this canvas, he dramatically simplified the composition in order to focus on his own face, which is at once romantic, in the way he presents himself as a handsome young Bohemian, and also haunting, in the singularity of his gaze. The body is painted as an essentially flat plane, except for a few outlining strokes to define the contour of his jacket. The absence of volume in the figure continues into the flat space around him, which is painted with a similar tone of blue. Indeed, the use of blue for all aspects of this composition, apart from the carefully painted, thin strokes of contrasting reddish brown, which make up the artist's beard and moustache, contributes to the intensity of this new self-image.

Coquiot later famously described this phase in Picasso's work as the Blue Period,[6] and while this term has since been universally adopted by scholars and writers, it is often associated principally with the paintings, which reflect sources of inspiration in older Spanish art, that he did in Barcelona in 1902-3.[7] However, the roots of Picasso's Blue Period are quite specifically French in origin. Typically, Picasso responded to the climate and artistic situation in which he found himself, and the shift we find in subject matter in his work in late 1901 reflects a concern he shared with his new writer friends with the plight of social outcasts and the poor. At the same time, Symbolist currents in French art stimulated him to develop the formal aspect of his art in compelling ways in order to gain new levels of emotional expression.

On a personal level, the Blue Period can be seen to have been triggered by a sense of remorse on Picasso's part when, in Paris, he became acutely aware of the absence from his life of Casagemas. In the autumn of 1901, he set about to commemorate his friend's tragic death in a series of paintings, one of which (pl. 58) was done primarily in blue. In this work, the brushstrokes are applied as if he were modelling the dead man's face, shroud, and the space around the deathbed or coffin with the paint itself. The colour blue, which contrasts the yellowish-white of the skin, serves symbolically to evoke the coldness and silence of death.

Around this time, Picasso was visited by two artist friends, Pierre Girieud and Fabien Launay, both of whom were represented by Berthe Weill. Girieud later recalled that he was especially taken with one particular composition: 'I saw on that occasion in his little studio

on the boulevard de Clichy, not far from Wepler's [brasserie], a number of different canvases. I remember well a portrait he had done of a Spanish painter, who had recently committed suicide, on his death bed, and it was very poignant.'[8]

Another of Picasso's commemorative paintings, in which the dead man's head is depicted close up, with a funeral candle burning brightly at the side (pl. 57), is done with radiating brushstrokes and a hot palette, all very much reminiscent of Van Gogh. Whether or not he and Girieud discussed the Dutch artist at the time he was working on this little painting we do not know, although Girieud's paintings reflect his own great enthusiasm for the work of Van Gogh at this time.[9] In any case, the artistic allusion provided Picasso with a means to associate the death of his young friend with the suicide by a bullet ten years earlier of the Dutch artist. The sadness and guilt that Picasso must have felt – after all, when he had decided to go to Madrid, he had abandoned the troubled Casagemas to return to Paris alone – are more palpable in this tiny painting than in anything he had done before.

A third death's head (pl. 54), most of which was painted primarily with white and icy blue shadows, places emphasis through an additional build-up of paint on the bloody scab of the bullet wound in Casagemas's temple, as if Picasso, who had not been a witness, needed to render this detail with grisly realism to come to terms with the finality of the act. In addition to several compositions referring to Casagemas's funeral,[10] his friend's suicide would be commemorated once more during the Blue Period when, in Barcelona, Picasso painted over his earlier canvas *Last Moments* – a painting about death – with one

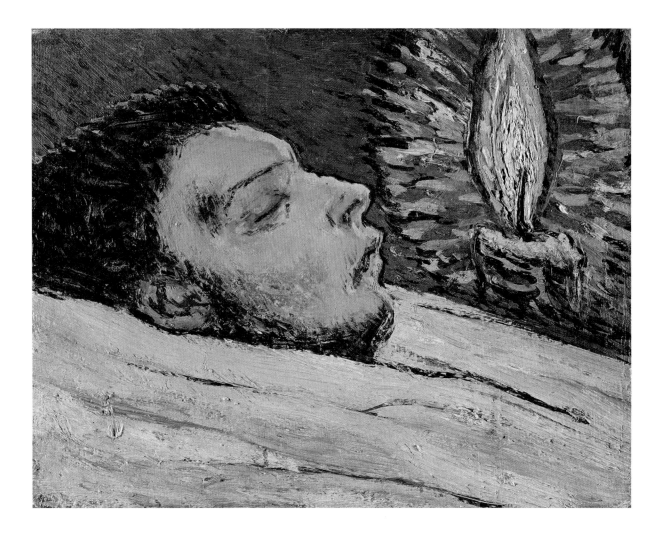

PL. 57 *Head of the Dead Casagemas*
Paris, 1901
Oil on panel, 27 x 35 cm
Musée national Picasso, Paris

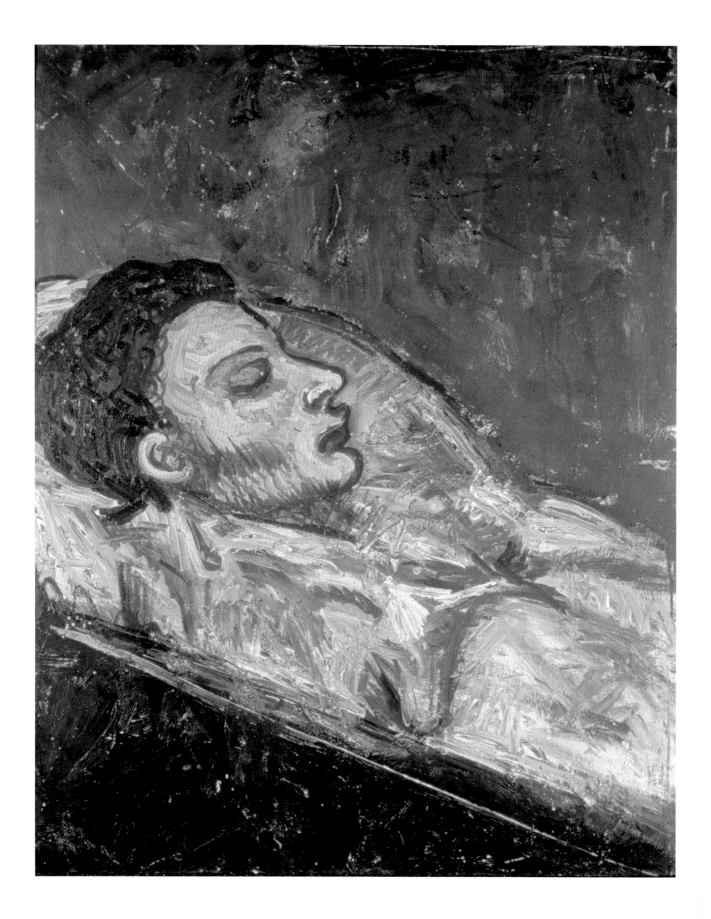

PL. 58   *Casagemas in his Coffin*
Paris, 1901
Oil on cardboard, 72.5 x 58 cm
Private collection. Courtesy of James Roundell

**La Vie**
Barcelona, 1903
Oil on canvas, 196.5 x 129.2 cm
The Cleveland Museum of Art. Gift of
the Hanna Fund

about life, *La Vie* (fig. 24). In this allegorical composition, Casagemas is given the role of the artist in the scene,[11] and Germaine, the woman responsible for his anguish, is portrayed as his naked lover. At the right is a mother and child (the promise of life), while behind them are canvases representing old age and grief. Through the act of painting *La Vie*, Picasso bid a double farewell: to his friend's memory and, at the same time, to the image of *Last Moments*, which had defined his own arrival in the French capital as a Spanish artist at the Exposition Universelle.

The most characteristic subjects of Picasso's French Blue Period are the prostitutes and their babies who were confined in the Saint-Lazare prison in the 10th district of Paris (pl. 59). The prison (fig. 25) and its female inmates had a certain popular appeal in Montmartre cafés, since they had first been celebrated by Aristide Bruant in the song 'A Saint-Lazare' (fig. 26). For Picasso, the opportunity to visit the prison came about as a result of his meeting a certain Doctor Louis Jullien, who gave him permission to work there.[12] Picasso did a number of

FIG. 25    Saint-Lazare prison
1900
Photograph by Eugène Atget
Bibliothèque nationale de France, Paris

compositions showing the women wearing white bonnets (pl. 83), which identified those prisoners who were infected with venereal disease. Curiously, this bonnet resembles the Breton headdress that Gauguin had used, almost as an abstract flattened form, in some of his Pont Aven paintings. In *Women at the Prison Fountain* (pl. 60), a large work that appears to have been left unfinished, Picasso grouped the heads of the women and child around the fountain in the courtyard of the Saint-Lazare prison. This commonplace scene is the occasion for an ambitious group composition that, for all intents and purposes, transcends narrative. The emphasis on the profiles of the figures, with the fountain behind them at the right, results in a subject evocative of something more permanent, something resonant of the timelessness of sculpture, even Egyptian art. As Sabartés recalled, 'Picasso believes that

art emanates from sadness – and pain. With this we agree. That sadness lends itself to meditation, and that grief is at the well-spring of life.'[13]

The great dignity with which Picasso portrayed the Saint-Lazare women – not as low-life inmates, but as individuals confined in their loneliness – also evokes the example of Van Gogh. The Dutch artist, perhaps more than any other in the 1880s, had treated ordinary people in his paintings with enormous respect, elevating them through the original way in which he painted them to a higher, and often noble, status. *An Old Woman of Arles* and *Portrait of Camille Roulin* (pls. 61, 62), for example, take portraiture to a different level, with brushstroke and colours conveying either the dignified facial structure of the old woman, who is dressed simply in dark blue, or the flush of youth in the cheeks of the boy, with his cap and

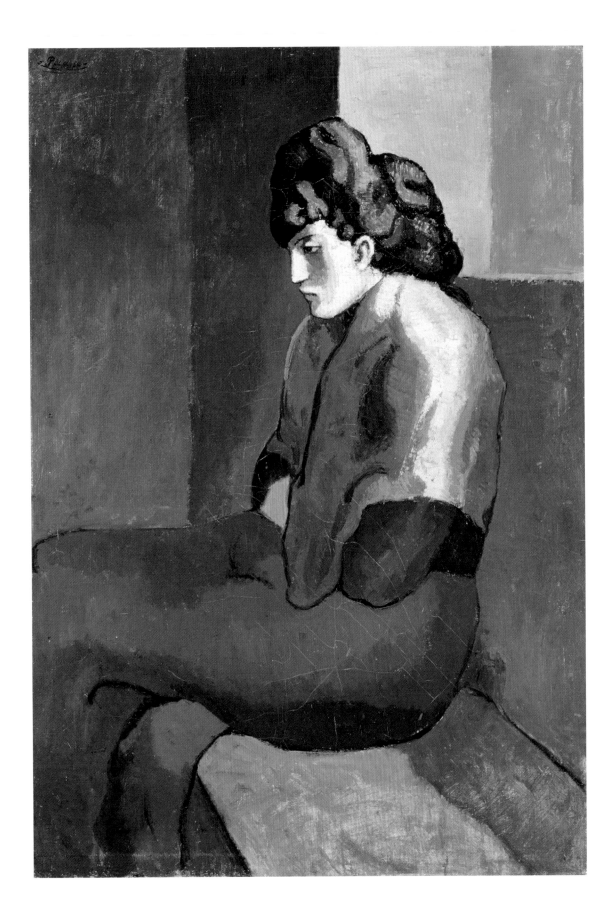

PL. 59   *Melancholy Woman*
Paris, 1901
Oil on canvas, 100 x 69.2 cm
Detroit Institute of Arts. Bequest of
Robert H. Tannahill

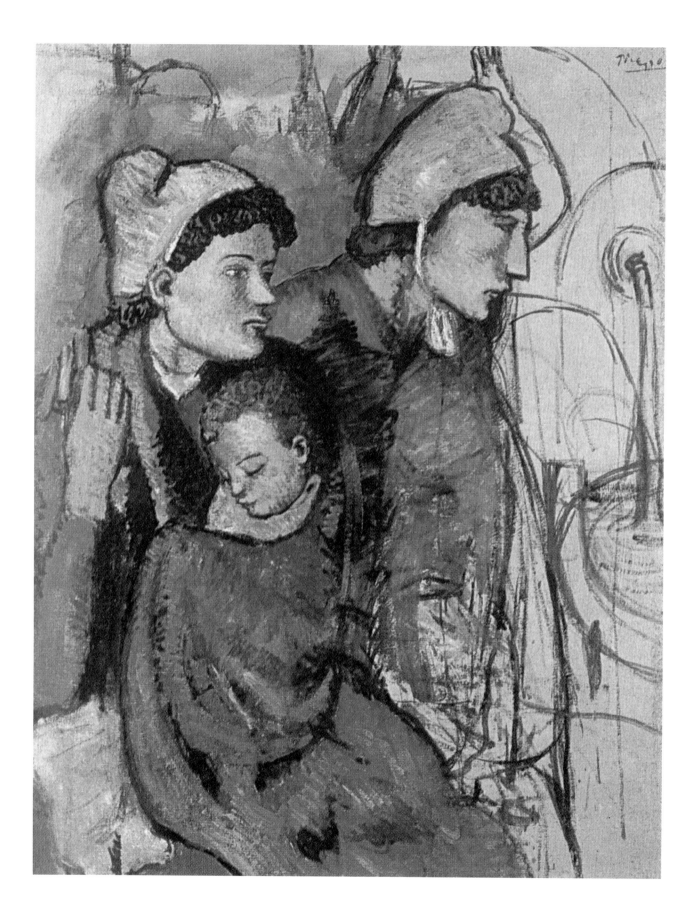

PL. 60 **_Women at the Prison Fountain_**
Paris, 1901
Oil on canvas, 81 x 65 cm
Private collection

FIG. 26 **THÉOPHILE-ALEXANDRE STEINLEN**
*A Saint-Lazare*
1887
Bibliothèque nationale de France, Paris
The song by Aristide Bruant (from the collection
*Dans la Rue*, on which he collaborated with Steinlen)
incorporates a copy of Toulouse-Lautrec's illustration of
an inmate of the Saint-Lazare prison writing a letter to
her boyfriend.

clothing rendered in animated fashion. A commitment to naturalism guided Van Gogh in his approach to his different subjects, even when he did his own version of Delacroix's *Pietà* (pl. 63), in which he wished, above all, to focus on the mother's grief, rather than on Christian beliefs: 'In a great gesture of despair she [...] is stretching out her empty arms, and one can see her hands, a working woman's good, solid hands.'[14]

In the case of the Saint-Lazare paintings, we know that Picasso worked from life, but this does not necessarily mean that the women in question modelled for specific compositions or that they actually sat for him. Instead, he was more likely to have watched them and to have made mental notes of their characteristic prison clothing

and attitudes, which he would then transform into compositions carried out in the studio. Although he was struck by their ordinariness as people, his paintings reveal that he also wanted to give his portrayals a wider meaning.

In addition to Picasso's first-hand experience of observing the patterns of everyday life of the prisoners with their children, the elevation in his work of these pathetic women to modern-day Madonnas can be considered in light of the strong and still prevalent religious strain in French art, both among academic painters and, especially, among the Symbolists. Picasso's own training in Spain as a religious artist made him especially receptive to these currents, in which Christian themes or primitive spirituality were given fresh

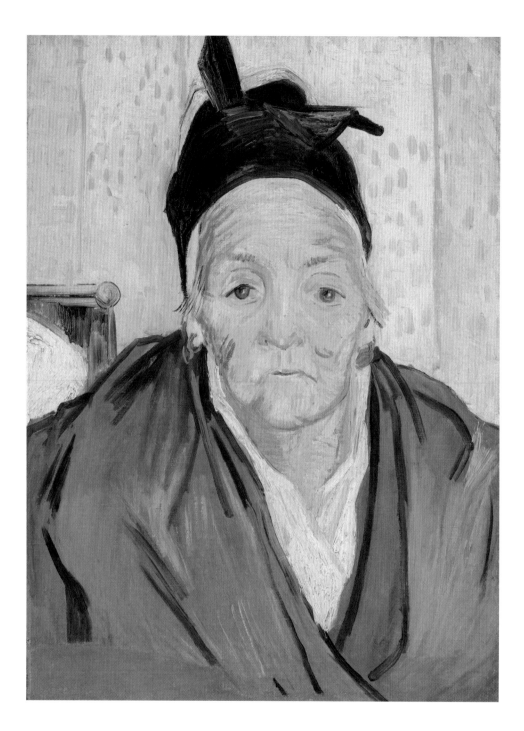

**VINCENT VAN GOGH**
*Portrait of Camille Roulin*
Arles, 1888
Oil on canvas, 40.5 x 32.5 cm
Van Gogh Museum, Amsterdam
(Vincent van Gogh Foundation)

PL. 63    **VINCENT VAN GOGH**
*Pietà (after Delacroix)*
Saint-Rémy, 1889
Oil on canvas, 73 x 60.5 cm
Van Gogh Museum, Amsterdam
(Vincent van Gogh Foundation)

expression through the way in which the composition was painted, rather than simply as a rendering of a well-known iconographic motif. For Picasso, the discovery of an artistic means through colour and form to evoke subjects with religious connotations in a radically new way would be at the heart of his developing Blue Period.[15]

As sales from the Vollard show had been good, with more than half of Picasso's works reportedly sold,[16] this must have finally given him – at least, for the time being – some financial independence from Mañach, whose close presence in the apartment on boulevard de Clichy was becoming a source of increasing irritation.[17] Whatever the nature of their disagreements, early in 1902, they argued and ended their close association for good, with Picasso moving out to return to Spain. Mañach continued to work with Berthe Weill, and, in Picasso's absence, organized a show, which included the few remaining works by Picasso that he had in his possession, for the spring of 1902.[18] Among the paintings in the show that were mentioned by Adrien Farge in her preface to the catalogue are what she describes as a 'luxurious *Still Life*' (presumably pl. 18), a view of the Luxembourg Gardens (pl. 46) and a 'brilliant, clamorous *Fourteenth of July* (pl. 47), [which] combines the exaggerated movement and the intense life of the popular fête in the gaudiest of colours.'[19]

Mañach would also return to Barcelona within a couple of years, and his departure from Paris (and from Picasso) signalled the end of his career as a dealer and collaborator with Weill.[20] When Vollard visited Barcelona during the First World War, he remembered going to Mañach's factory, but he says nothing about the Catalan's former activity as a dealer. Instead, he illustrates his cunning with the story of how he prevented strikes by making his employees pay for the oil to light the lamp they kept burning in front of the statue of a saint.[21]

PL. 64    ***Study of a Head Looking Upwards***
Paris, 1902
Conté crayon on paper, 31.2 x 24.3 cm
Museu Picasso, Barcelona

# PICASSO SYMBOLISTE
MARILYN McCULLY

The third trip that Picasso made to Paris in October 1902 would not turn out as well as he had hoped.[1] Prospects for a major, new show in the French capital were few, if any. The canny Vollard seems to have absented himself from Picasso's life (and art) for the time being. Only when Picasso's reputation became more bankable several years later (in late 1905), would the dealer once again take a serious interest in his art. Berthe Weill, with whom Mañach still collaborated, helped by including Picasso in a show that opened on 15 November,[2] but her gallery and clientele were relatively small. According to Girieud, with whom, along with Launay and Pichot, Picasso would share his November show, 'The gallery was of the same dimensions as its proprietor, that is, very small and low, paintings were displayed from floor to ceiling in order to increase the exhibition space.'[3]

The nine works by Picasso in the November show, which are listed in the catalogue, included several paintings, some of which Weill probably already had in stock, three pastels devoted to the subject of '*concerts*' (café-concerts), and a few unidentified drawings.[4] In the preface to the catalogue, the feminist critic Thilda Harlor (*nom de plume* of Jeanne-Fernande Perrot) wrote that, 'The ardour of M. P.R. Picasso has already been noted. He has a tireless passion to see everything, to express everything. He is not bound by one manner, one genre. He has no set method.'[5] The Symbolist Charles Morice, a friend of Verlaine and Gauguin, who reviewed the show in *Mercure de France*, begins by saying that although two of the exhibitors were French and two Spanish, 'All four are citizens of Montmartre! Land of their desire, atmosphere of their labours and of their ambitions, of their art.' In

PL. 65    **Head of a Boy**
Paris, 1902
Conté crayon and charcoal on paper, 31.2 x 23.5 cm
Museu Picasso, Barcelona

his discussion of Picasso, Morice focuses on the artist's versatility, but also the profoundly sombre nature of his subjects: 'Picasso, who painted before he learned to read, seems to have been assigned the mission of expressing with his brush everything there is. One could talk of a young god who wishes to remake the world. But it is a sombre god. The hundreds of faces he paints grimace – never smile. His world is not more habitable than his squalid settings.'[6]

In spite of the critical attention he received from this small show,[7] however, Picasso seems not to have been ready on this visit to begin a new body of work with which to market himself again in Paris. Instead, he limited himself primarily to working on paper. And, as the story goes, the winter was so cold that, like the poet Rodolfo in *La Bohème*, he burned his drawings to stay warm. The only treasure he later claimed to have saved from the fire was his copy, annotated with his own drawings, of Gauguin's *Noa-Noa*, which had been given to him by Charles Morice.[8]

Picasso's lack of money also meant that locating suitable living and studio arrangements proved difficult. For reasons unknown, when he got to Paris this time, he chose not to return to Montmartre and eventually ended up in a seedy hotel on the left bank, where a group of Spaniards (none of them close friends) was staying. Picasso was put off by their rowdy parties that turned into debauchery, which he found disgusting.[9] Nonetheless, while he was staying at the Hôtel du Maroc , he made some moving and powerful charcoal and pencil drawings, including *Study of a Head Looking Upwards* and *Head of a Boy* (pls. 64, 65).[10] Later, he moved to the boulevard Voltaire, where he shared Max Jacob's tiny room. Although he loved being with his literate and amusing friend, the place was too small for both of them, and he was unable to carry out any major work.

Without a proper atelier, Picasso took the opportunity to visit various museums and monuments in Paris, including the Louvre. His Italian friend Ardengo Soffici recalled that, '[Picasso] would go from museum to museum nourishing himself on good old and modern painting, and since I used to do the same thing, it wasn't unusual for us to run into each other in the Impressionist room at the Luxembourg or in the Louvre. There Picasso always returned to the ground-floor rooms, where he would pace around and around like a hound in search of game between the rooms of Egyptian and Phoenician antiquities – among the sphinxes, basalt idols and papyri, and the sarcophagi painted in vivid colours.'[11]

Picasso's preference for visiting the antiquities sections is reflected in the Hôtel du Maroc drawings, in which a focus on a classicizing approach to form and a stillness, which is reflected in his choice of subjects, even in crying figures, contrasts the quickly rendered and animated depictions of Parisian life and the caricatural magazine illustrations of the previous year. This new phase of Picasso's development anticipates the enormous strides he would take in his work in 1906, at a time when archaic art, once again, became an essential point of reference for the radical direction his approach would ultimately take.

Another of Picasso's discoveries on his forays around Paris was the Panthéon, where he was struck by the paintings by Puvis de Chavannes.[12] In the late nineteenth century, Puvis de Chavannes had become something of a hero for advanced artists, including Toulouse-Lautrec,[13] and his reputation among painters was still high. Puvis's artistic approach to conventional subjects

FIG. 27   **Charity** (drawing after Puvis de Chavannes's mural
*Sainte Geneviève Feeding Paris*)
Paris, 1903
Ink on paper, 14.8 x 18.1 cm
Museu Picasso, Barcelona
The inscription reads 'After Puvis in the Panthéon
the painting of the famine' ('De Pubis en el Panteon
el cuadro de la hambre').

had represented a welcome departure from the tired
old formulae of academic painting. Sketches reveal that
Picasso actually made drawings after Puvis's paintings
in the Panthéon, one of which, *Man Carrying a Sack*
(pl. 68), based on a figure in the right-hand section of
the work showing Saint Geneviève relieving the victims
of the famine in Paris, was reproduced several months
later in the Barcelona journal *El Liberal*.[14] Moreover,
the emergence of certain themes in his work at this
time, including Charity (fig. 27), the Golden Age (pl. 66),
and Christ-like fishermen (Museu Picasso, Barcelona),
reflects his immediate response to the French painter.[15]
In addition to subject matter, Picasso was especially
attracted to the emphasis given to gesture and the
placement of the figures in space in Puvis's compositions
(pl. 67), as opposed to excessive or explicit narrative

details. In the example of Puvis – and the fact that many
of his works were painted monochromatically in blue –
Picasso found confirmation that his own work was on the
right track.

The optimism of Picasso's first visits to the French
capital was, nevertheless, replaced in the winter of 1902-3
with disappointment and a certain amount of confusion
as to where he envisioned his artistic future taking place.
Paris seemed now to be unwelcoming, and he gave up on
the city of light, returning to Barcelona, where he would
stay for more than a year. Although he had no dealer nor
the prospect of a show, once back in the Catalan capital
he worked with renewed intensity, producing a large
number of canvases and panels as well as the complement
of a huge number of drawings. Many of the Barcelona
compositions reflect the inspiration of older Spanish art,

PL. 66　**The Golden Age**
Paris, 1902
Pen and sepia ink and wash on paper, 26 x 40 cm
Museu Picasso, Barcelona

PL. 67 **PIERRE PUVIS DE CHAVANNES**
*Charity*
1894
Oil on canvas, 91.4 x 71 cm
Mildred Lane Kemper Art Museum, Washington University, St Louis

PL. 68    ***Man Carrying a Sack (after Puvis de Chavannes)***
Paris, 1902
Graphite pencil on paper, 31.2 x 23.5 cm
Museu Picasso, Barcelona

FIG. 28 **Two Women at a Bar**
Barcelona, 1902
Oil on canvas, 80 x 91.4 cm
Hiroshima Museum of Art

primarily in subjects that allude to religious iconography, including, once again, *Maternités*, allegories of the senses, and the portrayal of beggar-philosophers, all of which had been a mainstay of sixteenth- and seventeenth-century painting.[16] At least temporarily, Picasso had reincarnated himself as a Spanish artist, but, at the same time, his developing formal approach continued to reflect the underpinnings of his French experience, in particular the examples of Gauguin and Rodin.

Gauguin was an artist to whom Picasso frequently referred in his own work throughout the early period,

and just before he left Paris, in homage to his hero, he even went so far as to sign a Gauguinesque drawing of a nude 'Paul' rather than its Spanish equivalent 'Pablo' (1902-3; private collection, Germany). Picasso had first seen paintings by Gauguin in 1901 at the sculptor Paco Durrio's studio in Montmartre, which he had visited with Sabartés,[17] and probably more examples at Vollard's gallery. Evidence of Gauguin's influence can already be detected even among the works Picasso did for the Vollard show, and the French painter's work continued to exert an influence on Picasso's multi-figure compositions

**PAUL GAUGUIN**
*Portrait of a Young Woman (Vaite Goupil)*
1896
Oil on canvas, 75 x 65 cm
Ordrupgaard, Copenhagen

FIG. 29    Picasso's Barcelona studio, with *Two Women at a Bar*
           upside-down and a photograph of Rodin's *Thinker* tacked
           to the wall
           1902
           Archives Picasso, Paris

in the Barcelona Blue Period, especially when two or more figures are closely juxtaposed. In *Two Women at a Bar* (fig. 28), for example, flattened areas of colour, which are surrounded by a strong containing line, both convey and distinguish the forms, while the evocative palette also gives them a Symbolist resonance.

During periods of concentrated formal invention, Picasso often turned to sculpture to work out his ideas about volume and the different expressive qualities of three-dimensional form. A photograph of Picasso's Barcelona studio taken in 1902 reveals that he had tacked a photo on the wall of Rodin's *Thinker*, while his painting *Two Women at a Bar* appears on the easel beneath it (fig. 29). Also in 1902 and 1903, he tried his hand at

modelling in clay in the studio of a Barcelona friend (Emili Fontbona), where he produced several pieces, which were later cast in bronze. While his *Seated Woman* (1902; Musée Picasso, Paris) relates quite specifically to the crouching women in his Blue Period drawings and paintings, especially in the pose and angularity of the overall form, the modelling of the mask of a *Picador with a Broken Nose* (fig. 30) presents other sculptural considerations. The handling of the rhythms of light and shadow that result from the treatment of the surface suggests that Picasso had the example of Rodin in mind.[18] Moreover, his drawing of a portrait bust by Auguste Rodin (fig. 31), which appeared (along with the *Man Carrying a Sack*) in the Barcelona paper *El Liberal* (10 August 1903),

FIG. 30    **Head of a Picador with a Broken Nose**
Barcelona, 1903
Plaster, 19 x 14.5 x 12 cm
Marina Picasso Collection
Courtesy of Galerie Krugier & Cie, Geneva

FIG. 31    Picasso's drawing of Rodin's bust of Jules
Dalou (1883), as reproduced in *El Liberal*,
10 August 1903
Arxiu Històric de la Ciutat, Barcelona

is not without interest in this regard. Even in its graphic rendering, the drawing reflects the attention paid to the effects of light and shadow that play on the sculpted surface in Rodin's work.

A striking comparison can also be made between Rodin's sculpture of an emaciated old woman (pl. 70) and Blue Period figure compositions, including *The Old Guitarist* (fig. 32), where emotion is conveyed through the compelling treatment of form. In Picasso's painting, he crowds the bent old man's body, with its bony, pointed shoulders almost reaching the top of the composition, into the available space; while, in Rodin's sculpture, the twist and compression of the equally emaciated features of the woman's body serve to express her frailty and age.

Over the course of the next months, Picasso's mood was one of frustration. He moved out of one studio, because of the lack of seriousness of the painter he shared the space with, into another, where he could work alone.[19] Finally, he realized, once and for all, that his artistic future lay elsewhere, and in the spring of 1904 he made the decision to make a permanent move to Paris. A farewell article, written by Carles Junyer-Vidal, about the precocious young talent and his accomplishments to date appeared in *El Liberal* on 4 March 1904. In summary, Junyer-Vidal sings Picasso's praises as a painter who demonstrates the most serious of intentions in his art, ending with the prediction that it is Paris where he will achieve his deserved recognition: 'Each new product

PL. 70    **AUGUSTE RODIN**
*She who was Once the Helmet-Maker's*
*Beautiful Wife*
1883
Bronze, 50.5 x 31 x 23 cm
Private collection. The Edelweiss Trust

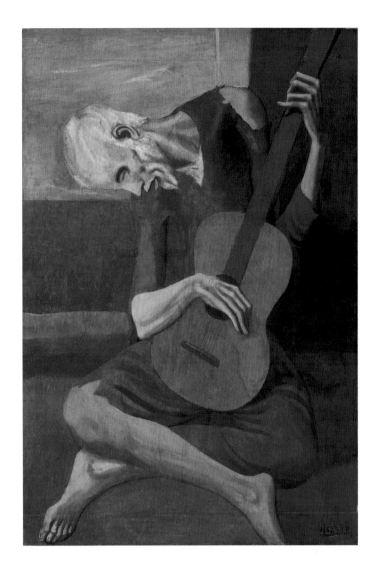

FIG. 32  **The Old Guitarist**
Barcelona, 1903-4
Oil on panel, 122.9 x 82.6 cm
The Art Institute of Chicago. Helen Birch Bartlett
 Memorial Collection

of the young artist is a step further from the beginning towards the end: an example of superior life, an ascendant life. Although Picasso hates stupidity, routine and indifference – the negative aspects of social consciousness – he replaces these with positive statements. He works with faith, enthusiasm and devotion, his convictions deepening every day, and his forces manifest their explosive, shocking strength through to the day's end.

'Few, very few, have such honesty in Art. His ability is astonishing and, if he so wishes, he could produce and sell many works. But he sacrifices himself and refuses to please the philistines, unlike all the others who, cynically, consider that Art is just a trade or a pastime which anyone can do.

'Remember that Picasso's work cannot be compared to anything else produced in this country. It stands apart; let this be understood by everyone, both novices and experts.

'Picasso will return very shortly to Paris. There he will be properly judged.'[20]

PL. 71　***Picasso and Sebastià Junyer-Vidal Travel to Paris***
*1. Picasso and Junyer Depart by Train; 2. Picasso and
Junyer Arrive at the Border; 3. Picasso and Junyer Arrive in
Montauban; 4. Picasso and Junyer Arrive in Paris; 6. Junyer
Visits Durand-Ruel* [no. 5 is lost]
Paris, 1904
Pen and ink and coloured pencils on paper, five sketches,
each 22 x 16 cm
Museu Picasso, Barcelona

# LA VIE DE BOHÈME

MARILYN McCULLY

Picasso chronicled his train journey in mid-April 1904, which he made in the company of his friend Sebastià Junyer-Vidal (brother of Carles), in an amusing cartoon, including, once in Paris, a visit to the dealer Durand-Ruel (pl. 71). Picasso stayed for the first few days in Montparnasse with the Catalan artist-brothers Joan and Juli González, but the new arrivals learned that Paco Durrio's studio was now vacant on the rue Ravignan. Durrio had moved to a large house in the less built-up, outlying district of Montmartre known as the Maquis, in order to a set up a kiln – what he called his *cuisine atelier*.[1] Picasso and Junyer-Vidal took over the studio on the top floor of the building,[2] with a skylight that allowed them to have an impressive view of the city, reaching as far as the Eiffel Tower. Junyer-Vidal, however, stayed for only a short time, leaving Picasso with the whole of the place to himself.

The rambling wooden structure, known as the Bateau Lavoir for its resemblance to a creaking washboat, was already the home of an assortment of painters, sculptors, writers and models, many of whom would contribute to the rich context in which Picasso's artistic ideas would develop so rapidly over the course of a few short years. Durrio and Sunyer had just moved out, but there were other Spaniards, including Canals, who lived there with his Italian girlfriend Benedetta Coletti (or Bianco).[3] Picasso's fellow-countryman Juan Gris would also move to a tiny studio there in 1908 with two windows overlooking the square. Among other foreigners who, at one time or another during this period, occupied the squalid building, were Dutch artists Otto van Rees and his painter wife Adja Dutilh, and Kees van Dongen and his wife, the painter Guus Preitinger. Van Dongen's brother Jean also

FIG. 33   Entrance to the Bateau Lavoir on rue Ravignan
Photograph by Brassaï taken in November
1946
Musée national Picasso, Paris

lived nearby in Montmartre and was married to a singer called Marie, who performed at the Lapin Agile.[4] Others included the young German Karl-Heinz Wiegels, who committed suicide in the building in 1908, and the Swiss artist Rodolphe Fornerod, who married Antoinette, one of the models who had shared Picasso's rue Gabrielle apartment in 1900. A number of French artists and writers also occupied studios, and Picasso's great friend Max Jacob would move next door in 1907.[5]

It was at the Bateau Lavoir, in the late summer of 1904, that Picasso met his first love, the model Fernande Olivier, who was staying with Ricard Canals and Benedetta. Fernande recalled that one summer evening after returning from a modelling job, she was sitting outside in front of the Bateau Lavoir, next to a group of noisy Spaniards, among whom was Picasso, when a storm came up: 'The sky was black, and when the clouds suddenly broke, we had to rush for shelter. The Spanish painter had a little kitten in his arms which he held out to me,

laughing and preventing me from going past. I laughed with him. He seemed to give off a radiance, an inner fire, and I couldn't resist this magnetism. I went with him to his studio, which is full of large unfinished canvases – he must work so hard, but what a mess. Dear God! His paintings are astonishing. I find something morbid in them, which is quite disturbing, but I also feel drawn to them.'[6]

At the beginning of their relationship, Fernande continued living in Canals's studio and working as a model, for François Sicard and Fernand Cormon, among others. Benedetta, too, worked as a model for Bartholomé's Père Lachaise *Monument des morts*, and, famously, for Degas.[7] In September 1904 the two friends posed together for Canals. The painting and its subject, *At the Bullfight* (pl. 73), which was destined for the Salon, had been commissioned by the Catalan banker Ivo Bosch, who was a Paris resident and a collector. The folkloric aspect of the scene – Spanish *majas* in mantillas and

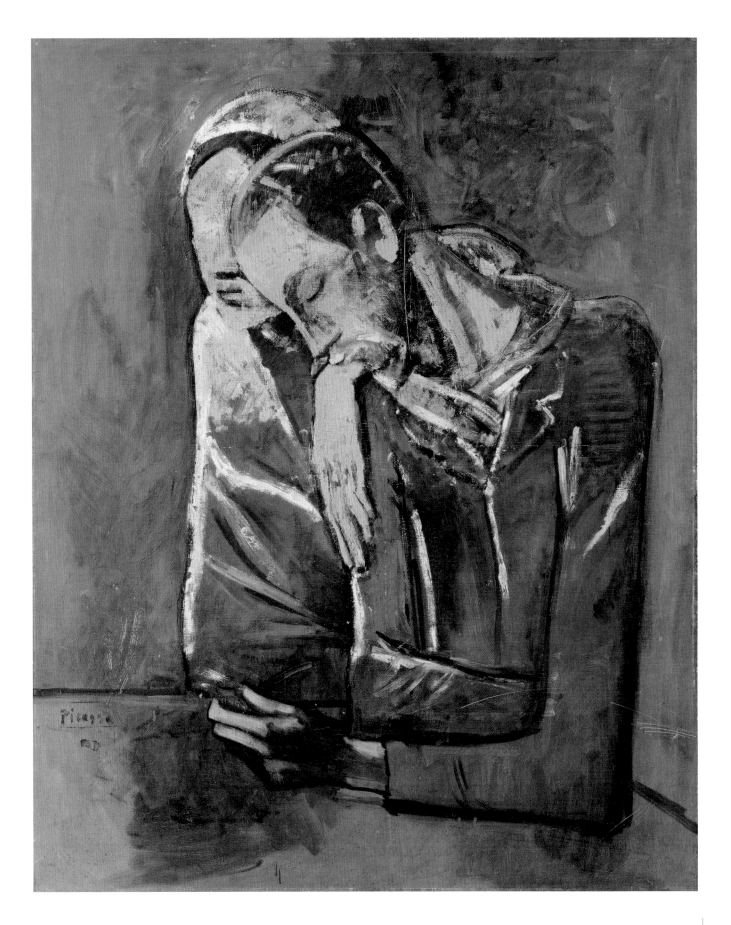

PL. 72 *Poor Couple*
Paris, 1904
Oil on canvas, 100 x 80.5 cm
Merzbacher Kunststiftung

colourful dresses – is the focus of the composition rather than the bullfight that the female spectators are supposed to be attending.

Joaquim Sunyer, who was Fernande's lover when she met Picasso and who was still courting her at the Bateau Lavoir, also did a composition based on the two models together, but instead of the bullring, he showed them among the audience at the Cirque Médrano (pl. 74). Sunyer's portrayal is colourful and, indeed, affectionate, but the two women tend to resemble each other in the composition. Nonetheless, through his confident use of pastel he created in his work a lively mood, in which the women appear to be thoroughly enjoying the (again unseen) performance below them.

When Picasso painted a portrait of Benedetta some months later (pl. 75), he carried on the Spanish theme that Canals had introduced by having her pose for him wearing a mantilla. Perhaps, by doing this, he was saying to Canals,

as well as to his rival Sunyer, I can go one better. Picasso's painting is, to judge from photographs of the sitter, an excellent likeness, but the emphasis in this work is on the way in which it is painted. Rather than spending time on fiddly or picturesque details, Picasso was able through a build-up of carefully modulated brushstrokes and layers of paint to create the impression of substance and sculptural form. Moreover, the warm tonality that suffuses the whole of the composition – even in Benedetta's black mantilla – creates an atmosphere that, if anything, emanates from the studio, where the painting was done, rather than from Canals's bullring or Sunyer's circus.

A group exhibition that opened at Berthe Weill's gallery in late October featured the work of Picasso along with six other artists, among whom were several other up-and-coming painters, including Raoul Dufy and Francis Picabia. Picasso was represented in the show with five paintings, including *L'Enterrement* (one of the

**RICARD CANALS**
*At the Bullfight* **(Fernande and Benedetta)**
1904
Oil on canvas, 157 x 256.3 cm
Private collection, Barcelona

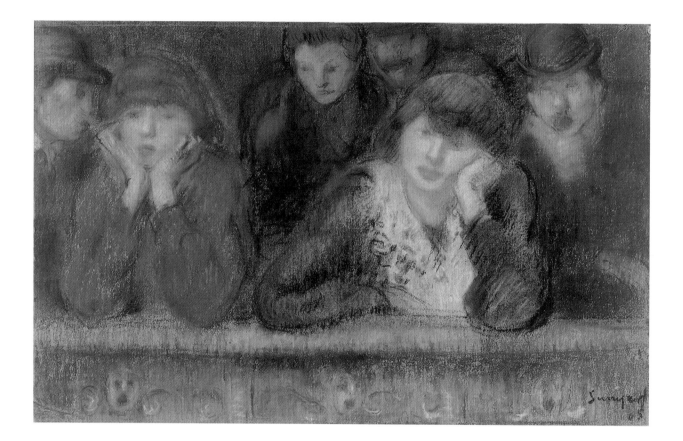

PL. 74    **JOAQUIM SUNYER**
***At the Cirque Médrano* or *The Box***
1905
Pastel on paper, 31 x 48 cm
Collection Eusebi Isern Dalmau

PL. 75   *Portrait of Benedetta Canals*
Paris, 1905
Oil and charcoal on canvas, 90 x 69.5 cm
Museu Picasso, Barcelona

versions of the *Burial of Casagemas*), five pastels and one gouache, in addition to two drawings.[8] Although Weill seems to have been able to sell some of Picasso's work, he was apparently not satisfied with her efforts. She later recalled: 'I can easily sell a few Picassos here and there, drawings or paintings, but I can never manage to provide for his needs, and I'm really upset about this as he is resentful; his eyes frighten me and he takes advantage!! In order to keep going I have to buy a little from everyone, and it wouldn't be possible with just one artist; but how do I get him to understand that?'[9]

Before he had left Barcelona, Picasso had made a little money from the sale of *La Vie*,[10] but that was probably already spent, and the need to earn a living in Paris was pressing.[11] Juli González suggested printmaking as a possible source of income, and, with this in mind, prepared a large zinc plate for Picasso to work on. Fernande describes this large print, known as *The Frugal Repast* (pl. 76), which she also saw in the studio in September: 'He's working on an etching showing an emaciated man and woman seated at a table in a wine shop, who convey an intense feeling of misery and alcoholism with terrifying realism.'[12] The scene, which is still very much a Blue Period subject, was executed with great skill, suggesting that Picasso had quickly mastered the technique of etching and the use of a scraper.[13]

For printing Picasso went to Eugène Delâtre, who was well known among local artists as the printer of Toulouse-Lautrec, and whose atelier was located on the rue Lepic, just below the summit of Montmartre. Picasso apparently had some success in selling at least one impression of *The Frugal Repast*,[14] but he also asked his friend, Sebastià Junyent to try to sell some on his behalf back in Barcelona.

Junyent responded to his request on 26 December 1904: 'Thank you for sending the etching, which is so well done. It seems to me you will sell many in Paris, but here it will be more difficult; you know the kind of art they like here. Nevertheless, I'll try and sell some. I congratulate you for your sale in Paris – it's something at least – and proves that not everything has to be unpleasant. I still haven't taken one to your father, but I'll do it the first chance I have.'[15] Encouraged by the interest generated by this first serious attempt at printmaking, Picasso decided to produce more prints during the winter to be included in his next show, which was planned for February 1905.

Charles Morice was in charge of the organization of the exhibition at the Galeries Serrurier,[16] which was run principally as an interior design and furniture shop by the Belgian Gustave Serrurier-Bovy's French partner, René Dulong, on the boulevard Haussmann.[17] Picasso was to be featured along with two other artists, the Swiss Albert Trachsel and the Frenchman Auguste Gérardin. Before the show opened on 25 February, Morice sent various messages to Picasso, all of them written in early February, requesting titles and prices for the works, with a reminder that it was absolutely necessary to have the paintings framed.[18] In addition, he discussed the catalogue, which he proposed that they work on together.[19] A series of lecture-discussions was also planned by the gallery, as we know from their prospectus, on the back of which Picasso drew a personal invitation for Max Jacob (pl. 77).

The Serrurier show came at the right moment for Picasso, for it offered him a fresh opportunity to present himself as an artist in his own right – rather than in the reflected light of late nineteenth-century French painters – and one to be reckoned with on the contemporary Paris

PL. 76   *The Frugal Repast*
Paris, 1904
Etching with drypoint on paper, 46.2 x 37.8 cm (plate size)
Collection Pieter and Olga Dreesmann, Brussels

art scene. Not since Vollard's in 1901 had he had the opportunity to exhibit a significant body of new work, and this time he came up with a subject and a means to paint it that reflected, in part, the world of ideas and literature of his new French friends. His poetic transformation of the theme of saltimbanques (acrobats) and the related subject of circus performers would attract the attention of collectors and critics, as well as the public who visited the show.

Troupes of travelling performers or little circuses were a familiar sight both in the countryside and in the city during Picasso's early years in France. The tattered Harlequin costumes that they often wore and the roles that they played also evoked a much older art-historical and cultural tradition, which evolved from the *commedia dell'arte*. While this form of street performance had its origins in late-Renaissance Italy, the costumes and actions associated with the shenanigans of the principal characters, Harlequin, Pulcinella and others, had been subsequently taken up and modified in other countries. In England Punch became a clown or puppet, while a specifically French character was the dreamy Pierrot or his counterpart Gilles, immortalized by Watteau. More recently, artists, including Daumier (pl. 80), Cézanne and Degas, had portrayed similar, costumed characters in their paintings. While Daumier focused on the popular performances by entertainers of this kind, Degas chose to portray Harlequin and Pierrot as they appeared in ballet productions.[20] Cézanne went so far as to dress his son and a friend in the traditional costumes on stage in a carnival composition.[21] In a theatrical context the characters represented the two sides of man's temperament. The multicoloured diamond pattern of Harlequin's close-fitting attire, with his black mask, hat and baton, came to symbolize his mischievous, quick-witted personality, while Pierrot's attire – black cap, floppy collar and voluminous white robe – came to be associated with the moon, and an innocent, susceptible character, who loses his girlfriend to Harlequin.

A nineteenth-century, especially French, descendant of the *commedia dell'arte* was the Harlequinade – a troupe of entertainers and dancers, who performed usually raucous skits in cabarets or outside a circus tent in the *Parade*. On their little stages, these characters, often dressed in Harlequin's and Pierrot's costumes, acted out their bawdy routines to the accompaniment of music or drums. Their frequent depiction by cartoonists and poster artists, including Adolphe Willette and Jules Chéret, made them a familiar aspect of popular culture in Paris at the turn of the twentieth century. And while other artists before him, including Rusiñol and Casas in Barcelona and Daumier, Toulouse-Lautrec and Seurat in France, had taken up the subject of these performers, what Picasso accomplished was to turn the theme of saltimbanques into *his* subject. The poetic world that they inhabited and that he depicted became the stuff of what Coquiot would later – principally with reference to the change in Picasso's palette – describe as his Rose Period.

By virtue of their costumes, Picasso's saltimbanques echo their traditional incarnations, but his Rose Period Harlequins (pl. 78, 79) refer quite specifically to travelling entertainers – troupes of strong men, acrobats and other assorted family members and their animals. He later told Palau i Fabre that it was after seeing a performance of a group of saltimbanques on the Esplanade des Invalides that he was inspired to paint

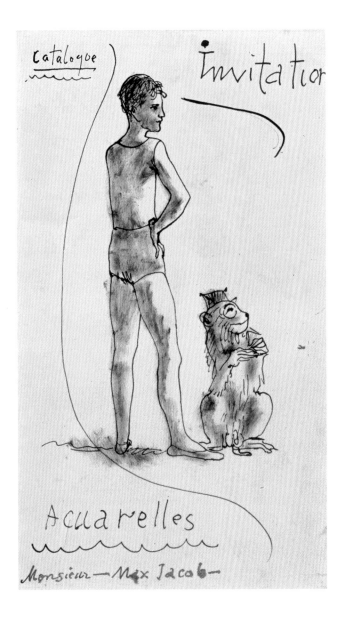

PL. 77   *Young Acrobat and Monkey* (Invitation to Max Jacob)
Paris, 1905
Pen and ink and watercolour on paper, 21.6 x 12.7 cm
Collection Pieter and Olga Dreesmann, Brussels

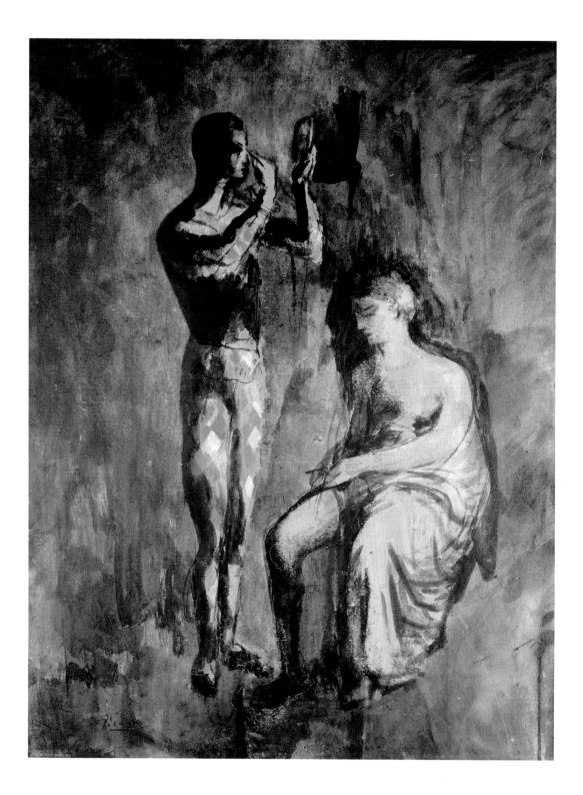

PL. 78   *Harlequin Applying Make-up*
Paris, 1905
Gouache on cardboard, 69 x 53.5 cm
Marina Picasso Collection

PL. 79    *Jester on Horseback*
Paris, 1905
Oil on cardboard, 100 x 69.2 cm
Virginia Museum of Fine Arts, Collection of
Mr and Mrs Paul Mellon, Richmond, Va.

PL. 80   **HONORÉ DAUMIER**
*Crispin and Scapin*
1863-4
Oil on canvas, 60.5 x 82 cm
Musée d'Orsay, Paris

FIG. 35  **At the Lapin Agile**
Paris, 1905
Oil on canvas, 99.1 x 100.3 cm
The Metropolitan Museum of Art, New York.
The Walter H. and Leonore Annenberg
Collection, Gift of Walter H. and Leonore
Annenberg, 1992, Bequest of Walter
H. Annenberg, 2002

them.[22] In a certain respect, he saw in the patterns of their itinerant lives a parallel with the experience of the struggling artist, living on the margins of society and surviving through art.

Picasso's own identification with the Harlequin/saltimbanque, which serves as a reformulation of his Paris persona, is clearly demonstrated in his 1905 painting *At the Lapin Agile* (fig. 35). This composition originated as a kind of advertisement for the Montmartre locale, which was run as a cabaret by a character called Frédéric Gérard, known as Frédé, and the unframed canvas can be seen hanging on the wall in a photograph of the interior.[23] In the painting the artist is dressed in Harlequin's costume, while Columbine, who is seated at his side, is none other than his old friend (and one-time mistress) Germaine. Behind them in the distance is Frédé strumming his guitar. By including himself with the woman responsible for Casagemas's death, Picasso seems to be saying that since that dark time things had moved on, and their aspirations and lives had changed. Germaine had married another Catalan, the painter Ramon Pichot, and they had

settled down in the Maison Rose, not far from Frédé's establishment. For his part, and by virtue of the strength of his art and his personality, Picasso now occupied the centre of the Montmartre art scene, with the promise that, soon, he would play a much larger role.

For the Serrurier show, Picasso selected 28 paintings and drawings, including a group of eight saltimbanque compositions, plus two *estampes* (presumably etchings), three engravings and one sketchbook. Among the paintings was a street scene on the rue Ravignan, a version of *Woman with a Crow* (fig. 36), featuring Frédé's daughter Margot, which was acquired by Olivier Sainsère,[24] a portrait of the Wagnerian opera singer Suzanne Bloch,[25] several unidentified portraits and figure paintings, and a few Barcelona works, including *Paysage de Montjuich (Espagne).*[26]

Of the writers who published reviews of the show, the poet Guillaume Apollinaire's piece, which appeared in *La Plume* on 15 May 1905, was by far the most significant in making Picasso's name known among circles of writers and artists in Paris at that time. Apollinaire, who had

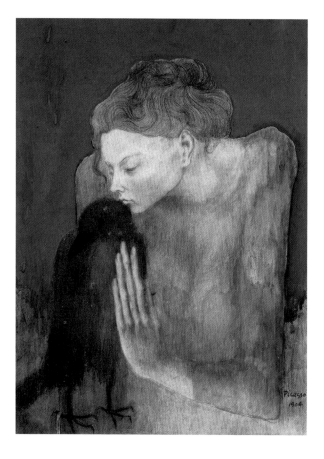

FIG. 36 **Woman with a Crow**
Paris, 1904
Gouache and pastel on paper, 60.5 x 45.5 cm
Private collection

met Picasso in October of the previous year, would not only become an important contact for the artist, but he remained a close friend and significant collaborator in some of Picasso's projects until his death in 1918. In his review he spoke most evocatively of the saltimbanques: 'The harlequins go in splendid rags while the painting is gathering, warming or whitening its colours to express the strength and duration of the passions, while the lines, delimited by the tight curves, intersect or flow impetuously...

'...Adolescent sisters, treading in perfect balance the heavy balls of the saltimbanques, impose on these spheres the radiant motion of worlds. These still adolescent youngsters have the anxieties of innocence; animals instruct them in the religious mystery. Some harlequins match the splendour of the women, whom they resemble, being neither male nor female.

'The colour has the flatness of frescoes; the lines are firm. But placed at the frontiers of life the animals are human, and the sexes are indistinct.'[27]

The adolescent girl balancing on a ball is the subject of a painting of 1905 now in the Pushkin Museum, which was originally acquired by Gertrude Stein and later sold to the Russian Ivan Morosov. The same youthful acrobat appears in several related compositions, including a watercolour that was purchased by Stein's friends Etta and Claribel Cone, as well a drypoint, *Saltimbanques* (fig. 37), which may have been included among the prints in the show. Apollinaire is one of the first critics to cite Picasso's printmaking activity, in which he sees the poetry of the theme of saltimbanques evoked through the delicacy of the drypoint line.

Apollinaire's observation that Picasso's colour has 'the flatness of frescoes' relates to the matt and evocative qualities of gouache, which the artist favoured for so many of his saltimbanque compositions as a means to emphasize the poetic qualities of his figures and the vague spaces that they occupy. In this regard, the example of the Symbolist Odilon Redon would not have escaped his attention. Redon was a frequent exhibitor during the early

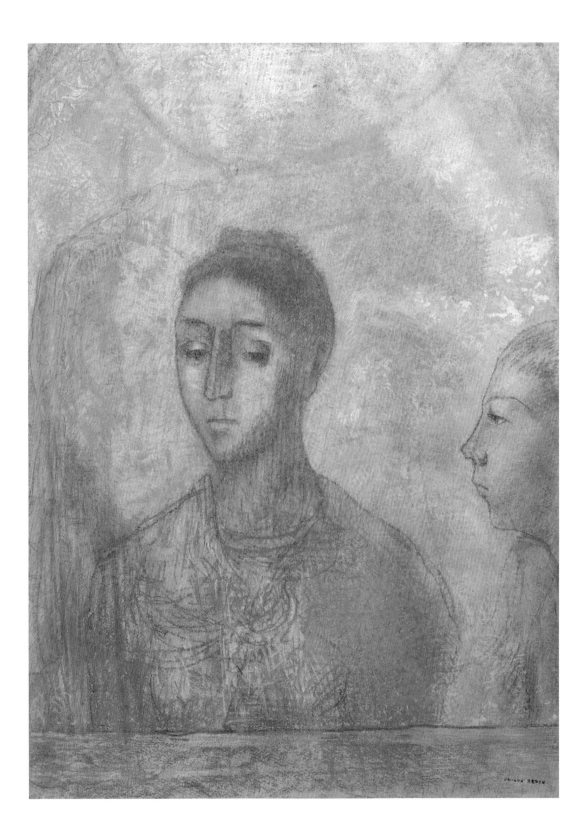

PL. 81 **ODILON REDON**
***Woman and Child***
c. 1898
Pastel on paper, 59.5 x 43.6 cm
Van Gogh Museum, Amsterdam

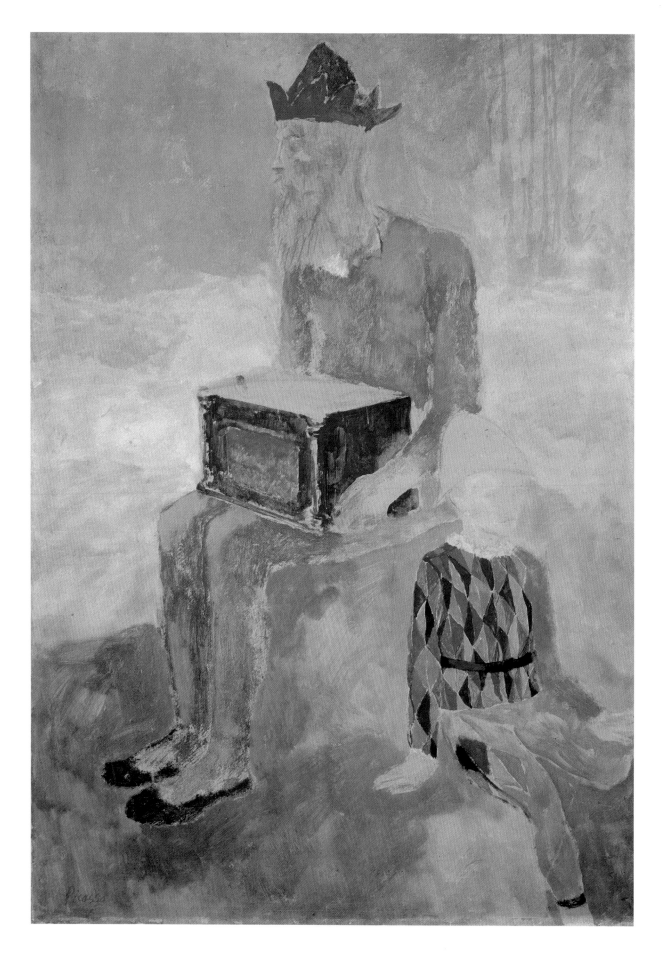

PL. 82   *Hurdy-Gurdy Man and Young Harlequin*
Paris, 1905
Gouache on cardboard, 100.5 x 70.5 cm
Kunsthaus Zurich

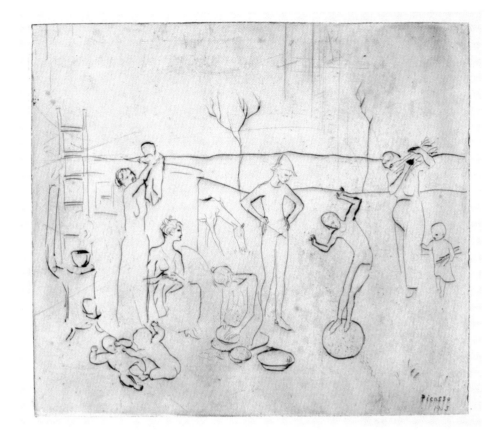

FIG. 37 **Saltimbanques**
Paris, 1905
Drypoint, 28.8 x 32.6 cm
Marlborough Gallery, New York

years of the century, and he was featured at the 1904 Salon d'Automne with some 18 paintings and 21 pastels, in addition to drawings and lithographs. Beginning in the late 1890s, Redon had experimented with pastels, sometimes dipping his pastel sticks in water, in order to create contrasts between thick, impasto-like lines and the powdery ones drawn with unwetted pastel.[28] He applied these different techniques to a range of subjects, including mystical scenes as well as the heads of women and children (pl. 81), in which the medium contributes to the dreamy, Symbolist tone that Redon wished to convey. Although Picasso also used contrasts in his application of paint, his preferred method at this time was to work with thin washes of paint – oil, as in the *Girl Balancing on a Ball*, or gouache – to create figures whose presence is as ephemeral and evocative as their marginal existence as travelling performers.

Poet and painter shared a fascination with the lives of saltimbanques. Spurred on by his perceptive response to Picasso's paintings, Apollinaire wrote poetry that, in some cases, seems to exist as a parallel expression of what appeared on canvas. The hurdy-gurdy player, for instance, was portrayed by Picasso in the company of a boy in harlequin's costume (pl. 82). Painted in soft tones, the thinly applied gouache tends to fuse the figures with their setting, the empty space of a *terrain vague*. Apollinaire described a hurdy-gurdy player in his poem 'Phantom of Clouds', where he supplies the eerie sounds of the instrument to accompany his scene:

> See that thin savage-looking one
> The ashes of his ancestors are coming out in his grey beard
> He carries all his heredity in his face
> And seems to dream of the future
> While mechanically turning a barrel-organ
> Whose sweet voice wails marvellously
> Gurgling false notes and muffled groans.[29]

PL. 83    ***Woman with a Cap***
Paris, 1901
Oil on canvas, 41 x 33 cm
Museu Picasso, Barcelona

# 'ALL FIELDS OF KNOWLEDGE'

## Picasso's Art and the Intellectual Environment of his Early Years in Paris

PETER READ

Maurice Raynal, one of the Bateau Lavoir initiates who watched Picasso at work, described how, in his 'impeccable' blue clothes, the artist, 'his pipe between his teeth, used to paint with meticulous care'.[1] Raynal later extended that commentary: 'It is hard to imagine the level of ardent and controlled fervour that the Blue Period works represent in Picasso's art. I saw him paint several of them. He seemed so penetrated by what he was doing that he appeared physically incarnate in the subjects he was painting. Armed sometimes with little stubs of brushes, he appeared to draw the lines out of the card or the canvas as if with tweezers, and the whole drawing meekly followed his hand; it was if he had it on a leash. The speed at which he realized even his most complicated compositions testified to his trance-like state, which was all the more unconscious in that he seemed himself to be discovering the new world his hand was creating.'[2]

Raynal bears witness to Picasso's absolute, shamanistic involvement in the creative act. In his view, however, that intense commitment did not lessen the relevance of the constantly varied intellectual appetite that motivated Picasso and the best of the young artists around him: 'All fields of knowledge would be more or less consulted, perhaps randomly, but always in spirit and never literally. Poetry, literature, philosophy and science were successively investigated, much more for their secret intentions than their actual achievements. And poetry certainly remained for them the symbol of imagination.'[3] But to what extent did that intellectual environment actually shape or nourish Picasso's artistic development or any particular works?

FIG. 38   *Portrait of Max Jacob*
Paris, 1904-5
Ink on paper (with letterhead of the Café Faurena,
75*bis*, boulevard de Clichy), 25.8 x 20.1 cm
Private collection (M. L., Paris)

From 1901, Picasso's first French friend in Paris, Max Jacob (fig. 38), played an essential role in his literary and linguistic development, taking him to the theatre and teaching him French with dramatic renditions of works by Romantic and Symbolist poets.[4] Picasso in turn recognized Max's potential and famously told him to seize the time, leave his day-job and 'Live like a poet'.[5] The two friends gave each other considerable moral and material support: Picasso's gifts to Max included a hand-painted, four-panel folding screen,[6] while Max apparently paid the deposit on Picasso's Bateau Lavoir studio.[7] Some of Picasso's drawings seem directly related to poems he discovered through Max, notably by Vigny and Verlaine, though of course he found much of the essential inspiration for his Blue Period repertoire in the work of artistic models such as Degas, El Greco and Steinlen. His art from that time also reflected, however, an essential aspect of the contemporary Parisian zeitgeist, particularly apparent in the intellectual microclimate of Montmartre. This was the widespread sense of loss and estrangement that resulted from recent dramatic changes to the fabric of the city.

In response to overcrowding, cholera and tuberculosis – the population of Paris had doubled since the 1820s – Baron Georges-Eugène Haussmann had begun in 1852 to open broad boulevards, with new pavements, drainage, sewers and squares. Paris became the 'City of Light', but the wider streets also hindered the erection of barricades and facilitated military mobility. Property developers made fortunes, but the poor were shoved aside and out to the suburbs as their backstreets were demolished. In Montmartre, a vogue for non-conformist, anarchistic bohemianism expressed resistance to the

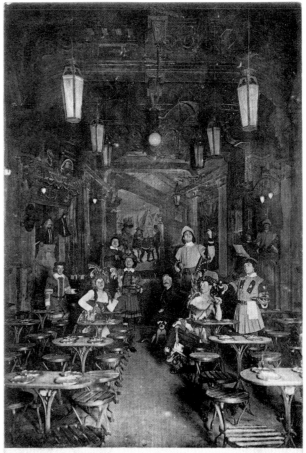

FIG. 39    Interior of the Cabaret des Truands
          (100, boulevard de Clichy), with servers
          wearing 'medieval' costumes
          c. 1904

**L'ARAIGNÉE—TAVERNE DES TRUANDS**
100 Boul de Clichy (*Paris Montmartre*)
*Vue Intérieure*

values underlying the rationally designed and centrally controlled city. At the Quat'z'arts, the Chat Noir, the Lapin Agile and other cabarets, nostalgia for lost medieval quarters made the writings of the fifteenth-century poet François Villon relevant and fashionable.[8] Jehan Rictus (the medieval pseudonym of Gabriel Randon), performed slang poems in a style that recalled underworld jargon and the working-class dialect used in anarchist newspapers such as *La Sociale* and *Le Père Peinard*. Rictus spoke for the downtrodden, and a definitive edition of his doleful compositions, entitled *Les Soliloques du pauvre*, appeared in 1903, with over one hundred illustrations by Steinlen, opening with a drawing of a homeless family on the street, huddled against the cold.[9]

This contagious sense of resentful alienation was one of the reasons why Picasso, after the vibrant colours and brushstrokes of his first Paris paintings, shifted to monochrome scenes of poverty and alcoholism, depicting gaunt and crippled street vendors, buskers, beggars and schizophrenics, or prostitutes interned at Saint-Lazare (pl. 83), an institution off the rue du Faubourg Saint-Denis which had developed from a leper colony founded in the twelfth century. All these figures emerge from pre-Enlightenment shadows. Picasso went on to paint the displaced and dispossessed of Barcelona, another city being radically remodelled, before continuing along the same track after his return to Paris in 1904, in late Blue Period works such as *Les Misérables* (fig. 40), an ink and gouache drawing of a family being evicted from their home.

Roger Marx dubbed Picasso the 'Spanish Steinlen':[10] his Blue Period combined elements of Steinlen's style and social conscience with the mood of Jehan Rictus's

FIG. 40   **Les Misérables**
Paris, 1904
Pen and gouache on cardboard,
dimensions unknown
Private collection, Paris

plaintive soliloquies. Pierre MacOrlan referred to the Bateau Lavoir's 'medieval décor',[11] and Jules Romains found Picasso's studio 'so dilapidated and bare that, on reflection, I wonder if it wasn't rather studied.'[12] Picasso's style and environment at that time indeed amounted to a conscious rejection of bourgeois standards and signalled that he identified with those who were marginalized by Haussmann's grandly hygienic city.

In 1905, however, Picasso's encounter with a brilliant new group of friends, mainly French-speaking poets of his own generation, marked a change. They included Guillaume Apollinaire, André Salmon and figures such as Nicolas Deniker and Maurice Cremnitz, now forgotten, but seen then as rising literary stars. In their company, Max Jacob came into his own as a sparkling debater and entertainer, while writing piles of poetry and prose

that he would publish in later years. This new sense of community, centred on his studio, helped Picasso break away from increasingly dated bohemian nostalgia and reconnect with the trail-blazing spirit which had brought him to Paris in the first place.

Much has been made of the creative empathy established between Picasso and Guillaume Apollinaire (fig. 41).[13] The two articles, beautifully observed and crafted, that Apollinaire published on Picasso's paintings and drawings in April and May 1905 cemented their alliance. Apollinaire's mental landscape and poetic practice also brought to the studio a new model of imaginative and creative diversity, untrammelled by canons or conventions. According to Maurice Raynal, Picasso and Apollinaire 'immediately found they were brothers in the love of liberty that drove them both.'[14]

Less credit has been given to André Salmon, who also met Picasso early in 1905 and had known Apollinaire since 1903, from the literary and social evenings organized by the magazine *La Plume* in the basement of a Latin Quarter café, where they launched their literary careers. Salmon was the son of an artist and engraver, and in 1896, aged fifteen, he had travelled to St Petersburg, where his father had work and where he found a job at the French Consulate. He was tall, slim and elegant, and in 1905 he was, according to Max Jacob, 'the darling of Montparnasse as it was then, and was very rightly considered as the great poet of the time and the future hope of Poetry, just as much as if not more so than Guillaume.'[15] He published his book *Poèmes* that year, well before Apollinaire or Max Jacob produced their first collections, and for ten or so deluxe copies Picasso provided an engraving, showing two young acrobats decompressing after a performance (fig. 42). Salmon's faith in Picasso's genius was instant and absolute, and one poem in that volume, 'Le Banquet', is dedicated to the artist and ends, 'You declared me a Poet at the end of the banquet',[16] recalling Picasso's advice to Max Jacob and confirming his role as the figure of authority who validated poetic vocations.

Salmon promoted Picasso's painting in a noteworthy article published in November 1905. Ostensibly reviewing the Salon d'Automne, Salmon quickly shifts into praise for Picasso and the perspicacious dealers then exhibiting his work: 'Picasso, with whom we meet, is not in the exhibition, doubtless with very good reason, but we regret not seeing here his visionary harlequins, his prophetic children, his breathless flowers and dolorous mothers.

FIG. 42   **Two Acrobats**
Paris, 1905
Musée national Picasso, Paris
Printed as a frontispiece to André Salmon's
*Poèmes*.

Vollard and Sagot more happily are exhibiting some of his incomparably poignant canvases. Painters and poets are duty-bound to go down rue Laffitte. People know too well the boulevard and not enough rue Laffitte, so nearby, where there are ten canvases by Picasso, which are the newest contribution to painting for ten years, and at Durand-Ruel's there is an incomparable El Greco that Madrid could not hold onto.'[17]

If the writings and legendary exploits of Arthur Rimbaud helped inspire Picasso's early aspirations, this was thanks to Salmon, who was the main Rimbaud enthusiast of the group. His 1906 poem 'Arthur Rimbaud' presents the young genius as a born exile, explorer and prophet, close to the indigenous peoples he encountered in Africa.[18] In 'Bad Blood' ('Mauvais sang') in *A Season in Hell*, Rimbaud indeed sided with the native population facing French troops who invade African shores. Salmon expressed a similar position in the poem 'Makohoko 1er', from his 1907 collection *Féeries*, where an African king stands alone on a beach, weeping and contemplating suicide. His warriors are dead, his kingdom has been laid to waste and the French kepi on his head indicates where the responsibility lies.

Apollinaire in 1903 stated that young immigrants enrich the spiritual heritage of their new nation just as the introduction of chocolate and coffee enriched the nation's tables and tastes.[19] That cosmopolitan humanism joined with Salmon's anti-imperialism to help shape the intellectual environment within which Picasso developed an interest in African carving. He indeed associated Salmon with that aspect of his work by including sculptural drawings of him (fig. 43) among

FIG. 43 **Portrait of André Salmon**
Paris, 1907
Charcoal on paper, 60 x 40 cm
Musée national Picasso, Paris

his graphic experiments leading up to *Les Demoiselles d'Avignon* (fig. 48).

Max Jacob dubbed the Bateau Lavoir 'the Cubist Acropolis',[20] implying an elevation that was both mental and topographical. Picasso, he wrote, was exclusively focused on pursuing 'that ideal of perfection in drawing which has been his aim in life', quoting him as saying 'I don't know if I'm a great painter, but I am a great draughtsman.'[21] Picasso was never, however, above politics. The company he kept and the paintings he exhibited at Vollard's gallery led a police report in June 1901 to brand him an anarchist to be kept under surveillance, a decision reiterated when his works were again exhibited in May 1905.[22] Picasso's Blue Period subjects were not politically neutral, and Fernande Olivier, when she met him in August 1904, rightly discerned in

them an 'agonized appeal to all human compassion' which seemed to show 'a deep and despairing love of humanity.'[23]

In 1905, Picasso's new friends must hardly have appeared more reassuring in police eyes than the Spanish immigrants he had previously frequented. Apollinaire, for one, was stateless and illegitimate, officially regarded as Russian, but often taken to be a Jewish immigrant because his real name, Wilhelm de Kostrowitzky, was Polish. His poem 'Avenir', published in *La Plume* on May Day 1903, prophesied an apocalyptic revolution that would liberate humanity from militarism and servitude, expressing an anarchist mindset that was further reflected in his early short stories, featuring ragpickers and vagabonds. His first book, published in late 1906, was a sacrilegiously obscene and violent novel, *Les Onze mille verges*. André Salmon, for his part, had been raised amidst tales of the 1871 Paris

FIG. 44    Cover of *Vers et Prose*, December 1905/January-
February 1906

Commune, in which both his parents had participated, and he always nurtured anarchist sympathies.[24]

Figures who were close to the Bateau Lavoir circle included the great debunker of authoritarian régimes, Alfred Jarry, author of *Ubu Roi*, and the philosopher and critic Mécislas Golberg, an exiled Polish Jew who in 1895 had founded *Sur le trimard: Organe des revendications des 'sans travail'* ('On the road: The Voice of the Jobless'), a libertarian newspaper devoted to the unemployed, the bottle-washers, the sandwich-board carriers and all other varieties of the lumpenproletariat, known collectively as 'trimardeurs'. He was deported from France in 1896 and 1898, was imprisoned when he returned illegally to Paris, but was eventually allowed to stay, on condition that he refrained from political activities. From January 1905 he was the literary director, editorialist and *éminence grise* of

*La Revue littéraire de Paris et de Champagne*, and though he was increasingly immobilized by tuberculosis, he continued to publish books and articles, finished his final and best known work, *La Morale des lignes*, and exerted considerable influence until he died in December 1907. He was particularly close to Salmon, whom he had helped by getting a poem of his published for the first time, in *La Plume*.[25] Jarry and Golberg were known to Picasso by reputation, even if he may never have met them.

Specialist periodicals such as the monthly *Revue littéraire de Paris et de Champagne*, where Golberg also gave Salmon a regular arts column, were then the essential vectors of cultural and intellectual debate. In spring 1905, a new literary magazine, *Vers et Prose* (fig. 44), was launched by Paul Fort. Already in 1890, when he was seventeen and still at school, this extraordinary

man had founded Le Théâtre d'Art, making it France's first and leading Symbolist theatre company. Paul Sérusier, Maurice Denis, Gauguin, Vuillard and Bonnard were his resident stage and programme designers. He also edited *Le Livre d'Art*, a small-press, large-format magazine, which published Jarry's *Ubu Roi* in its second issue, dated April-May 1896. In July 1912, his literary peers elected him the 'Prince of Poets'.

André Salmon was the editorial secretary of *Vers et Prose*. Published three times a year, by its third issue the magazine had over 700 subscribers. *Vers et Prose* was attractive because, after years of sectarian and generational literary and artistic rivalry, it pioneered a conciliatory strategy that brought together recent work by Symbolist survivors and new writing by young poets. The periodical fostered a new sense of intellectual fraternity in Paris, and its success heralded the pre-war flowering of international, modernist creativity in the city. This positive spirit found its most convivial expression in the *Vers et Prose* social evenings every Tuesday at La Closerie des Lilas, a café with verdant terraces and an upstairs room, near a corner of the Luxembourg Gardens. Jules Romains described the scene: 'Around forty people, more or less grouped at tables, but with neighbourly communication from one to another. The smoke and noise of an ordinary room. But – to be fair – a much more exciting atmosphere. [...] Heads of every age and every style. Apparel of very variable elegance and strangeness. [...] Not many women.' Paul Fort, dressed completely in black, thick hair combed down over one ear, 'Big nose, big eyes, large moustache', stood near the door, shaking hands and welcoming everyone, on the look-out for possible subscribers.[26]

The meetings were cosmopolitan, intergenerational and predominantly literary, though some artists, particularly Picasso, attended.[27] Picasso had a reputation for being taciturn, but with a gift for mordant remarks. In 1905 he showed the young poet and law student Henri Mahaut his paintings and drawings, hardly making any comments, but he then followed up with a pithy and revealing admission concerning his Blue Period: 'All that is just sentimental.'[28] According to Salmon, at the Closerie des Lilas Picasso 'would listen and say a few extraordinary things'.[29] He often sketched caricatures, some of which have survived, of the friends, celebrities and illustrious nobodies who filled the room (fig. 45). Among them was Jean Moréas, a key figure at these evenings. Born in Athens in 1856, he had published a 'Symbolist Manifesto' in *Le Figaro* of 18 September 1886 and co-edited a weekly paper, *Le Symboliste*. In January 1891, a special issue of *La Plume* celebrated 'Le Symbolisme de Jean Moréas', but nine months later, Moréas proclaimed the death of Symbolism and of free verse and founded l'Ecole Romane, calling for a return to classical forms and clear expression, 'purity', 'dignity' and 'the Greco-Latin principle', which, he claimed, underpinned good French literature, from the eleventh-century troubadours to the seventeenth century of Racine and La Fontaine.[30] His own new poems were published as *Stances*, in four volumes, in 1899 and 1901, republished in 1905. At the Closerie des Lilas, he often sat at the back, facing the door, and greeted those arriving with a provocative epigram or a punning, satirical couplet. He would call out 'Monsieur Picasso is a very fine man,'[31] but he also claimed to despise painters[32] and would ask, 'Tell me, Picasso, did Velázquez have any talent?'[33] Picasso stole some of his limelight, so he set out to needle him.

Max Jacob recalled that 'One evening, Moréas spent an hour regularly repeating "Don Pablo Picasso de Ségovie!" in his sublimely croaky voice. Picasso grabbed his cap and said to me, "Bamanos!" which in Spanish apparently means "Let's go!" and which Apollinaire translated as "Barrons-nous!"'[34]

Moréas was at that time held in very high esteem and Apollinaire, for example, called him 'the perfect Poet'.[35] His 'Call to order' indeed made an essential contribution to powerful movements in both France and Catalonia that by the early twentieth century sought to define modernity through an emphasis on Mediterranean aspects of European cultural inheritance and identity. Such attitudes shaped much contemporary poetry and found expression in key works of sculpture such as Maillol's 1905 *The Mediterranean* or in the aesthetic ideals of writers as utterly different as Charles Maurras and Mécislas Golberg.[36] Picasso's susceptibility to that spirit was clearly evident in his Arcadian, neoclassical paintings of 1906, which used matt colours and shallow perspective to set naked figures, sometimes with horses (pl. 95), in arid, southern landscapes. This objective, synthetic and impersonal style of representation marked a crucial stage on his road to cubism.

The theme of shared artistic community prevalent in Picasso's saltimbanque paintings and other Rose Period works was reinforced by the broad sense of fellowship which *Vers et Prose* successfully promoted. Picasso was a charismatic presence at the Closerie des Lilas Tuesday sessions, but Paul Fort also came up to Montmartre. He and his second wife, Marguerite Gillot, with their young daughter Jeanne, moved out of rue Boissonnade in Montparnasse and into a flat on the corner of rue

Lepic and rue de l'Orient, probably in 1906. They would meet Picasso, Apollinaire, Jacob, Salmon and others in their local café, Au Téléphone, at the bend on rue Lepic, sometimes moving on afterwards to the Lapin Agile.[37] They also used to frequent Picasso's studio, where they enjoyed 'Fernande Olivier's good dinners'.[38] Gillot was a major part of the attraction, as she was a prize-winning poet and a stunningly beautiful, green-eyed blonde.[39]

Picasso and his friends gleefully bonded around their shared enthusiasm for fictional outlaws and renegades such as the criminal anti-hero Fantômas. By 1905, however, the anarchist movement in France was losing momentum. An awareness of politics and current affairs nevertheless continued to feature in Picasso's work, in oblique and unexpected ways. Max Jacob introduced Picasso to the violinist Henri Bloch, who would come with composer Déodat de Séverac and play in his studio.[40] Picasso made an ink and watercolour drawing, probably in early 1905, entitled *Circus Family with Violinist* (fig. 46), depicting a family of saltimbanques and their pet ape listening to a musician. The ape is placed in a similar position to the circus child and is listening to the music as attentively as the humans, as if to suggest their anatomical and mental similarities.[41] This led to a major painting of 1905, *Harlequin's Family with an Ape* (pl. 84). Part of the painting's power lies in its setting of itinerant modern characters against a timeless backdrop, in a way that recalls a long European tradition of religious painting, and particularly representations of the Holy Family. The ape replaces the ox or the ass associated with the stable in Bethlehem. The woman's fine Botticelli profile and the fresco-like texture, surface and colours serve to reinforce those historical connections. Apollinaire in his

FIG. 45   **Caricatures and Portraits**
Paris, 1905
Pen, brown ink and pencil on paper, 25.5 x 32.7 cm
Musée national Picasso, Paris
In the lower part of the drawing (left to right) are Apollinaire
(with pear-shaped head, smoking), Paul Fort, Jean Moréas
(with cigar), André Salmon (holding a pipe) and, below him,
Fernande Olivier.

first article on Picasso, in April 1905, observed that 'His naturalism enamoured of precision is matched by that mysticism which in Spain lies at the bottom of the least religious souls.'[42] Then in his May 1905 commentary on Picasso's pictures of saltimbanque families (pl. 85) he used vocabulary that specifically invoked the Virgin Mary and the New Testament story: 'The child brings the father closer to the woman, that Picasso wanted glorious and immaculate. [...] Noël! They gave birth to future acrobats among pet monkeys, white horses, dogs and bears.'[43]

In *Harlequin's Family with an Ape*, the man and the ape have equally shortened forearms, and both adults have elongated fingers and hand gestures similar to the ape's. Also striking are parallels between the ape and the half-naked child, sitting in similar positions and displaying similar genitals. The nocturnal visits Picasso and his friends regularly paid to the zoo at the Jardin des Plantes, the Paris Botanical Gardens, as recalled by Fernande Olivier and Max Jacob, may be relevant to an appreciation of this painting.[44] The poet Nicolas Deniker, who frequented the Bateau Lavoir with his young brother Georges, had a key to the Gardens because their father was Librarian there and the family lived on-site. Joseph Deniker (1852-1918)

FIG. 46    Reconstructed sketch sheet (Paris, 1905) made
up of drawings from the collection of the
Baltimore Museum of Art:
**Sketches of Monkey, and Clown's Family
with Violinist** (left)
Pen and black ink, watercolour and graphite,
19.6 x 15 cm
**Circus Family with Violinist** (upper right)
Pen and black ink, transparent and opaque
watercolour, 18.1 x 15.8 cm
**Monkey** (lower right)
Pen and black ink, brush and black wash,
20.1 x 18.8 cm
The Baltimore Museum of Art. The Cone
Collection, formed by Dr. Claribel Cone and
Miss Etta Cone of Baltimore, Maryland (left
and upper right); Bequest of Dr. Grace McCann
Morley, New Delhi, India, in Memory of Sarah
Stein (lower right)

was an eminent zoologist and botanist. An authority on the anatomy of apes, he had published in 1886 his thesis, illustrated with photographs and engravings, which compared gorilla and gibbon foetuses, three young apes and seven human foetuses. Deniker showed that clear differences between humans and gorillas only occur during the second half of the gorilla's foetal development, and one of his chapters focused on similarities between human and gorilla genitals.[45] He worked in a resolutely Darwinian tradition, and while it is unlikely that Picasso ever read any of his books, his sons may well have told him about them, especially as such research was then controversial.

Placed in this scientific and intellectual context, *Harlequin's Family with an Ape* appears to be a Darwinian allegory in which the figures are arranged to indicate an evolutionary pattern and genetic links relating the humans and the ape. The painting also, however, retains New Testament connotations, and so combines a religious heritage with a contemporary, scientific understanding of human origins and identity. It thus reflects the most important and hotly contested political and ethical issue in France that year, namely the government's plan to separate Church and State, to make the Republic overtly secular and to withdraw all state subsidies to any religion. That law had first been proposed to the French Chambre

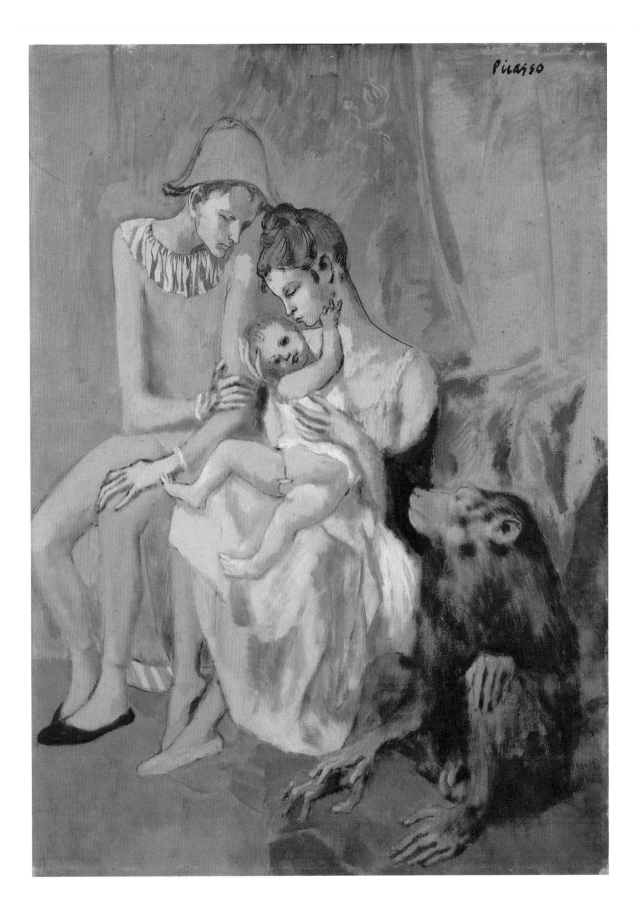

PL. 84 **_Harlequin's Family with an Ape_**
Paris, 1905
Gouache, watercolour, pastel and Indian ink on
cardboard, 104 x 75 cm
Konstmuseum, Gothenburg

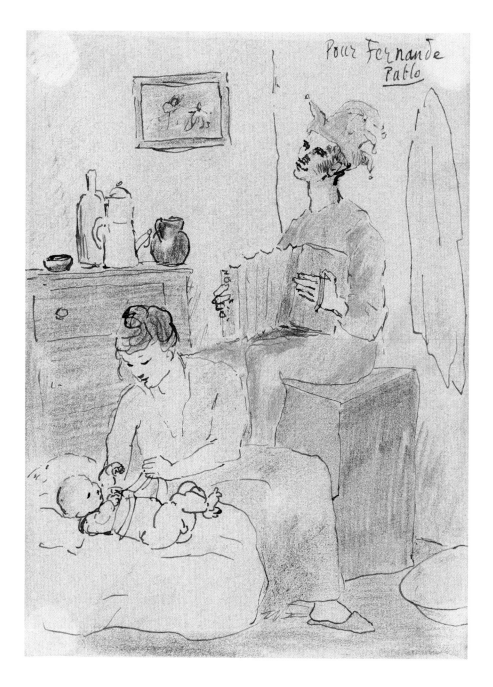

PL. 85    ***Family of Saltimbanques ('Pour Fernande')***
Paris, 1905
Ink, charcoal and watercolour on paper, 16.5 x 12.5 cm
Collection Gabriele and Horst Siedle, Germany

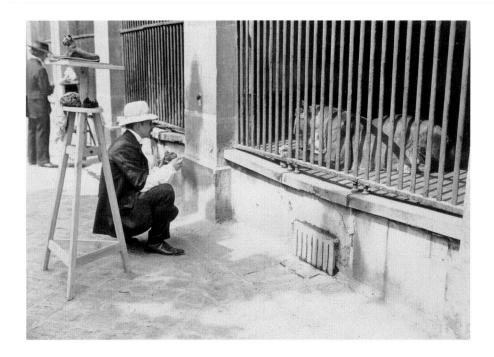

FIG. 47　Student from the Ecole des Beaux-Arts modelling
lions in the Jardin des Plantes
Paris, c. 1900
Photograph by Paul Géniaux
Musée Carnavalet, Paris

des députés on 31 January, was debated there repeatedly
and at length until July, then went up to the Senate
and finally passed into law on 9 December 1905. This
divisive issue thus remained front-page news throughout
the year. Picasso in his painting beautifully combined
sacred and secular viewpoints and values. A monkey in
a circus tent hardly looks incongruous; a Darwinian ape
amidst Christian imagery was however a provocative
juxtaposition, evoking a clash of cultures. This painting
disrupted hallowed pictorial traditions, but also ironically
subverted pedantic antagonisms on both sides of the
biggest issue of the day.

The sacred and the profane are similarly brought
together in Picasso's autumn 1905 canvas, *Boy with a Pipe*
(pl. 86), which depicts a young apprentice in blue working
clothes. Salmon remembered Picasso suddenly leaving

his friends to their discussions one night and rushing
back to his studio to add a crown of roses to the figure
in this painting, which he had not touched for a month.[46]
Salmon also gave a source for that brainwave: 'The roses?
From the image on a first communion card given to him
by a young girl on place Ravignan.'[47] So the blue boy is
beatified by the crown Picasso transferred to him from
the Virgin Mary or some other holy figure. A crown of
roses is also a crown of thorns, conferring on the working-
class youth a Christ-like identity, prefiguring a destiny of
suffering and an early death. The reflective expression on
the young worker's sallow, intelligent features suggests
a premonition of all this, and the final painting is thus
both spiritual and political. There is also a tinge of irony
introduced by the fact that the model for the blue boy was
no saint, but rather a delinquent named P'tit Louis who

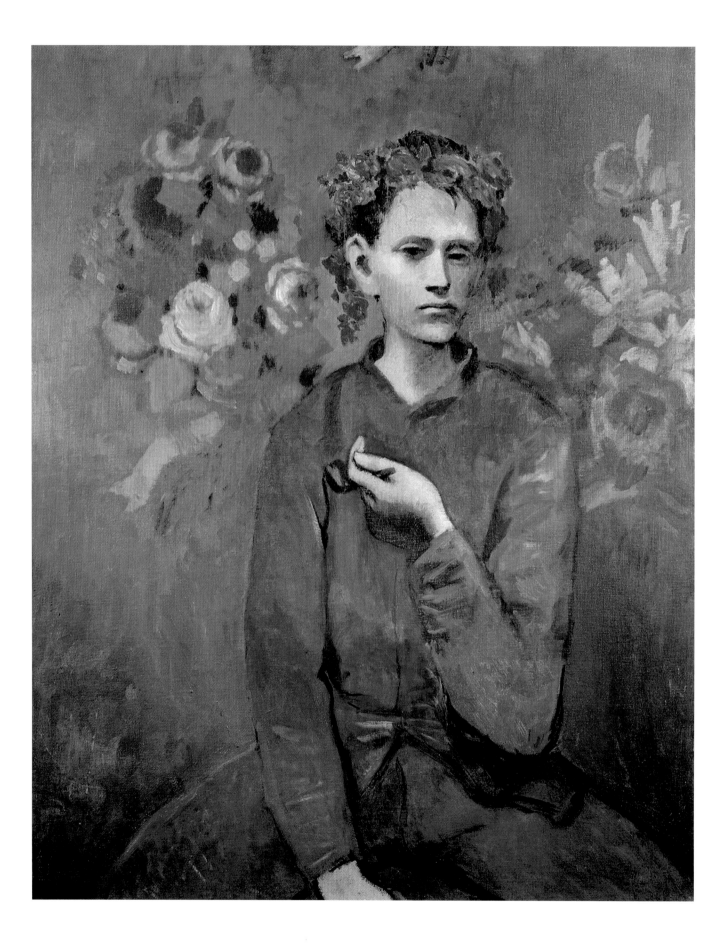

PL. 86    **Boy with a Pipe**
Paris, 1905
Oil on canvas, 100 x 81.3 cm
Private collection

controlled several Montmartre prostitutes and used to frequent the Bateau Lavoir.[48] In André Salmon's novel *La Négresse du Sacré-Cœur*, he is fictionalized as Camille Meunier, known as Mumu, who poses for a picture called *Le Marlou rose* (*The Pink Pimp*) on condition that he is given the preliminary sketch for the painting.[49] Salmon also wrote a key to this autobiographical novel, confirming the Bateau Lavoir group's fascination with the young delinquent, whom he described as 'a dreadful, attractive little character, an atrocious and gracious little criminal, an unashamed friend of evil, innocent perhaps if, as is not impossible, everything is written up there, in letters of fire, for all eternity.'[50] In 1912, Salmon made two other statements about the painting. Firstly, that it was made without a model,[51] a remark explained by a passage in *La Négresse du Sacré-Cœur* where Mumu sits for the portrait, but Sorgue, the artist, nevertheless mainly paints it on his own, at night, by the light of a candle in his left hand.[52] Secondly, that the painting could be a kind of self-portrait, evoking 'More or less the artist's own appearance during his working hours'.[53] By dressing the figure in his own blue artisan's outfit, Picasso indeed projected himself into the picture. As a result, this is a composite portrait, representing a figure who is simultaneously a sinner, a saint and the artist himself, gifted with grace and beauty, aware of his gloriously singular and probably painful destiny.

Joseph Deniker was also a well-known anthropologist and an expert on Oriental religions. Another of his major publications was *Les Races et les peuples de la terre*, published in 1900, where he studied the customs and social organization of peoples on all continents, including Europe, and questioned the validity of dividing human beings into racial 'types', because 'the more civilized peoples become, the more they mix with each other, within certain territorial limits.'[54] Consistently suggesting similarities between European and other peoples, Deniker emphasized the reality and value of social, cultural and ethnic mingling. He thus refuted the theories of Gobineau and, more recently, of Gustave Le Bon, who had published in 1894 *Les Lois psychologiques de l'évolution des races*, which posited the immutable division of racial groups and the pre-eminence of physical and psychological characteristics over social or institutional influences. Deniker's position was also diametrically opposed to that of royalists and nationalists such as Charles Maurras and Maurice Barrès, who promoted an exclusive ideal of French cultural identity and historic racial purity, and to republicans such as Jules Ferry, who used ideas of 'superior' European and 'inferior' non-European races to justify French colonial policies.

Christopher Green has cited Joseph Deniker's anthropological writing as an essential element in the intellectual context within which Picasso was operating, particularly with regards to *Les Demoiselles d'Avignon* (fig. 48). That painting may be seen as an experimental expression of racial and cultural hybridity, a work that 'scrambles the codes' by combining compositional and representational conventions that are specific to Western European art with elements from African and Oceanian cultures.[55] As Green suggests, Picasso probably never saw Deniker's *Les Races et les peuples de la terre*. Again, he may well, nevertheless, have heard of Joseph Deniker's ethnographic work from his sons, perhaps from the younger Georges Deniker, whose interests and inclinations were closer to those of his father, for he later

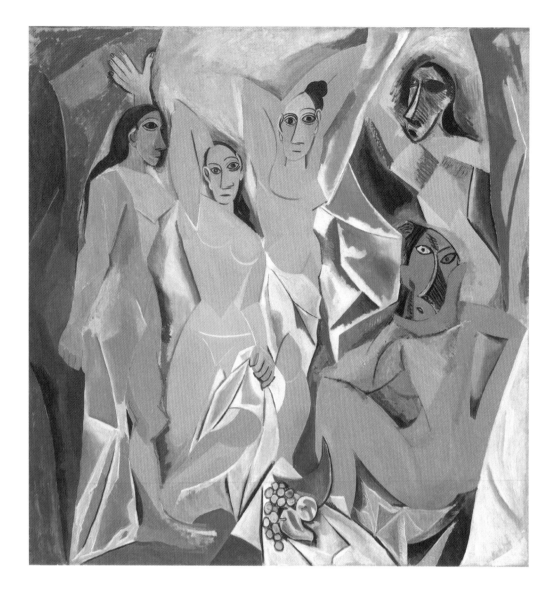

FIG. 48  **Les Demoiselles d'Avignon**
Paris, 1907
Oil on canvas, 243.9 x 233.7 cm
The Museum of Modern Art, New York.
Acquired through the Lillie P. Bliss Bequest

joined the French diplomatic service and became an authority on Oriental cultures and religions.[56] Picasso's collection of postcard photographs by Edmond Fortier (fig. 49) showing ethnic types from Senegal, Sudan and other parts of West Africa confirms his interest in anthropological iconography.[57] If Picasso was indeed aware of Deniker's objections to the concept of immutable racial categories, he must have viewed somewhat ironically these photographs, with captions confidently referring to ethnic 'types of women' from various regions.

Mécislas Golberg had a degree in Social Sciences from the University of Geneva and was also passionately interested in anthropology. In 1895, he attended the Paris Congress of the International Institute of Sociology and gave a paper entitled 'L'origine des races et la division du travail' which prefigured Joseph Deniker's book of 1900. Citing social variations in tribes in different regions of Africa, using accounts by German and British explorers, Golberg demonstrated that as societies evolve and become more complex, they assimilate disparate peoples and races, creating a melting pot which nullifies clear racial identities. Informed by his reading of Emile Durkheim, he stated that socio-economic rather than racial factors thus become the defining characteristics of any group or people, and the more developed a society is, in Europe, Africa or elsewhere, the more it is racially mixed. Golberg's arguments and examples demonstrated incidentally that some of the African peoples subjugated by European military power were in fact long-established communities, highly evolved and sophisticated.[58]

FIG. 49 **Malinke Woman**
1906
Postcard photograph by Edmond Fortier
(from Picasso's collection)
Archives Picasso, Paris

There was thus philosophical and scientific consistency between writers who worked only at one remove from the Bateau Lavoir and who were attached by family or friendship to Picasso's closest associates. This created an intellectual context that makes it all the more likely that the vertiginously disruptive power of *Les Demoiselles d'Avignon*, despite its disjunctive ambiguities, was aimed not only against traditional, Western canons of beauty, but also, to some extent, against philosophical and political systems which are racially hierarchical and culturally divisive.

Picasso read the papers, but did not bury his nose in scientific tomes. His friends at the Bateau Lavoir tended however towards ideas which corresponded poetically to arguments that others made scientifically. During

his early years in Paris, Picasso was utterly involved in the practical process of making art and in a constantly shifting relationship with works he encountered by artists he admired, past and present. He was however alive to contemporary political, philosophical and literary issues and debates and this also affected his art. And finally, he was surrounded and supported by a culturally sophisticated and creatively imaginative social network that stimulated and extended his innate intellectual curiosity and thus contributed to the complexity, value and significance of his work.

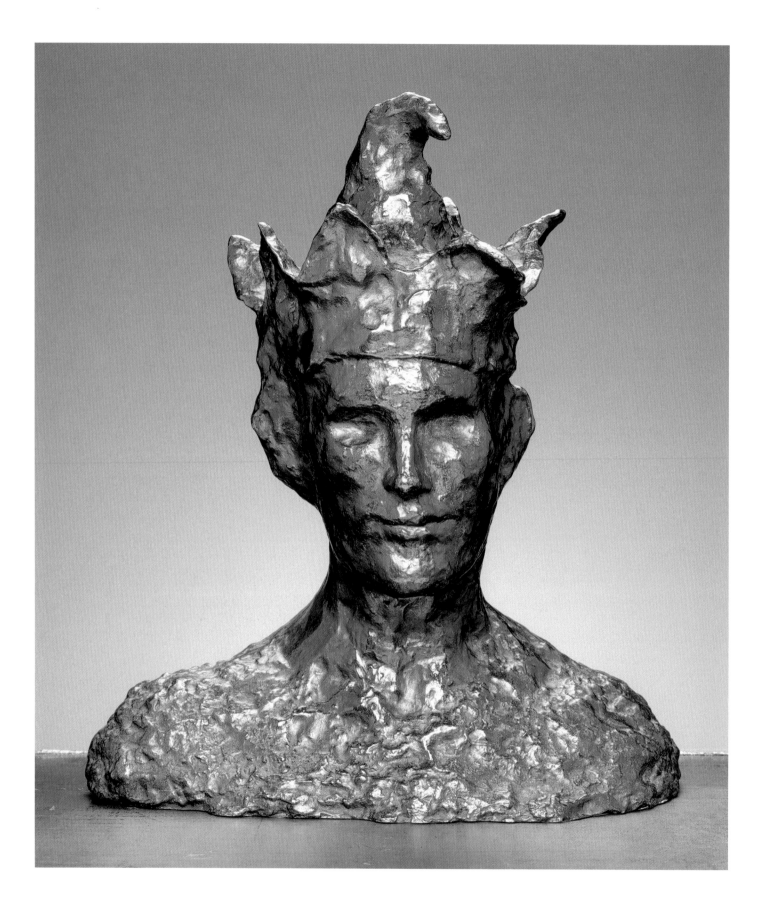

PL. 87    **Head of a Jester**
Paris, 1905
Bronze, 41.5 x 37 x 22.8 cm
Collection Fondation Pierre Gianadda, Martigny

# THE WIDENING OF PICASSO'S CIRCLE

MARILYN McCULLY

As a result of the Serrurier show and its positive critical reception, Picasso's name and reputation was enhanced in the Paris art world. Moreover, his association with the community of artists and writers who lived or gathered at the Bateau Lavoir meant that he became more fully immersed in French life than ever before. By far Picasso's closest friends in 1905 were Max Jacob, Guillaume Apollinaire and André Salmon. Fernande, who kept a journal during her years with Picasso, recounts that, 'Max Jacob and Apollinaire come by every day, and Max, who's so witty and amusing, so spirited and dynamic, is our master of ceremonies. Picasso and Guillaume could laugh all night long at Max's improvisations and stories, his songs, and the faces he pulls. Then other friends turn up and the studio echoes to our laughter. [...] One of the others who comes here a lot is André Salmon, who's also a friend of Max and Guillaume, though he's very different and his poetry has more sentiment.'[1]

On one occasion, after a visit to the Cirque Médrano and late at night, Picasso reportedly modelled a portrait of Max, which he later turned into a *Head of a Jester* (pl. 87).[2] In its final form, the work alludes quite specifically to similar saltimbanques in Picasso's Rose Period paintings. Sculpture now became an increasingly important aid in his artistic exploration; it allowed him to experiment both with the surface and with the balance of substance and illusion in three-dimensional form.

Fernande also mentions in her memoir the names of the places where they would go for meals and entertainment, as well as some of the people they frequently saw. At a local restaurant called Vernin's, for instance, where Picasso could charge their meals when

FIG. 50   Derain's Paris studio
1908
Photograph by Gelett Burgess
Archives Taillade

he was out of money, among the regulars were theatrical people – the director Charles Dullin and assorted actors – in addition to a Spanish group that included the sculptors Durrio and Manolo and the guitarist Fabián de Castro.[3] Of Durrio, Fernande writes fondly: 'Paco Durio [sic], the one who asked me to marry him last year, is very small, very round, and has a tireless, enquiring mind. [...] He was a great friend of Gauguin's when they both lived in the rue de la Grande-Chaumière, before Gauguin went to Tahiti, and Picasso is his other passion.'[4] She goes on to say that they often have meals with Canals and Benedetta or with the Spanish painter Zuloaga, 'where the expenses are shared with his compatriots [the Basque painter] Etchevarría, Pichot and [another Barcelona artist] Anglada.'[5]

Outside the studio and the world of Montmartre, Picasso also ventured further afield. Fernande says that on Tuesday evenings they began to frequent the Closerie des Lilas on the boulevard Montparnasse,[6] and there they attended the *Vers et Prose* evenings organized by Paul Fort, the journal's founder. According to her, Jean Moréas liked to tease Picasso about Spanish literature, while the writer Maurice Raynal, who later wrote the first full-length study of Picasso's work,[7] was intent on squandering his inheritance by spending money on artists and art.[8]

Around this same time, Picasso became friendly with several French painters, including André Derain and Maurice de Vlaminck, and on occasion they exchanged visits to their respective studios. Derain and Vlaminck were among the circle of young artists who were considered at that time followers of Matisse. Their 'Fauve' canvases, which they submitted to the 1905 Salon d'Automne, where Matisse was featured in a room devoted solely to his paintings, caused a sensation. In a review of the show, the Nabi painter Maurice Denis singled out Matisse's *Woman with a Hat* (fig. 19), which

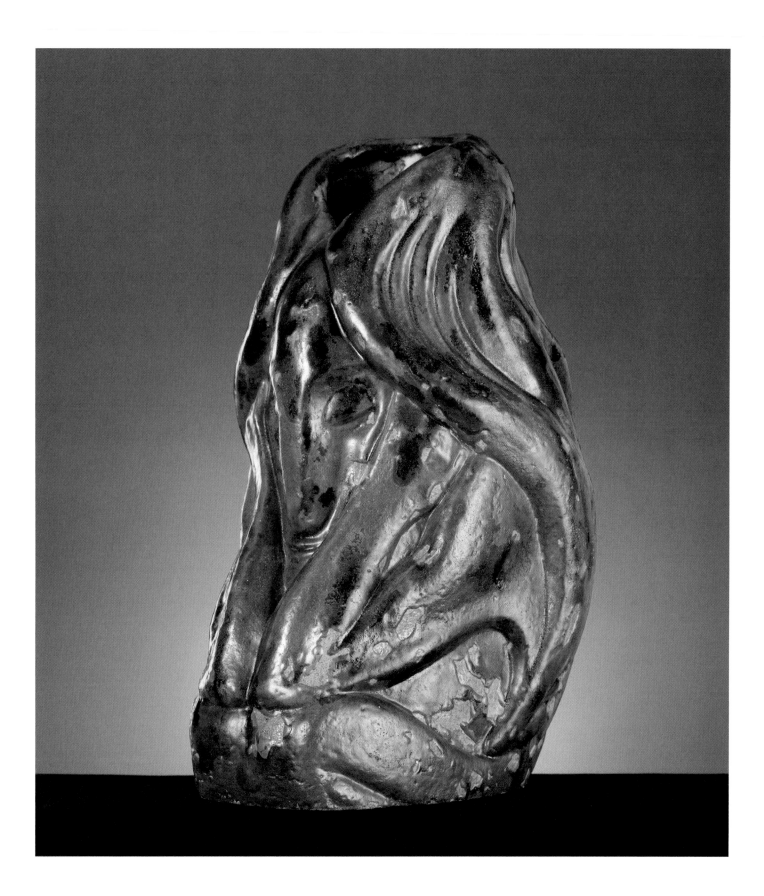

PL. 88   **PACO DURRIO**
*Anthropomorphic Pot*
1900-5
Glazed stoneware, 37.8 x 23.5 cm
Musée d'Orsay, Paris

he praised for its instinctiveness and for what he described as its demonstration of 'pure painting'.[9]

To coincide with the Salon d'Automne, Berthe Weill gave some of the Fauves a show in her little gallery, and she recalled that Apollinaire and Picasso were regular visitors.[10] Picasso was not particularly interested in the landscape painting of his new friends Derain and Vlaminck, but, as a Spaniard trained to use a generally earthen or monochromatic palette, he was impressed by the freedom with which, under the influence of Matisse, they used colour for both form and space in their compositions (pl. 93). However, it was their shared interests and the seriousness with which Picasso and his new painter friends all approached art that brought them together.

The Dutch contingent in Montmartre included a journalist, Tom Schilperoort, who gained a certain amount of notoriety in 1905 for having interviewed Mata Hari, a Dutch woman masquerading as an Indonesian who was making a name as an exotic dancer in Paris at that time.[11] Schilperoort had come into a small inheritance, which allowed him to go home for the summer, and he invited Picasso to join him in Holland. Although Fernande was aggrieved that he was going to leave her behind, he accepted.[12] Picasso later recalled that just before his departure he did a little drawing of a lawyer pointing his finger and, in jest, signed it 'H. Daumier'. During his absence, while Salmon and some other friends were staying in his studio, someone sold it as an authentic Daumier.[13] 'I didn't have any money,' Picasso later recalled, 'A little, at least, was needed to make the trip. Max Jacob didn't have any more than I did. He went to the concierge and returned with 20 francs. I had a satchel [...] and I'd put my paints in,

but the brushes wouldn't go. So I broke them in half and was on my way.'[14]

The trip to Holland in the second half of June 1905 was made by train, with stops in Amsterdam, Haarlem and Alkmaar. Unfortunately, although he may have visited Amsterdam en route,[15] he missed the large Van Gogh retrospective there, which only opened in mid-July.[16] For the last leg of the journey, he changed to a boat in order to continue along the North Holland Canal until he reached the village of Schoorldam, near Schoorl, where Schilperoort was staying. Picasso found lodgings in a house that belonged to Dieuwertje de Geus, the daughter of the postman, and he was apparently given attic space above the café next door in which to work.

For the most part, during the weeks that he was in Holland, Picasso made drawings, some of them in sketchbooks, of his observations of local life, the houses along the canal, and his visits to the nearby towns of Hoorn and Alkmaar. Nonetheless, he did produce at least three large gouache compositions, including *Three Dutch Girls* (pl. 89)*, La Belle Hollandaise* (fig. 51) and *Nude in a Bonnet* (now lost). In the case of the first, he painted the girls, wearing wooden clogs, in front of one of the typically thatched cottages that line the canal. As Gerrit Valk pointed out, it was probably more than coincidence that he used the colours of the Dutch flag for their dresses.[17] Several postcards in the Archives Picasso, which the artist acquired on the trip, confirm that the bonnets and hat (worn by the central figure) were typical of the region. In contrast to the waif-like women in his Paris compositions, these Dutch girls are healthy and curvaceous.

According to some reports, his landlady Dieuwertje de Geus agreed to model for Picasso in his loft, and once

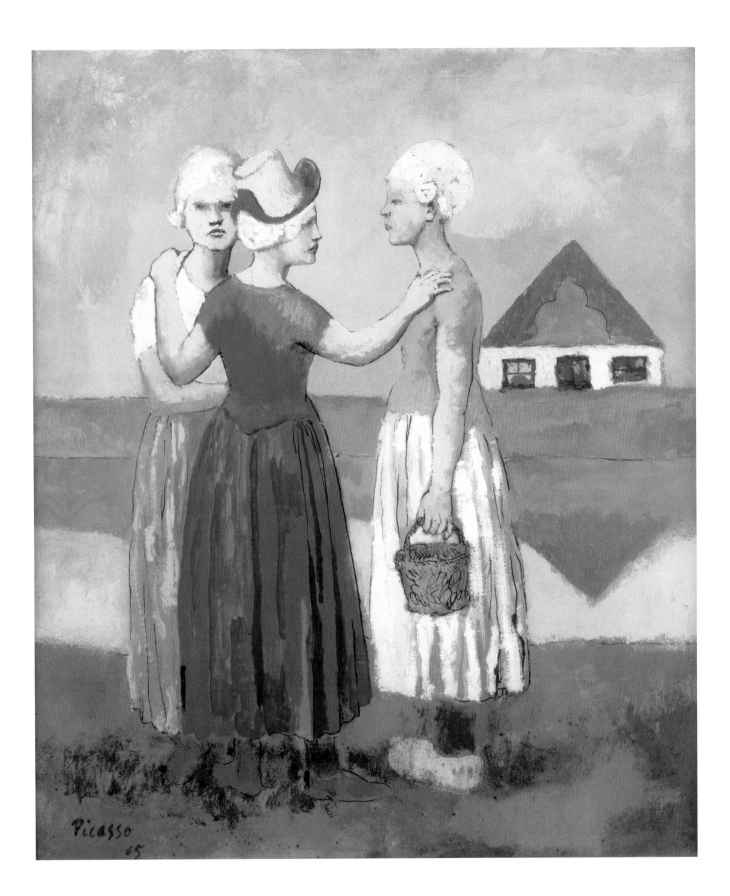

*Three Dutch Girls*
Schoorl, 1905
Gouache on paper, 77 x 67 cm
Centre Pompidou, Paris,
Musée national d'art moderne

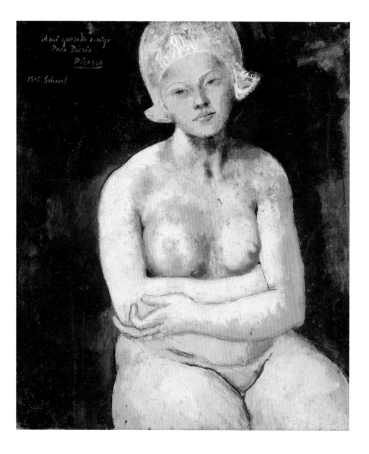

FIG. 51    *La Belle Hollandaise*
Schoorl, 1905
Gouache, oil and chalk on cardboard
mounted on panel, 77.1 x 65.8 cm
Queensland Art Gallery, Brisbane. Purchased
1959 with funds donated by Major Harold de
Vahl Rubin

the locals learned that she was posing nude, they were apparently openly displeased.[18] Picasso was not put off, and his painting *La Belle Hollandaise* represents a celebration of physical beauty, especially the young woman's voluptuous breasts.[19] In this work, Picasso built up layers of pink gouache as if he were creating the flesh through the medium itself, a combination of gouache, oil and chalk. His Dutch model wears a bonnet typical of the North, which Baedeker described (in 1905) as 'a broad band of silver gilt in the shape of a horseshoe across the forehead, serving to keep the hair back, and decorated at the sides with large rosettes or oval plates of gold. Above this is worn a cap or veil of rich lace, with wings hanging down to the neck.'[20] When Picasso later gave this gouache to his friend Durrio, it was probably in exchange for the facilities and help the sculptor would provide him in the following year.

The third gouache, *Nude in a Bonnet,* shows a standing nude wearing a similar cap, but the photograph of the work in Zervos's catalogue raisonné does not provide enough evidence for us to confirm whether the model can be identified as Dieuwertje de Geus or someone else. What we can tell is that in this composition the figure is portrayed out of doors, in what appears to be a lush wilderness rather than a typically flat, Dutch landscape. The plants and trees seem to be painted thinly, as if this were an exotic backdrop or stage set, transforming the local girl into a South Seas beauty *à la* Gauguin.

Picasso was amazed at the impressive stature of Dutch girls, 'the size of guardsmen,' he said.[21] In part, this accounts for the change in his approach to the figure in the gouache compositions that he took back with him to Paris.[22] On his return, a growing emphasis on monumentality and a new sense of weight in his figures can be detected in his compositions. One additional consequence of his time away: the experience of being alone in Paris and being jealous of the Dutch women to

FIG. 52    **Family of Saltimbanques**
Paris, 1905
Oil on canvas, 212.8 x 229.6 cm
National Gallery of Art, Washington DC.
Chester Dale Collection

whom Picasso was attracted seems to have encouraged Fernande to move in with him in the Bateau Lavoir once he was back.

Picasso was becoming aware of the radical new directions being taken by Matisse and his acolytes, and a sense of rivalry now prompted him to move in a new direction. In the years ahead, he would generally take a break, in Spain or by the sea, during the summer, and this would often act as a spur for a new development. The few weeks in Holland encouraged him to forge ahead. However, before abandoning his saltimbanques and circus scenes, Picasso had to finish the large composition known as *Family of Saltimbanques* (fig. 52), which he may have considered for submission to the autumn Salon. Drawings done before he went to Holland and additional notations in his Dutch sketchbooks suggest that during the summer he was still playing around with the arrangement and positions of the figures who make up the saltimbanque

family. Fernande remembered that he made changes to the composition,[23] and it is likely that his Dutch experience also played a part in the revisions he made to the final version, notably in the painting of the landscape, which resembles the range of sand dunes on the beach near Schoorl.

As it turned out, Picasso decided not to submit the large *Family of Saltimbanques* to the Salon, but chose instead to keep the canvas, which he ultimately sold in 1908 to André Level.[24] His decision not to show the work may have been prompted, as Richardson has suggested, by the increasingly strong competition he felt from Matisse.[25] The French painter's lively and colourful canvases were far more adventurous and modern, in the manner in which they were painted, than Picasso's more sedate, albeit poetic, painting of saltimbanques, which conjured up the example of compositions by artists of the past, including the seventeenth-century Le Nain brothers[26] as

FIG. 53 **HENRI MATISSE**
*Le Bonheur de Vivre*
1905-6
Oil on canvas, 176.5 x 240.7 cm
The Barnes Foundation, Merion, Pa.

well as Manet.[27] As it turned out, Matisse's *Le Bonheur de Vivre* (fig. 53) would be characterized by Charles Morice as 'the talking point' of the Salon des Indépendants in the following spring.[28]

At the end of 1905, Picasso did one more 'farewell' composition, a drawing entitled *The Death of Harlequin* (fig. 54). This scene may well have been inspired by a literary source, or even, as Reff pointed out, the funerary reliefs of Gothic sculpture or the lamentations of Renaissance painting.[29] On a personal level, *The Death of Harlequin* represented the last of the saltimbanques in Picasso's oeuvre, at least for the time being.[30]

Sales of Picassos at this period were done either directly from the studio, or handled by a few dealers, including Vollard, a small shop owner known as Père Soulier, and Clovis Sagot, but there would be no major exhibitions in Paris of Picasso's work until 1910.[31] Nevertheless, as Read has discovered,[32] in November

1905 Picasso's work was exhibited simultaneously at Vollard's gallery at no. 6 rue Laffitte and at Sagot's Galerie du XXème siècle at no. 46 on the same street. The ten canvases shown, including some featuring saltimbanques, must have represented recent purchases by the two dealers and indicate that Vollard had not lost sight of the artist he had shown in 1901.

Fernande describes how the unscrupulous Sagot, whose character she contrasts with the honourable Vollard,[33] would often drop in on Picasso to look at recent work and then drive a hard bargain for any purchases. Sagot had been quick to recognize the commercial potential of the saltimbanque paintings and had bought several in early February 1905.[34] Later that year, just after Picasso had returned from Holland, when he was in need of money to buy paints and canvases, he invited Sagot to the studio. 'He came in with Pablo,' Fernande reports, 'and decided on three quite large works: two gouaches Pablo

FIG. 54 **The Death of Harlequin**
Paris, 1905-6
Gouache over charcoal on cardboard,
68.5 x 95.7 cm
National Gallery of Art, Washington
DC. Collection of Mr and Mrs Paul
Mellon

had done in Holland [*Three Dutch Girls* and, presumably, *Nude in a Bonnet*] and a life-size painting of a little naked flower-girl with a basket of flowers. Sagot made an offer of 700 francs for the three, and when Picasso turned this down he left. [...] Anyway, after a few days we still desperately needed money, so Pablo decided to go back to Sagot and accept his offer. But Sagot said he had thought it over and that 500 francs was really the most he could give for the three pictures.'[35] She goes on to relate that Picasso returned to the studio empty-handed, but decided to go back and accept the offer. The wily Sagot then reduced the price to 300 francs, and Picasso was forced to accept.

One of the happier consequences of Picasso's relationship with the stingy Sagot was that it was through the sale at his gallery of the *Young Girl with a Basket of Flowers* (fig. 55) that he met the American brother and sister, Leo and Gertrude Stein. Sometime later, on their first visit to his studio, they also bought 800 francs worth

of pictures, 'far more than we ever dreamed possible', Fernande remarked.[36] Picasso was particularly taken with Gertrude, and he offered to paint her portrait, and that was the beginning of a close friendship. Stein later reported that over the course of the winter and spring (1905-6) she had posed for her portrait some 'ninety times',[37] and that she had 'come to like posing, the long still hours [...] intensified the concentration with which she was creating her sentences.'[38] She also famously noted that in the spring, Picasso painted out the head,[39] only to finish it without her present in the autumn (fig. 56).

Although others have challenged the veracity of Stein's claim that the portrait required ninety sittings,[40] we might also question whether, in fact, the painter, who only four years earlier had caused dismay among critics for painting up to three canvases a day, actually worked on the canvas over so many months. Recent technical studies have revealed that, indeed, the head was reworked

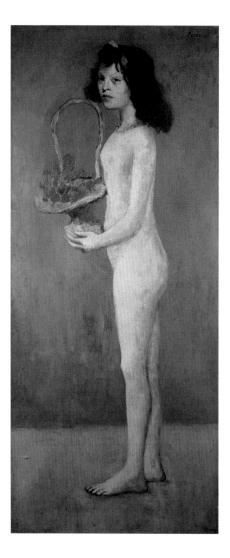

FIG. 55    **Young Girl with a Basket of Flowers**
Paris, 1905
Oil on canvas, 152 x 65 cm
Private collection

significantly, but that 'Picasso painted the initial portrait quickly and directly using a limited palette'.[41] Why then the reported frequency of the sittings? Surely, the occasion of the painting of the portrait had become a means of cementing a friendship between Stein and Picasso – and also with Fernande, who sometimes read out loud to Gertrude when she came to the Bateau Lavoir studio. 'Nobody remembers being particularly disappointed or particularly annoyed,' Stein recalled, 'at [the] ending to the long series of posings.'[42] The timing of the end of the sessions coincided with the departure in the late spring of Gertrude and Leo Stein for Italy, and Pablo and Fernande for Spain.

Over the next decade, Gertrude Stein and her partner, Alice Toklas, would become loyal patrons, and they also introduced Picasso to their literary circle as well as to other American collectors. Stein later remembered that their friend from Baltimore, Etta Cone, found Picasso and Fernande appalling but romantic: '[Etta Cone] was taken there by Gertrude Stein whenever the Picasso finances got beyond everybody and was made to buy a hundred francs' worth of drawings. After all a hundred francs in those days was twenty dollars. She was quite willing to indulge in this romantic charity. Needless to say these drawings became in very much later years the nucleus of her collection.'[43] Gertrude and Leo also held an artistic and literary salon at their home on the rue de Fleurus on Saturday evenings, and they observed among the regular guests that a rivalry between Picasso and Matisse was brewing.[44]

PL. 90    *Female Nude with Arms Raised*
Paris, 1907
Gouache on paper, 63 x 46.5 cm
Sainsbury Centre for Visual Arts,
University of East Anglia, Robert and Lisa
Sainsbury Collection, Norwich

PL. 91    **HENRI MATISSE**
***Standing Nude***
1907
Oil on canvas, 92.1 x 64.8 cm
Tate, London. Purchased 1960

PL. 92 **POLYNESIAN**
*Tiki*
Marquesas Islands (French Polynesia), 19th century
Wood, h: 72 cm
Private collection
Acquired by Picasso in 1907.

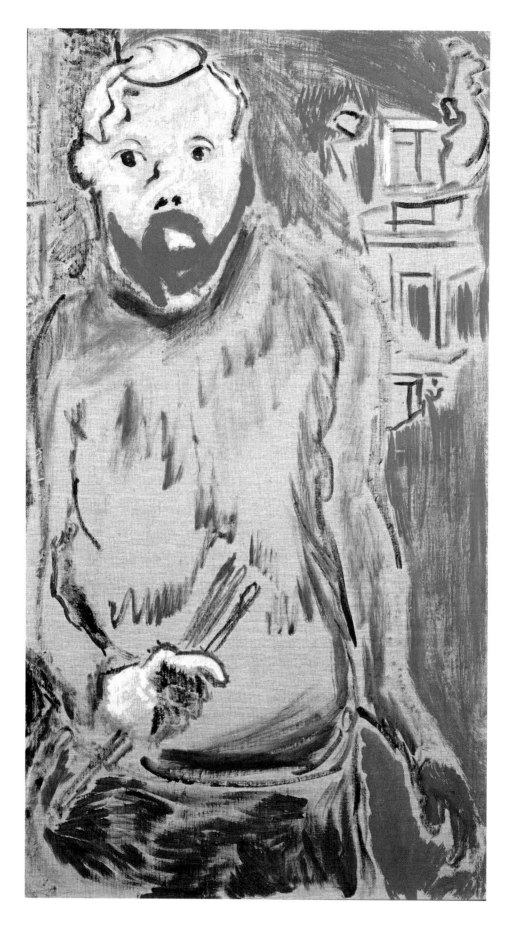

PL. 93    **ANDRÉ DERAIN**
*Portrait of Matisse in his Studio*
1905
Oil on canvas, 93 x 52.5 cm
Musée Matisse, Nice

**Gertrude Stein**
Paris, 1905-6
Oil on canvas, 100 x 81.3 cm
The Metropolitan Museum of Art, New York.
Bequest of Gertrude Stein, 1946

As an artist, Matisse would remain something of a benchmark for Picasso throughout his life, and his painting as well as his sculpture inevitably provoked a response in Picasso's art. They met in person for the first time in the spring of 1906, either at the Steins' apartment or at the Galerie Druet, where Matisse was exhibiting 55 paintings, along with sculptures, watercolours and other works on paper. Over the months that followed, both artists can be seen to have developed in a somewhat parallel fashion, particularly focusing on the exploration of new artistic means, although with quite different results, to represent figures in their work (pls. 90, 91). Another important and shared interest between them was the oeuvre of Gauguin, and they both visited and absorbed much from the Gauguin memorial retrospective at the Salon d'Automne in 1906. The so-called 'primitive' qualities that Gauguin had brought to his compositions would aid both Matisse and Picasso, in their handling of colour and space as well as of the paint itself, to simplify the human form to its essentials.

In addition to the evenings when they were both present at the Steins', Picasso, as Max Jacob reported, could sometimes be found at Matisse's studio. 'For a while, we used to go on Thursday evenings to Matisse's for dinner, Picasso, Salmon, Apollinaire and myself. I think it was at Matisse's that Picasso saw Negro sculpture, or at least he was struck by it, for the first time.'[45] Indeed, the Fauves' early acquisition of examples of African art, as well as Derain's experiments in sculpture, would become of special relevance over the coming months to Picasso's artistic investigation.

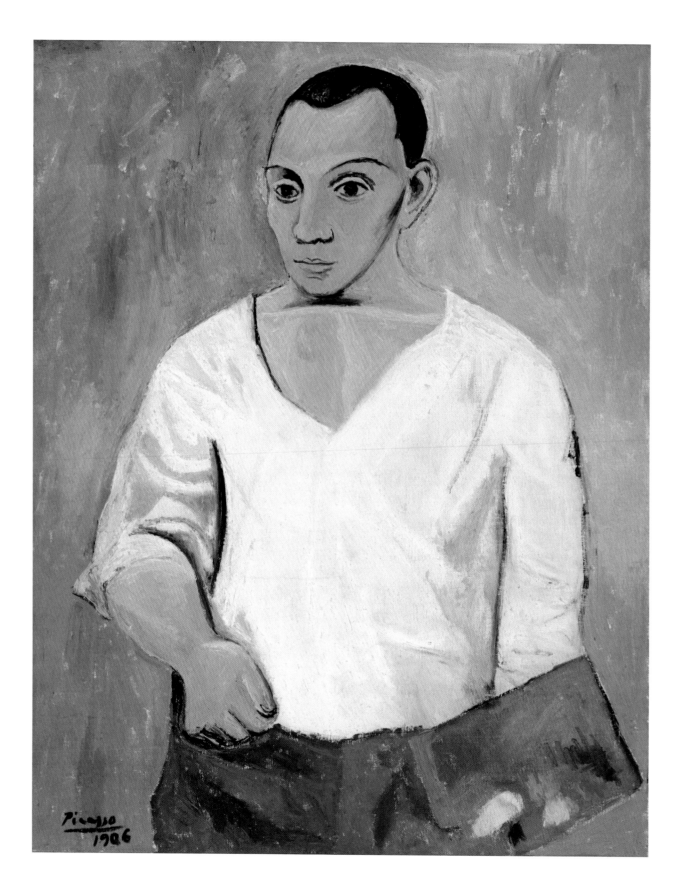

PL. 94    *Self-Portrait with a Palette*
Paris, 1906
Oil on canvas, 91.9 x 73.3 cm
Philadelphia Museum of Art. A. E. Gallatin Collection

# EATING FIRE

## MARILYN McCULLY

Early in 1906, Picasso went back, as it were, to source for his inspiration, that is, principally to older art. We know from Soffici that he had haunted the antiquities section of the Louvre, and early in 1906 an exhibition of recently discovered Iberian sculpture, also at the Louvre, especially attracted his attention. The archaic stone sculptures from Cerro de los Santos (Albacete) (pl. 96) and Osuna (an archaeological site not far from Picasso's birthplace, Málaga) called out to his sense of identity not only with Spain but with the arts of the ancient world. As a consequence, a significant shift in his choice of subjects and also in his palette and artistic approach occurred in his paintings. Now, he was less concerned than ever before with producing work that was 'in fashion' in Paris and concentrated on coming up with something true to his own vision, something that could carry with it an evocation of the origins of Western art, but in modern terms.

Drawings suggest that Picasso was considering carrying out new group compositions, but no longer in the guise of the saltimbanque families that had preoccupied him just months before. Ancient sources of inspiration, especially archaic *kouroi*, come to mind for the groups of boys with horses at a watering place which Picasso did in the spring of 1906 (fig. 57). As if trying the new subject out before beginning a large canvas, he started by producing a series of drawings, some with colour, and also prints, which generally show the figures in an outdoor setting. The absence of any specific reference to where the naked riders are, apart from a watering place for the horses, evokes an older time or place. While Picasso may have had Gauguin's primitive *Riders on the Beach* (1902;

 **The Watering Place**
Paris, 1905-6
Gouache on cardboard, 37.8 x 58.1 cm
The Metropolitan Museum of Art, New York. Bequest of
Scofield Thayer, 1982

private collection) in mind, what he wanted to do was to come up with a vision that was both classical and modern at the same time. In the case of a small *Boy on a Horse* (pl. 95), Picasso painted over another, earlier, composition, building up the surface with heavy white impasto.[1] While, in the end, Picasso never did a major group composition, his ideas came together in one large canvas focusing on a single figure, the *Boy Leading a Horse* (1906; Museum of Modern Art, New York).

Vollard was aware that Picasso's recent work was becoming increasingly marketable, and in the spring of 1906 he made the bold move of buying a group of 27 paintings and gouaches for 2000 francs.[2] For Picasso, not only did this windfall represent a boost of confidence, but the money allowed him and Fernande to leave Paris for the summer, and he was able to return to Spain for

the first time in two years. On this occasion, he decided to go to Gósol, a village high up in the Pyrenees, which had been suggested to him by a Catalan friend, the sculptor Enric Casanovas, as a place where he could work undisturbed in idyllic surroundings. After spending some days seeing family and friends in Barcelona, Picasso gathered together a supply of art materials, and he and Fernande made the arduous journey, some of it by mule, to Gósol. 'The village is up in the mountains,' Fernande wrote, 'above the clouds, where the air is incredibly pure, and the villagers – almost all of whom are smugglers – are friendly, hospitable and unselfish. We have found true happiness here. There is no one here for Pablo to be jealous of, and all his anxieties seem to have vanished, so that nothing casts a shadow on our relationship. [...] Pablo is in high spirits and likes to go off hunting with

PL. 95   *Boy on a Horse*
Paris, 1906
Oil on canvas, 50.5 x 31 cm
Private collection

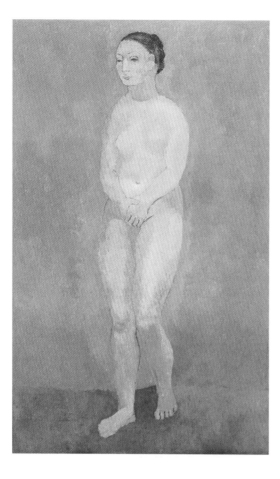

FIG. 58   **Nude with Joined Hands**
Gósol, 1906
Oil on canvas, 153.7 x 94.3 cm
The Museum of Modern Art, New York.
The William S. Paley Collection

the villagers or join them on excursion into the high mountains.'[3]

The many drawings and paintings that he did of Fernande reveal that having her so close and focusing on her as a model helped him develop his approach to the representation of the body. In Gósol the pink and reddish tones of the palette he used to paint Fernande, principally nude, began to infiltrate every aspect of the space and objects surrounding the figure (fig. 58). The implications of this change would be far-reaching: he realized that objects and space could be represented on an equal basis, and that three dimensions could be created from this new rendering of space and volume on a two-dimensional plane. This discovery would lead in just a few years to the most fundamental property of Picasso's revolutionary cubism.

While he was in Gósol, Picasso also began doing wood carvings, with the example of Gauguin very much on

his mind.[4] However, he lacked proper tools for carving, and he wrote to Casanovas asking him to send them, along with a new supply of paper.[5] In the meantime, he roughly carved pieces of wood that the villagers found for him. It appears that the tools never arrived, and Picasso and Fernande's sudden departure from Gósol because of a typhoid outbreak in the village meant that he had to postpone his plans for sculpture. However, once back in Paris, he continued his experiments by carving woodblocks to make prints, which recall Tahitian woodcuts by Gauguin.

Not surprisingly, given his friend Durrio's knowledge and collection of Gauguins, Picasso contacted him on his return from Gósol and asked for assistance with making more ambitious sculpture. Durrio's best known sculpture of this period was his *Head of a Youth* (pl. 97), which, like many of Gauguin's sculptures, was made of clay and fired as stoneware. The Basque offered Picasso space in his

PL. 96    **IBERIAN**
*Head of a Man*
Cerro de los Santos (Albacete), 3rd century BC
Limestone, 20 x 17.5 x 13 cm
Musée du Louvre, Paris (on deposit at Musée
d'Archéologie nationale, Saint-Germain-en-Laye)
In Picasso's possession 1907-11.

PL. 97    **PACO DURRIO**
*Head of a Youth* or *Head of an Inca*
First third of 20th century
Glazed stoneware, 30.6 x 16.5 x 18.7 cm
Museo de Bellas Artes de Bilbao

PL. 98    **PAUL GAUGUIN**
*Tehura*
1891–3
Painted and gilded pua wood, 22.2 x 7.8 x 12.6 cm
Musée d'Orsay, Paris

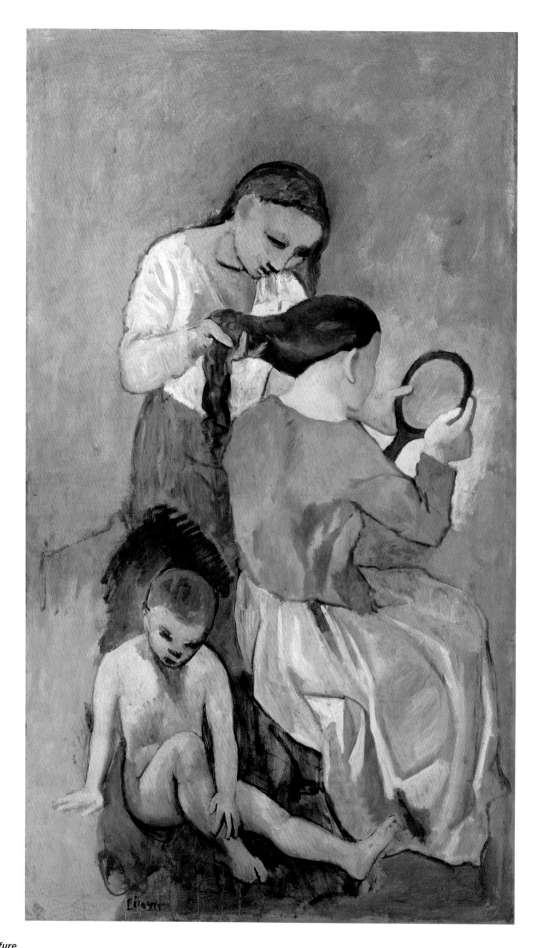

PL. 99    *La Coiffure*
Paris, 1906
Oil on canvas, 174.9 x 99.7 cm
The Metropolitan Museum of Art, New York.
Wolfe Fund, 1951; acquired from The Museum
of Modern Art, New York, Anonymous Gift

atelier and probably some technical advice concerning the potential of producing ceramic sculptures, as well as the use of the kiln for his experimentation. At least one ceramic original, *Woman Combing her Hair*, survives from this collaboration.[6] Although the sculpture was later cast in bronze (pl. 101), traces of glaze can still be seen on the surface, suggesting that the ceramic piece was intended to have colour. Even as a bronze, this three-dimensional work can also be related to drawings and paintings of the same subject. Considered as a group, the *Woman Combing her Hair* works (pls. 99, 100, 101, 102) reveal the dramatic strides that Picasso was making in the autumn of 1906, as if one medium could, as it were, lead to the next – drawing to sculpture to painting, or even in reverse order.

Another of the ceramic sculptures that Picasso worked on at Durrio's studio in the Maquis is a life-size and technically accomplished head of Fernande, which was also later cast in bronze (pl. 104). This portrayal, which can be related to the drawings and paintings that he had done of her in Gósol, emphasizes the beauty of Fernande's almond-shaped eyes and the overall structure of her head. In some respects, Picasso's delicate charcoal drawing *Fernande Olivier* (fig. 59) seems to have served as a template for the sculpture. The simplification and careful working of the facial features in the drawing correspond quite closely to the sculpture, while the rendering of the hair falling loosely at the back and on her shoulders is also remarkably similar in the three-dimensional form.

Picasso's *Self-Portrait with a Palette* (pl. 94), which was done in late 1906, represents yet another reformulation of his self-image – this time, with a nod to Cézanne. The older artist, whose death on 23 October 1906 was commemorated at that year's Salon d'Automne with an exhibition of paintings (and with a major retrospective at the Salon in 1907), would become increasingly important as Picasso moved closer and closer to achieving a completely new approach in his work. In *Self-Portrait with a Palette*, the modelling in paint of the figure extends into the space around him. In this way, Picasso evokes the example of Cézanne's portraiture, in which the placement of the figure in the composition is so often tied to its surroundings through colour and by the actual handling of the paint.[7] Related to Picasso's *Self-Portrait with a Palette* are a number of drawings that he made of himself, sometimes naked, and often in the acting of painting or drawing. In the *Self-Portrait* the palette is an extension of his hand: Picasso the artist is Picasso the creative force.

Over the next six months or so, Picasso worked with a fury, even though he was not, as far as we know, preparing for an exhibition. With Vollard's continuing acquisitions[8] and the Steins as patrons, he seems to have made enough money to support his effort. The Steins also stepped in to help him in the spring of 1907, by arranging for a second studio in the Bateau Lavoir, on a lower level, to be made available for him to paint on an even larger scale.[9] During this intense period of artistic activity, Picasso focused on images of the female nude, filling sketchbooks and numerous sheets of paper, and painting on both small and large canvases. Only occasionally do we find male figures, and these are either portraits – including a memorable one of Max Jacob (1907; Museum Berggruen, Berlin) – a sailor or a medical student, whom Picasso considered including in his largest composition of this series, *Les Demoiselles d'Avignon* (fig. 48), which was probably begun in the late spring of 1907 and finished in the summer.

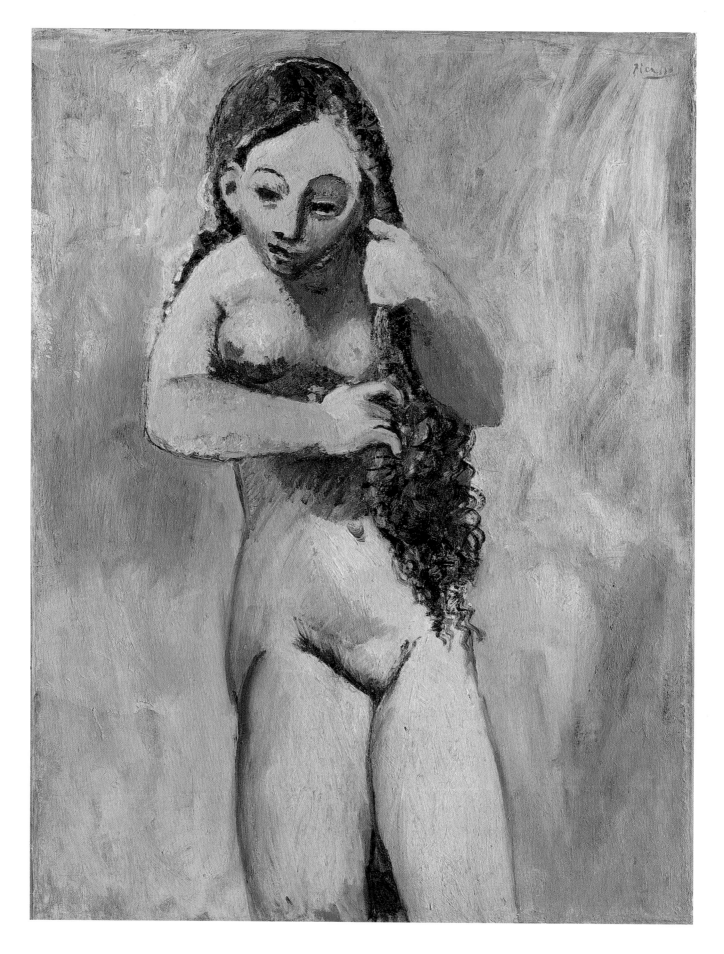

PL. 100    *Nude Combing her Hair*
Paris, 1906
Oil on canvas, 105.4 x 81.3 cm
Kimbell Art Museum, Fort Worth, Texas

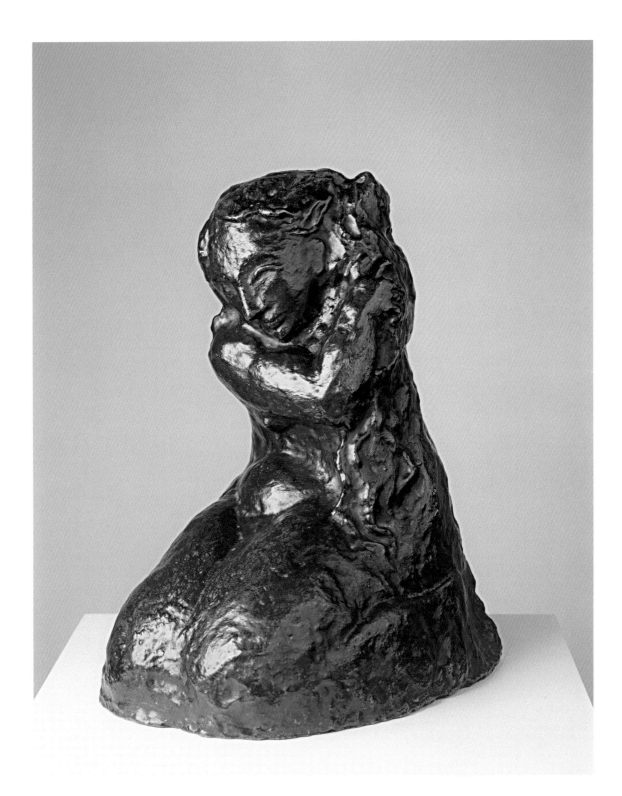

PL. 101   **Woman Combing her Hair**
Paris, 1906
Bronze, 42.2 x 26 x 31.8 cm
Museum Ludwig, Cologne

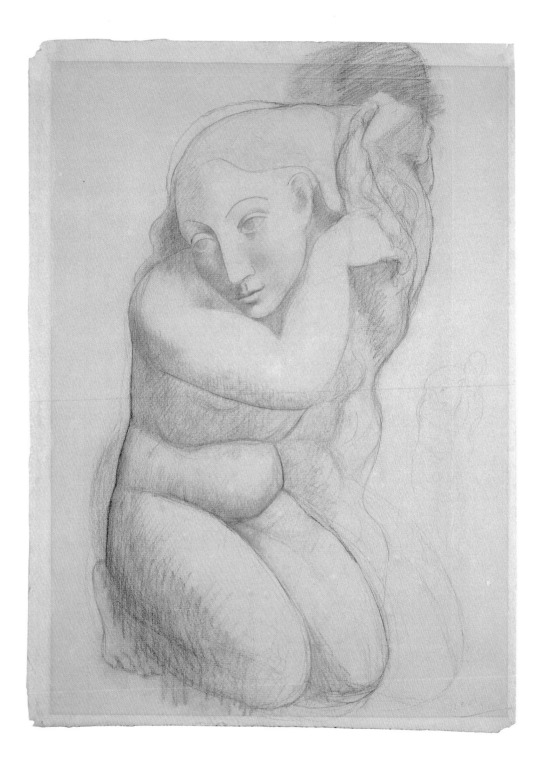

PL. 102    **Woman Combing her Hair**
Paris, 1906
Pencil and charcoal on paper, 55.8 x 40.7 cm
Sainsbury Centre for Visual Arts,
University of East Anglia, Robert and Lisa Sainsbury
Collection, Norwich

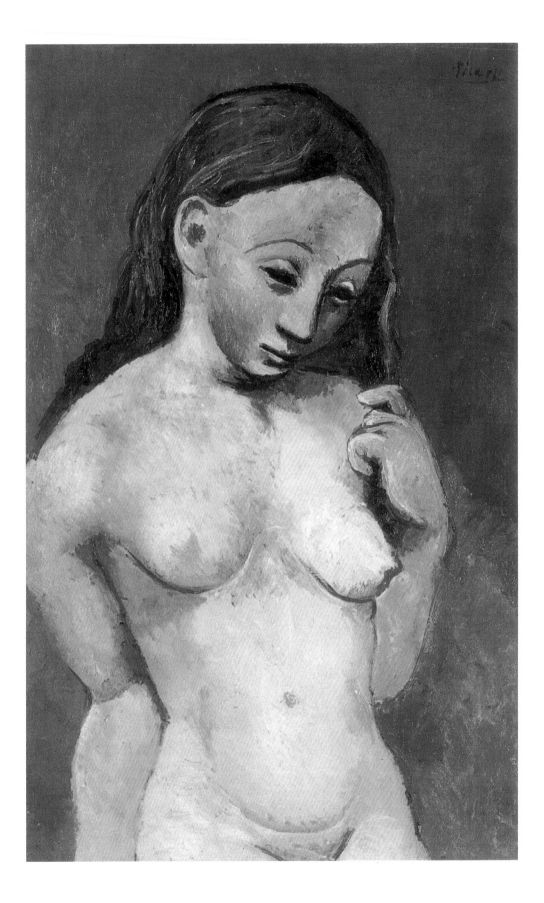

PL. 103   **Nude Woman on a Red Background**
Paris, 1906
Oil on canvas, 81 x 54 cm
Musée de l'Orangerie, Paris

FIG. 59 **Fernande Olivier**
Gósol, 1906
Charcoal with stumping on paper, 61 x 45.8 cm
The Art Institute of Chicago. Gift of Hermann Waldeck

Just as he had painted Fernande in front of a mountain in Gósol on a wooden bedstead (1906; Fundación Almine y Bernard Ruiz-Picasso para el Arte), Picasso also began to recycle pieces of wood both for sculptures and, especially in 1908, for paintings. In the case of the small *Doll* (pl. 107), a wooden carving that he did in the summer of 1907, he recycled a turned leg from a chair (the nail holes to fix it are still visible on the back). In its strictly upright frontality, the wooden figure has echoes in similar carvings from other cultures, notably American Indian dolls known as Kachinas, which were used to teach children the rituals of their spiritual lives. In Picasso's case, he gave this small doll to the daughter of his friend Antoinette Fornerod, who lived in the Bateau Lavoir.[10] Perhaps the most impressive of the series of wooden sculptures done in Paris in 1907 was the large *Head* (fig. 60): in its stylization and technique, like the woodcuts, this evokes Gauguin's 'primitive' ceramic sculptures and carvings in wood (pl. 98).

As recounted earlier, Max Jacob claimed that Picasso's discovery of tribal art at Matisse's studio had marked the beginning of his cubism,[11] but this overstatement leaves out many other contributing factors, for instance the role of Braque in that artistic journey. Moreover, Picasso's visit to the ethnographic collections in the Trocadéro Museum in the summer of 1907 was, for him, a revelation. In African and Polynesian sculptures (pl. 92) and, especially, masks, Picasso recognized the magical power of art, and he saw that what seemed rational in another culture could result in a significantly different way of representing man and his emotions. Spiritual ideas as well as life experience – for example, birth or death – could emanate from the transformation of the materials themselves, some of them quite ordinary, in contrast to the traditional Western approach to art as imitation.

The group of works surrounding the genesis of the *Demoiselles d'Avignon* (pl. 109) represented the

PL. 104    *Head of a Woman (Fernande Olivier)*
Paris, 1906
Bronze, 35.7 x 24.8 x 24.4 cm
Museu Picasso, Barcelona

PL. 105   **HENRI DE TOULOUSE-LAUTREC**
*Red-Haired Girl in a White Blouse*
1889
Oil on canvas, 60.5 x 50.3 cm
Museo Thyssen-Bornemisza, Madrid

PL. 106 **Study for *Woman with her Head Bent***
Paris, 1906
Pencil on paper, 31.5 x 48 cm
Staatsgalerie Stuttgart

FIG. 60    Wooden sculpture, *Head* (1907; Musée national
Picasso, Paris), among paintings and drawings
in the Bateau Lavoir studio
1908
Photograph by Picasso
Private collection

breakthrough that Picasso had sought in his work, and this was confirmed by the changes he made to the painting itself. Just as works by Cézanne (pl. 108), Gauguin and Matisse had provided him with alternative ways of representing the nude in space, African masks inspired a radical and aggressively new approach. Once he had absorbed what he had seen in the Trocadéro, he returned to the *Demoiselles* canvas, which was still in progress, and repainted, in a startling and 'African' manner, the heads of the figures on the right of the composition.

By no means all of the paintings done during the first half of 1907 were studies for the *Demoiselles*; rather, they were part of the whole intensive project that Picasso had undertaken, which culminated in that large composition. Just as ideas for earlier group compositions – the *Family of Saltimbanques* (fig. 52) in 1905 and *The Watering Place* (fig. 57) in 1906 – had generated other large-scale

and impressive single- or double-figure compositions, his work on the *Demoiselles* also gave rise to several memorable single- or multi-figure paintings. These ranged from a series of nudes in a forest, including *Three Figures under a Tree* (late 1907; Musée Picasso, Paris) and *Three Women* (1908; State Hermitage Museum, St Petersburg), which was acquired by Leo and Gertrude Stein, to the twin *Standing Nudes* (pls. 110, 111), which were done on some recycled wood from an old wardrobe in the spring of 1908. In these two compositions, the shape of the narrow panels themselves emphasizes the hieratic postures of the nudes. The generally earthen tonality that Picasso used both for the figures and for their surroundings relates to the wooden supports and has the effect almost of turning them into fetishistic objects. In all of these figure paintings Picasso was able to harness the power of his discoveries to his own vision of a woman who is created by the artist's hands and is as close to nature as her African

PL. 107   *Doll*
Paris, 1907
Carved wood, brass pins, traces of oil and gesso,
23.5 x 5.5 x 5.5 cm
Art Gallery of Ontario, Toronto

PL. 108 **PAUL CÉZANNE**
*Bathers*
c. 1890
Oil on canvas, 28 x 44 cm
Musée d'Orsay, Paris (on deposit at Musée Granet,
Aix-en-Provence)

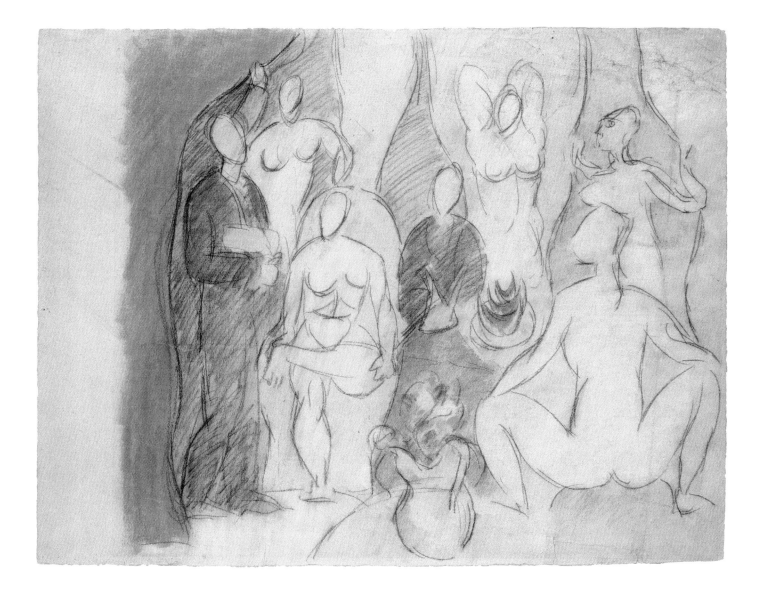

**Study for** *Les Demoiselles d'Avignon*
Paris, 1907
Pencil and pastel on paper, 47.6 x 63.7 cm
Stadt Basel (on deposit in Kunstsammlung Basel)

PL. 110    ***Standing Nude***
Paris, 1908
Oil on wood panel, 67 x 26.7 cm
Private collection

PL. 111  *Standing Nude with Upraised Arms*
Paris, 1908
Oil on wood panel, 67 x 25.5 cm
Private collection

PL. 112 **Nude with Raised Arms**
Paris, 1907
Pastel, black chalk and pencil on paper, 24 x 19 cm
Collection François Odermatt, Montreal

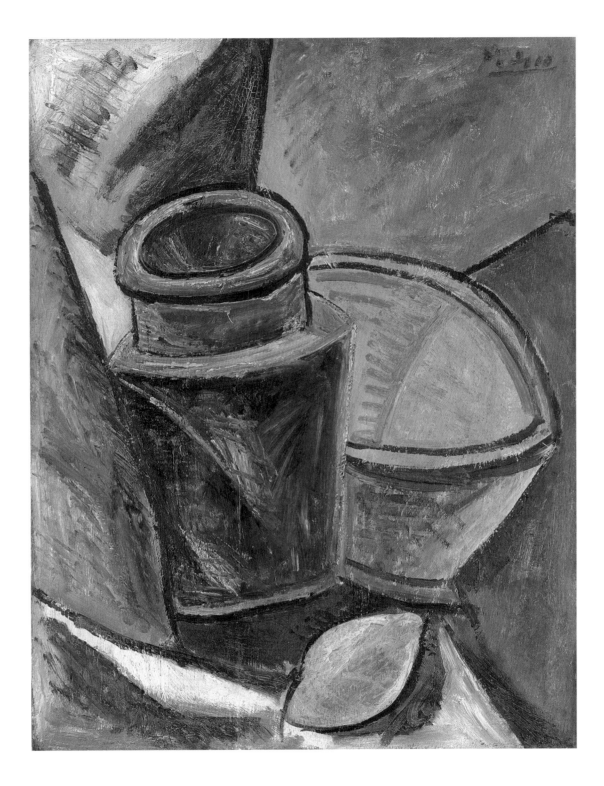

PL. 113    **_Carafe, Bowl and Lemon_**
Paris, 1907
Oil on panel, 63.5 x 49.5 cm
Fondation Beyeler, Basel-Riehen

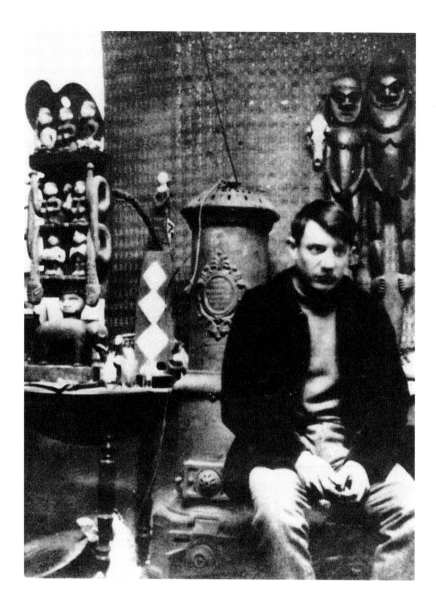

FIG. 61    Picasso in his studio in the Bateau Lavoir
1908
Photograph by Gelett Burgess
Musée national Picasso, Paris

sources. In other works that followed the *Demoiselles,*
the still life composition in the foreground of the painting
was the departure point for several remarkable still lifes,
including *Carafe, Bowl and Lemon* (pl. 113), in which
Picasso applied colour, marking and painting broad
strokes as if he were working on a piece of tribal art. The
shifting of perspectives, combined with the interior and
external views of the objects, also creates a sense of
internal energy that took Picasso's revolutionary approach
to the representation of objects in space into a new realm,
a development that ushered in cubism.

Based on accounts of witnesses who at one time or
another visited Picasso's studio during the genesis of the
*Demoiselles,* one has the sense that when he was ready
to show the canvas to his friends and collectors, he was
drained – every bit of physical and artistic energy had
been poured into the effort. Even Fernande had moved
out in September, finding the intensity of that creative
moment and its consequences on Picasso's state of
mind too difficult to share. Picasso wrote his old friend
Iturrino, with whom he had first set out to establish
his reputation in Paris in 1901, telling him about the

painting. The Basque painter replied, 'It made me very happy to receive your letter and you don't know how much pleasure it gives me to learn that you have been working for several *months* on a large work and that this painting will be different from the ones I know.'[12] Not all of Picasso's friends were quite as enthusiastic. When Apollinaire visited him, reportedly in the company of the critic Félix Fénéon, the poet apparently found the painting incomprehensible, and Fénéon is said to have advised Picasso to devote himself to caricature.[13] Others, including Salmon and Derain, were equally disturbed, and when Matisse brought the collector Sergei Shchukin to the studio, the Russian apparently exclaimed afterwards, 'What a loss for French Art!'[14]

—

Picasso had arrived in Paris in 1900 as a young, provincially trained Spanish painter. By 1907 he was challenging Matisse for the position of leader of the French avant garde. The way in which he had responded to the artistic milieu of the French capital and to specific artists along the way contributed to this transformation, but his work reveals that he was never an imitator. He had taken on board the discoveries and ideas of his contemporaries, as well as absorbing the rich and varied examples from the history of art, ancient and modern, that he was able to see in Paris in order to forge his own personal style. Ultimately, Picasso's approach was based upon a new kind of representation, drawing on the process of painting itself, which blurred the traditional distinctions between painting and sculpture, between imitation and reality. The focus of his art in 1907 would change the course of twentieth-century art, and, significantly, it was Georges Braque, with whom he would embark on the next stage of his artistic journey, who realized the far-reaching implications of Picasso's achievement. On seeing the *Demoiselles* for the first time, Braque remarked, 'With your paintings, it is as though you wanted to make us eat tow and drink kerosene!'[15] As an artist Picasso was leading the troupe by eating fire.

# NOTES

## PICASSO'S DISCOVERY OF PARIS

1   Although named as correspondents for *Catalunya artística* on 27 September 1900, neither Picasso nor Casagemas published any articles about the Exposition Universelle in the journal. Casagemas did write letters from Paris to the Reventós brothers back in Barcelona, and perhaps these were intended as notes for future articles.

2   Nonell and Canals shared an exhibition at the gallery of Le Barc de Boutteville on the rue Le Peletier in January-February 1898, while Nonell was featured in April 1899 at Vollard's on the rue Laffitte. Durand-Ruel organized an exhibition of works by Canals in his New York gallery in January-February 1902.

3   On 29 December 1900, a group of Spaniards (including Picasso, Casagemas and Pallarès) who called themselves the Spanish colony in Paris signed a manifesto, which appeared in the Barcelona journal *La Publicidad*, demanding amnesty for deserters from Cuba and the Philippines.

4   See Daix and Israël 2003.

5   'Hem considerat qu'ens llevavam massa tart, y per lo tant que menjavem a horas que no eran d'ordre y tot anava tal y com no devia anar. Ademàs que [...] l'Odette, comensava á embrutirse á causa d'alcohol, doncs tenia la bona costum de atrapar una mona cada nit. Per tant hem vingut en decidir que ni ellas ni naltres ens aniram al llit mes tart de la mitja nit; que acabariam de dinar cada dia avans de la una y, que després de dinar nosaltres nos aplicariam als nostres quadros y ellas farian feynes propres de la dona, tals cosir, netejar é besarnos é deixarse fort grapeijar. En fi amic meu, que aixó es una mena d'Eden ó d'Arcadia bruta.' Letter from Casagemas to Ramon Reventós, 11 November 1900 (Museu Picasso, Barcelona). Ocaña 1995, p. 319; trans. in McCully 1981, p. 31.

6   'Un sentiment vrai et douloureux vibre dans les *Derniers moments* de Ruiz Picasso'. Charles Ponsonailhe, 'La peinture étrangère', *L'Exposition de Paris*, vol. III, Paris 1900, pp. 202-3; trans. in McCully 1981, p. 25.

7   Notably absent from the Spanish section was Ramon Casas, who had submitted his large history painting *La Carga*, which was rejected. See Joan Brull's article complaining about the selection process, which he deemed to be political in its exclusion of Catalans and Basques from the Spanish section, in the Barcelona journal *Joventut*, 15 September 1901, pp. 593-5.

8   I am grateful to Rafael Inglada for making documentation, including comments made by members of Mañach's family, available to me from his unpublished study, which was presented as a lecture entitled 'Notícia de Pedro Mañach, el primer marxant de Picasso' at the Centre Picasso d'Orta, Horta de Sant Joan, in 2007.

9   According to Inglada, Mañach had studied the locksmith's and safe trade at the well-known firm of Fichet in Paris, before he opened the little junk cum antique shop that became the vehicle for his art dealing.

10  Berthe Weill claimed that, in addition to Picasso and Casagemas, Mañach, at one time or another, represented Nonell, Canals, Sunyer, Pichot, Torent, Iturrino and the illustrators Sancha and Gosé. Weill 1933, p. 65.

11  'Ja ha vingut el senyor qu'esperavam. Ha estat una pila d'estona aquí, ha vist els quadros y es segur qu'ens comprará algun. Ara estem esperant la contestació y'ls diners si es que n'ha comprat algun. El corredor es un tipo que's diu Mañac y que's cobre *només* el 20 per cent.' Letter from Casagemas to Cinto Reventós, 19 November 1900 (Museu Picasso, Barcelona). Ocaña 1997, p. 334.

12  Sabartés 1949, p. 48. Although a written contract is said to have existed, according to Inglada it disappeared from Mañach's possessions during the Spanish Civil War.

13  Picasso actually gave this drawing to his girlfriend Odette (spelled Odet in his inscription).

14  Maria Teresa Ocaña, in Ocaña 1997, p. 253, n. 5, has identified the *Blue Dancer* as the work Picasso referred to in a letter to Ramon Reventós of 12 October 1900 as the *Divan Japonais*. Ocaña adds that Virenque paid 150 francs for *L'Entrée de la plaza*.

15  Weill 1933, p. 67, identified this work only as 'a ravishing painting: child in a symphony of white, sold for 60 francs to M. Sainsère' ('une ravissante peinture: enfant dans une symphonie de blanc, vendue 60 francs à M. Sainsère').

16  Mañach organized Weill's inaugural exhibition (2-31 December 1901), which included jewellery by Bocquet and Durrio, paintings by Girieud and Launay, sculpture by Mlle Warrick, terracottas by Maillol and works by Raoul de Mathan, but nothing by Picasso.

17  Weill 1933, p. 65.

18  Eduard Vallès's recent discovery of the left-hand side of this drawing allows us to see the whole composition as it was originally intended, with a carriage and tall building completing the outdoor scene at the left. After cutting off this part of the drawing to please the new owner, a certain Vilaró, the story goes, Picasso re-signed the work in the lower left-hand corner. See exhib. cat., *Picasso versus Rusiñol*, Barcelona: Museu Picasso, 2010, pp. 82-3.

19  Among those who had painted the celebrated Montmartre dancehall were Renoir, Van Gogh, Toulouse-Lautrec and Ramon Casas.

20  See also Nienke Bakker's discussion of this painting in this catalogue, p. 85.

21  The Catalan sculptor Manolo Hugué also moved into the boulevard de Clichy studio when he arrived in Paris, just a few days before Casagemas's suicide on 17 February 1901.

22  'Els pastels [...] son tant sols un dels aspectes del talent d'en P, que sera molt discutit pero no menos apreciat [...]'. See Daix and Boudaille 1967, p. 333.

## THE 1901 VOLLARD SHOW

1   Mañach was probably responsible for submitting three works by Picasso to an exhibition held from 17 to 30 June (1901) at La Bodinière gallery on rue Saint-Lazare, which was organized by Adrien Farge, director of the short-lived journal *Art et littérature*. An expanded version of the show, with nine paintings and drawings (identified in the catalogue by titles, and, in some cases, medium) by Picasso, moved to the Villa Désiré in Dinard later in the summer (19 August – 30 September). Florence Rionnet reproduces two of Picasso's drawings that were included (*Self-Portrait* and *Portrait of Nonell*, c. 1900) in her article 'A la croisée des chemins: une exposition méconnue, Picasso à Dinard en 1901', exhib. cat., *Picasso à Dinard* (Dinard: Mairie de Dinard, 1999), p. 23.

2   Sabartés 1949, p. 51, says that the introduction to Vollard took place at the beginning of June 1901, just a little over three weeks before the opening of the exhibition. Vollard 1936, p. 219, remembered that Picasso had brought 100 works to show him on that occasion. This number seems exaggerated and probably refers to the whole body of work that he produced ahead of the show, including a few pastels and paintings that he had brought from Spain and other works that he had done since his arrival in Paris in mid-May.

3   In addition to group shows, including the Nabis (1898), individual exhibitions at Vollard's had included Van Gogh (1895), Cézanne (1895), Gauguin (1896), Van Gogh (1896-7), Cézanne (1898), Redon (1898), Gauguin (1898-9), Cézanne (1899 and again in early 1901).

4   'Tout autre est l'exposition juvénile, abondante, variée, "parisienne" de M. Pablo Ruiz Picasso.' Gustave Coquiot, *Exposition de tableaux de F. Iturrino et de P.-R. Picasso*, Paris: Galerie Vollard, 1901, p. 4.

5   Casagemas wrote Ramon Reventós on 25 October 1900 (Museu Picasso, Barcelona), 'Have you met Nonell yet? He's a nice guy, and he and Pichot are the only two decent ones around here. Today we met Iturrino who also seems to be a good guy.' ('Coneixes ja á en Nonell? es un xicot molt simpatico; ell y en Pichot son casi bé els dos unics tractables que rodaban per aqui. Avuy hem conegut á l'Iturrino que també 'm sembla qu'es una bona persona.') Ocaña 1995, p. 318.

6   Evenepoel's painting was acquired in 1899 by the Museum voor Schone Kunsten, Ghent; before his death in 1900, the artist had made sure it would be shown in Paris, and had also made a lithograph and poster after the painting, which popularized the Iturrino portrait even more widely; see Kosme María de Barañano and Javier González de Durana, *Francisco Iturrino: Obra gráfica*, Vitoria-Gasteiz: Argitartzailea, 1988, pp. 221-2.

7   Iturrino would show at Vollard's again in 1902, 1904, 1907 and 1911, but from 1902 he lived principally in Spain. Coquiot would include him along with Picasso in his book *Cubistes Futuristes Passéistes* (Coquiot 1914).

8   See note 2.

9   Among the artists who, at the same time, occupied studios on the boulevard de Clichy were Degas at 6, Gérôme at 65, Iturrino at 124 and Signac at 130. Fernand Cormon's studio school, which Van Gogh and Toulouse-Lautrec had attended in the 1880s, was also at 124.

10  Judging by the published list of works in the catalogue, Mañach had been successful in selling quite a few of them before the show opened, the largest number to Madame Besnard, who was, according to Daix and Boudaille 1967, p. 156, the wife of Picasso's supplier of artist's materials, L. Besnard, who had his shop on the rue de La Rochefoucauld.

11  The source for this is Félicien Fagus, La Revue Blanche, 15 July 1901, quoted on p. 47. Tinterow believes that Fagus's estimate of three paintings a day is an exaggeration (Tinterow and Stein 2010, pp. 34-6).

12  See, for example, Woman at the Theatre, which is on the back of the Absinthe Drinker (1901; private collection).

13  Although this painting is sometimes identified as a second portrait of Coquiot, Richardson 1991, pp. 199-200, has convincingly argued that the man portrayed is actually Vollard.

14  The portrait of Iturrino, which can be seen in a photo of Picasso, Mañach and the Spanish painter Torres Fuster in Picasso's studio (fig. 7), was ultimately covered over. An x-radiograph revealed that it is on the back of Girl Balancing on a Ball, (1905; Pushkin Museum, Moscow). See Anatoly Podoksik (who mistakenly identified Iturrino as Picasso's father), Picasso: The Eternal Quest, Leningrad: Aurora, 1989, pp. 148-9.

15  See, for example, Gauguin's Portrait of a Young Woman (pl. 69) or Van Gogh's 1889 portrait of Madame Roulin, La Berceuse (pl. 44). Tinterow notes a similar device in Seated Harlequin (autumn 1901; Metropolitan Museum of Art, New York) and points to the similarity of the background in that work to La Berceuse, which Vollard had purchased in 1900 (Tinterow and Stein 2010, p. 45). The allusion to Van Gogh would have been appropriate, since Coquiot was an enthusiast for the work of the Dutch artist; moreover, he claimed in his book Vincent Van Gogh (1923), that he had met Van Gogh in Paris in the mid-1880s.

16  Palau i Fabre 1980, nos. 500 (whereabouts unknown) and 565 (Heirs of the artist).

17  For a discussion of Picasso's practice of repainting in his early work, including the portrait of Mañach, see Ann Hoenigswald, 'Works in Progress: Pablo Picasso's Hidden Images', in McCully 1997, pp. 299-310.

18  Daix and Boudaille 1967, pp. 156-9, and Palau i Fabre 1980, pp. 247-57, have proposed some identifications, but many remain unconfirmed.

19  A few works, which were probably brought with him from Barcelona, referred to Spanish themes and were likely done in or near Madrid, including no. 4 Toledo, no. 33 Le Matador, no. 35 L'Arène, no. 43 Courses de village, no. 44 Eglise d'Espagne, no. 45 Village d'Espagne, and two portraits with Spanish titles, no. 53

Madrileña and no. 61 Carmen; in addition, three works seem to have been done in or near Barcelona: no. 42 Montjuich, no. 49 La Méditerranée and no. 50 Rochers.

20  'On démêle aisément, outre les grands ancêtres, mainte influence probable, Delacroix, Manet (tout indiqué lui, qui vient un peu des Espagnols), Monet, van Gogh, Pissarro, Toulouse-Lautrec, Degas, Forain, Rops, peut-être... Chacune passagère, aussitôt envolée que captée : On voit que son emportement ne lui a pas laissé le loisir encore de se forger un style personnel; sa personnalité est dans cet emportement (on conte qu'il n'a pas vingt ans, et qu'il couvrit jusqu'à trois toiles par jour). Le danger pour lui git dans cette impétuosité même qui pourrait bien l'entraîner à la virtuosité facile, au succès plus facile. Prolifique et fécond font deux, comme violent et énergique. Et cela serait tout regrettable, en face d'une si brillante virilité.' Félicien Fagus, La Revue Blanche, 15 July 1901. Fagus was rewarded by Picasso with a gift of Les blondes chevelures (1901; private collection), a painting that the critic mentioned in his review.

21  Daix and Boudaille 1967 believe that, apart from Waiting (Margot), they were done in Barcelona, while Palau i Fabre 1980 assigns them to Barcelona or Paris. Richardson 1991, p. 182, suggests that they may have been begun in Madrid but finished in Paris, and, more recently, Tinterow asserts that they were carried out in Madrid (Tinterow and Stein 2010, p. 34).

22  Sabartés 1949, p. 50, reports that Picasso disliked 'transport', that is, either sending or packing up and carrying his work, and that this was one of the reasons he had decided to return to Paris, in order to work there and to fulfil his contractual obligations to Mañach.

23  Steinlen was much affected by Zola's L'Assommoir (1877) and designed a poster for its dramatic adaptation in 1900. He also illustrated the novel Lourdes when it was serialized in Gil Blas Illustré in 1894.

24  Nonell, for instance, had initially been less impressed with Impressionist painting than he had with the works of Puvis de Chavannes, whom he called 'the greatest living painter' ('el mejor pintor en vida'), and also Whistler, Sargent and Carrière. Letter from Nonell to Raimon Casellas (3 March 1897), in 'Les anades de Nonell a Paris', D'Art, no. 2 (May 1973), p. 10. Later, Nonell became a convert to the work of Cézanne. Sunyer, who became friendly with the critic Gustave Geffroy, was also a great promoter of Cézanne as well as Renoir. See Rafael Benet, Sunyer, Barcelona: Polígrafa, 1975, p. 154.

25  Maurice Denis, 'Définition du Néo-Traditionnisme', Art de Critique, 23 and 30 August 1890.

26  'On a dit qu'à mes débuts à Paris je copiais Toulouse-Lautrec et Steinlen. Possible, mais jamais personne n'a confondu les toiles de Toulouse-Lautrec ou de Steinlen avec les miennes. Il vaut mieux copier un dessin ou un tableau qu'essayer de s'en inspirer, de faire quelque

chose d'approchant. Dans ce cas on risque de ne peindre que les défauts du modèle.' André Warnod, '"En peinture tout n'est que signe," nous dit Picasso' Arts, 29 June 1945; trans. in Dore Ashton, Picasso on Art: A Selection of Views, New York: Viking, 1972, p. 51.

27  Picasso reported in a letter to Ramon Reventós (11 November 1900) that he had stopped going to the brothel on the 'calle de Londres' because he was involved in his work. See Ocaña 1995, p. 319.

28  Information from Rafael Inglada.

29  In addition to poetry, Jacob was particularly interested in the occult and the Kabala, and he did a palm reading of Picasso's hands, predicting his future. See Read 1997 for a discussion of the French literature that Jacob and Picasso discussed together.

30  'J'allais les voir, Manach et lui ; je passais une journée à voir des piles et des piles de tableaux ! Il en faisait un ou deux par jour ou par nuit, et les vendait 150 francs à la rue Laffitte. Picasso ne savait pas plus le français que moi l'espagnol, mais nous nous regardions et nous nous serrions la main avec enthousiasme. Cela se passait dans un grand atelier, place Clichy, où des Espagnols assis par terre mangeaient et bavardaient gaiement. [...] Ils vinrent le lendemain tous chez moi, et Picasso peignit sur une grande toile, perdue ou recouverte depuis, mon portrait assis à terre, au milieu de mes livres et devant un grand feu.' Jacob 1927, p. 199; trans. in McCully 1981, p. 37. The painting of Max Jacob was, indeed, covered over; x-rays have revealed it underneath Mother and Child (1901; Harvard Art Museum/Fogg Museum). See Seckel 1994, p. 4.

31  Bernardó 2006, p. 226.

32  Ibid., p. 227. Viñes noted in his diary (29 April 1902) that the work, now known as Woman with Jewelled Collar, was originally exhibited at Berthe Weill's gallery that month with the title L'Hétaïre. This is one of two versions that Picasso made around the same time; the other is on long-term loan from the Art Gallery of Ontario to the Israel Museum, Jerusalem.

33  According to Jacques Lethève, Daily Life of French Artists in the Nineteenth Century, trans. Hilary E. Paddon, London: Allen and Unwin, 1972, p. 167, the artist Fabiano earned 5 francs a drawing for Le Frou-Frou (less 25 centimes for the receipt) in 1899. Presumably Picasso earned much the same.

34  In January 1902, Mañach organized a show at Berthe Weill's of works by illustrators, including Abel Faivre, Cappiello, Gosé, Hermann-Paul, Roubille, Sancha and Sem, though not Picasso.

35  Olivier 2001, pp. 174-5.

36  'Hi anàvem sovint. El propietari, el català Oller [...] em presentà als porters, i jo, en entrar, no feia sinó saludar. Moltes vegades hi anava acompanyat del critic Gustave Cocquiot [sic] i del pintor Bottini. Mai no vaig parlar amb Toulouse-Lautrec, el qual vaig veure molts cops en aquella casa.' Ferran Canyameres, Josep Oller i la seva època: L'Home del Moulin Rouge, Barcelona: Aedos, 1959, p. 201.

37 Tinterow points out that in addition to referring to Toulouse-Lautrec's familiar poster imagery, he also 'borrowed Lautrec's signature tonal shading, achieved using seemingly random splotches of color that function much like modern Ben Day dots.' (Tinterow and Stein 2010, p. 38)

## THE REPUTATION OF VINCENT VAN GOGH IN PARIS AROUND 1900

1 See, for example, the recent exhibitions *Picasso et les maîtres* (Paris, 2008), *Picasso: Challenging the Past* (London, 2009), *Picasso-Ingres* (Paris, 2004) and *Matisse-Picasso* (London/Paris/New York, 2002-3). Madeline 2006 is more concerned with finding parallels between the two artists than with exploring Van Gogh's influence on Picasso.

2 'le plus grand de tous'. Parmelin 1965, p. 126. 'Cézanne, il l'admirait; Van Gogh, il l'aimait.' Malraux 1974, p. 23; trans. in Malraux 1994, p. 16.

3 'When one starts a painting one never knows how it will turn out. When it is finished one still doesn't know. You might say that painting ripens until it's good enough to eat. Think of Cézanne, think of Van Gogh. People don't understand that *I'm* Van Gogh, right?' ('Quand on commence un tableau, on ne sait jamais ce qu'il va devenir. Quand il est fini, on ne le sait pas non plus. La peinture, on dirait qu'elle mûrit pour devenir bonne à manger. Voyez pour Cézanne, pour Van Gogh. Les gens ne comprennent pas que c'est moi, Van Gogh, non?') Malraux 1974, p. 114; trans. in Malraux 1994, p. 123.

4 'On s'est mis à parler peinture comme si c'était un concours, dit Picasso. C'est à celui qui "ira le plus loin". Mais qu'est-ce que ça veut dire, le plus loin?... Quand il s'agit de peinture, qu'est-ce que ça veut dire franchir le mur du son, avec une toile? Ça veut dire ne rien faire dessus? Faire n'importe quoi? Ou bien ça veut dire être Van Gogh?' Parmelin 1965, p. 102.

5 Drawings that Picasso 'signed' El Greco include *Yo El Greco* (1899; Museu Picasso, Barcelona).

6 Richardson 1991, p. 95.

7 J. van Gogh-Bonger and V.W. van Gogh (eds.), *Verzamelde brieven van Vincent van Gogh*. 4 vols. Amsterdam and Antwerp: Wereld Bibliotheek, 1952-4. Translated in its entirety into English (1958) and French (1960).

8 'Picasso parle tout le temps de Van Gogh, pense tout le temps à Van Gogh, [...]. Pour lui, Van Gogh est le peintre à la vie exemplaire, jusques et y compris la mort.' Hélène Parmelin, *Les Dames de Mougins*, Paris: Cercle d'Art, 1964, p. 106, trans. Christine Trollope in *Picasso says ...*, London: Allen & Unwin, 1969, p. 37. The story has it that Picasso carried a copy of a newspaper cutting about Van Gogh's self-mutilation around with him ('Chronique locale', *Le Forum Républicain*, 30 December 1888); he discovered this article during a visit to Musée Réattu in Arles in 1957 and asked for a copy of it. See Madeline 2006, pp. 78-9. This brief item reports that Van Gogh had presented his cut-off ear to a prostitute and that the 'pauvre aliéné' had subsequently been admitted to hospital.

9 During this period he also painted variations on masterpieces by El Greco, Velázquez, Poussin, Courbet, Delacroix, Manet and others. See Susan Grace Galassi, 'Picasso's "Old Master" Period', in exhib. cat. *Picasso: Challenging the Past*, London: National Gallery, 2009, pp. 109-39. Picasso had already depicted Arlésiennes in 1912 and 1937; this was a traditionally popular subject that both Van Gogh and Gauguin had portrayed.

10 'Die kwam daar om die Van Gogh schilderijen te zien. En toen hebben we één schilderij, maar ik weet nou niet meer welk, [...] van de muur gehaald, en dat wou hij buiten bekijken.' Interview with Johan and Anneke van Gogh, Wassenaar, 1 August 2003, by Sjraar van Heugten and Chris Stolwijk. Unpublished transcript (Van Gogh Museum, Documentation). With thanks to Roelie Zwikker for drawing this to my attention.

11 Penrose 1958, p. 75.

12 Gabriel-Albert Aurier, 'Les Isolés: Vincent van Gogh', *Mercure de France*, January 1890, pp. 24-9.

13 Octave Mirbeau, 'Vincent van gogh', *L'Echo de Paris*, 1 March 1891.

14 Emile Bernard published the following articles between 1891 and 1905 (collected in Bernard 1994): 'Vincent van Gogh', *Les Hommes d'Aujourd'hui*, no. 390 (1891); 'Vincent van Gogh', *La Plume* (1891); 'Vincent van Gogh', *Mercure de France* (1893); 'Notes sur l'Ecole dite de Pont-Aven', *Mercure de France* (1903); 'Paul Gauguin et Vincent van Gogh', *La Rénovation esthétique* (1905).

15 '...une unité qui, à la longue, le démontre très équilibré, très logique, très conscient. En des toiles dernières, d'aucuns virent la folie. Mais qu'est-elle lorsqu'elle se fait deviner sous la forme présente, sinon le génie?' Emile Bernard, 'Vincent van Gogh', *Les Hommes d'Aujourd'hui*, no. 390 (1891), in Bernard 1994, pp. 26-8 (p. 27).

16 See also Zemel 1980, pp. 62-73.

17 Van Gogh had work at the Salon des Indépendants in 1888 (3 paintings), 1889 (2 paintings), 1890 (10 paintings) and 1891 (10 paintings). In April 1892 Emile Bernard mounted an exhibition of 16 paintings and a few drawings in Galerie Le Barc de Boutteville.

18 The first exhibition in Vollard's gallery ran from 4 to 30 June 1895. The works were given on commission by the artists Paul Gauguin and Emile Schuffenecker and by Madame Grammaire-Aurier, the mother of Albert Aurier, who had died in 1892. See Rabinow 2006, pp. 51-3.

19 The second exhibition ran from December 1896 to February 1897. See Rabinow 2006, pp. 54-7.

20 'Le public ne montra guère d'empressement. Les temps n'étaient pas encore venus...' Vollard 1936, p. 62. French edition 1937 (Paris: Albin Michel), p. 80.

21 Although it has been asserted that Vollard got rid of all his Van Goghs 'in a fit of bad temper', his ledgers reveal that he continued to buy and sell Van Goghs regularly after 1897 (see Rabinow 2006, p. 58).

22 'Vincent avait l'ambition de se faire une place parmi les peintres du groupe des grands impressionnistes français et il reste à peu près le seul qui n'ait pas encore la réputation qu'il mérite. [...] La présentation des œuvres de Vincent chez Vollard a été toujours déplorable. [...] En quelques mois, nous pourrons faire une favorable agitation autour du nom de Vincent.' Julien Leclercq to Jo van Gogh-Bonger, Paris, 12 October 1900 (Van Gogh Museum, Van Gogh Family Archives, b4129 V/1984).

23 Bernheim Jeune 1901. In the end Jo van Gogh-Bonger did not lend any works, so Leclercq had to draw on French collections (Ambroise Vollard, the brothers Emile and Amédée Schuffenecker, Octave Mirbeau, Jos Hessel and Auguste Rodin are among those listed as owners).

24 'Ses souffrances physiques, qui furent réelles et ont amené des troubles passagers, n'ont jamais compromis sa conscience d'artiste. Elles l'ont exaltée, comme il est arrivé à d'autres qui avaient en eux l'essence du génie; elles ont sublimé ses facultés en usant sa machine humaine, certes, mais aussi en faisant de lui un visionnaire.' Bernheim Jeune 1901.

25 'En trois années [...] il accomplit une carrière prodigieuse et si personnelle qu'il prend une place bien distincte parmi les maîtres qui lui ont donné l'impulsion. [...] Ce nom [Vincent] évoquera des idées magnifiques de couleur.' Ibid.

26 Marcel Giry, 'Van Gogh and the Fauves', in exhib. cat. *Vincent van Gogh and Early Modern Art: 1890-1914*, Essen & Amsterdam 1990, pp. 267-72.

27 'Il faut aimer Vincent van Gogh et honorer toujours sa mémoire, parce que, celui-là, fut véritablement un grand et pur artiste...' Octave Mirbeau, 'Vincent van Gogh', *Le Journal*, 17 March 1901. See also Zemel 1980, pp. 84-8.

28 According to Anthony Blunt, Picasso had got to know Van Gogh's work through the Catalan painter Isidre Nonell, who supposedly introduced it in Barcelona, but he gave no source for this assertion. See Anthony Blunt and Phoebe Pool, *Picasso the Formative Years: A Study of his Sources*, London: Studio Books, 1962, pp. 11, 13-14. Further research is required into Van Gogh's reception in Spain, particularly among Picasso's friends Nonell, Casas and Rusiñol, who had all lived in Paris. So far, no explicit references to Van Gogh have been found in the Barcelona press of the time. In 1901 Octave Mirbeau's article in *Le Journal* about the Van Gogh show at Bernheim Jeune was, however, picked up by the critic Raimon Casellas (information kindly supplied by Teresa M. Sala, 17 March 2010). See Jordi Castellanos, *Raimon Casellas i el Modernisme*, vol. 2, Barcelona: Curial, 1983, p. 284, n. 24.

29 Richardson 1991, p. 172.

30 Bernheim Jeune probably had four of Van Gogh's paintings at that moment (Bernheim Jeune 1901). During the Paris Exposition of 1900 Leclercq showed 17 works from Jo van Gogh-Bonger's collection in his own house

in rue Vercingétorix, 'so that they can be shown to the many foreigners I know and who come to see me' ('afin de les montrer aux nombreux étrangers que je connais et qui viendront me voir'). See Chris Stolwijk and Han Veenenbos, *Account Book of Theo van Gogh and Jo van Gogh-Bonger*, Amsterdam: Van Gogh Museum & Leiden: Primavera Pers, 2002, p. 29; and letter from Julien Leclercq to Jo van Gogh-Bonger, 14 March 1900 (Van Gogh Museum, Van Gogh Family Archives, b1895 V/1962). However, there is nothing to indicate that Picasso had any contacts with Leclercq at this time.

31 Fernande Olivier, Picasso's companion from 1905 onwards, recalled that Vollard was always very secretive about his stock. Olivier 2001, p. 199.

32 Vollard bought Van Gogh's *Dance Hall at Arles* in 1897 and probably still had it in his gallery around the turn of the century. In 1908 the painting is listed as 'Collection Mme Michelot' in Paris (exhib. cat. 'Quelques œuvres de Vincent van Gogh', Galerie Druet, Paris, 6-18 January 1908). From Bernheim Jeune 1901 and Vollard's ledgers (Vollard Archives, Musée du Louvre, MS 421) we can deduce that between 1900 and 1905 he bought and sold or had in stock at least 24 works by Van Gogh. See also Rabinow 2006, pp. 48-59.

33 See Marilyn McCully in this catalogue, p. 47.

34 'On lui reprocha d'imiter Steinlen, Lautrec, Vuillard, Van Gogh, etc., mais tout le monde reconnaissait qu'il y avait là une fougue formidable, un éclat, un œil de peintre.' Jacob 1927, p. 199; trans. in McCully 1981, p. 37.

35 Vollard's ledger records the purchase of eight paintings from the Roulin family in 1900, probably including the following portraits: *La Berceuse* (F 505), a version of *Madame Roulin and her Baby* (F 491 or F 490), *Portrait of Armand Roulin* (F 492), *Portrait of Marcelle Roulin* (F 441a), *Portrait of Camille Roulin* (F 537), *Portrait of Madame Roulin* (F 503).

36 Richardson 1991, p. 221.

37 The Bernheim Jeune show included an 'Arlésienne (fond rose)' belonging to Vollard. See Bernheim Jeune 1901, p. 12. This was either the version in São Paulo (F 542) or the one in Rome (F 540). Clearly Toulouse-Lautrec's portraits of solitary drinkers and prostitutes in the bars of Montmartre were also an important factor in Picasso's choice of these subjects.

38 This exhibition, from 24 March to 30 April 1905, included, according to the catalogue, 36 paintings, some 10 drawings and an etching from French private collections and the art trade (some of them the same works that had hung in the 1901 show).

39 Hilary Spurling, *The Unknown Matisse: A Life of Henri Matisse, the Early Years, 1869-1908*, London: Hamish Hamilton, 1998, pp. 296, 330-2.

40 The rivalry between Jean-Auguste Dominique Ingres and Eugène Delacroix, the leading lights of neoclassicism and romanticism respectively, was legendary. The former emphasized line, the latter colour, and a debate raged in the French art world as to which of the two was pre-eminent.

41 'His taste in painting in those days tended towards El Greco, Goya and the primitives, and above all Ingres, whose work he loved to study in the Louvre.' ('En peinture, ses goûts d'alors le portraient vers le Greco, Goya, les primitifs, et surtout vers Ingres, qu'il se plaisait à aller étudier au Louvre.') Olivier 1933, p. 172; trans. Jane Miller in *Picasso and his Friends*, New York: Appleton-Century, 1965, p. 138.

42 Amsterdam, Stedelijk Museum, 'Tentoonstelling Vincent van Gogh', 15 July - 1 August 1905. Picasso passed through Amsterdam just two weeks before the opening of the exhibition (see 'The Widening of Picasso's Circle', note 16). He was very short of money, and staying in Holland longer may not have been an option.

43 Richardson 1991, p. 228.

44 Françoise Gilot and Carlton Lake, *Life with Picasso*, New York, London & Toronto: McGraw-Hill, 1964, p. 348.

45 'mon travail à moi j'y risque ma vie et ma raison y a fondrée à moitié'. Van Gogh Letters 2009, vol. 6, RM25.

## FRENCH ORIGINS OF THE BLUE PERIOD

1 'Grande es la impresión que recibo al contemplarme a través de ese maravilloso espejo "azul", que para mí es como un lago inmenso cuyas aguas tienen algo de mí, porque en ellas me he visto: porque lo he contemplado desde su formación y me ha mostrado un nuevo aspecto de Picasso en esa época que se inaugura en 1901, y me permite vislumbrar un nuevo horizonte que dirige mis ansias de infinito.
'Con ser uno de los primeros cuadros "azules", su sobriedad lleva la marca que se afianza en el curso de una "época", muy distinto de las otras de Picasso. La línea que encierra la idea es elocuente por su simplicidad. El gesto que plasma revela la impresión que sugiere al efecto la presencia del amigo sorprendido en su abandono.' Sabartés 1953, p. 74, first pub. in English in Sabartés 1949, pp. 63-4.

2 'La paleta está en el suelo: el blanco puesto en el centro, en cantidad abundante, constituye la base de esa especie de argamasa que compone sobre todo con azul. Los demás colores alegran el contorno. No recuerdo haberle visto nunca paleta en mano. Él me asegura que a veces la ha empuñado, como la empuña cualquiera. Es posible: pero yo siempre le he visto componer los colores agachándose sobre una mesa, una silla o el suelo.' Sabartés 1953, pp. 90-1, first pub. in English in Sabartés 1949, p. 78.

3 For a recent discussion of *The Blue Room* in the context of Degas, see Kendall 2010, p. 78.

4 *The Greedy Child* has sometimes been identified as the work described as no. 47 *L'Enfant blanc*, in the Vollard show. However, as argued here, the way this work was painted is more characteristic of the post-Vollard compositions. There are other possible candidates for no. 47, including *Little Girl with a Pendant* (1901; private collection) and *Little Girl with a Hat* (1901; Harvard Art Museum/Fogg Museum).

5 Baldassari also suggests that the inspiration for *The Greedy Child* may have come from a photograph of a child in a kitchen (*Die kleine Köchin*) on the back of a visiting card found among Picasso's possessions. See *Le miroir noir: Picasso, sources photographiques 1900-1928*, Paris: Réunion des Musées nationaux, 1997, p. 28, fig. 18.

6 Coquiot 1914, p. 148.

7 Robert Lubar, 'Barcelona Blues', in McCully 1997, pp. 87-101, also argues that the social concerns of Picasso and his generation in Spain were fundamental to his portrayal of poverty and subjects with political significance.

8 'Je vis alors dans son petit atelier du Boulevard de Clichy, non loin de Wepler, des toiles toutes différentes; je me souviens du portrait qu'il avait fait alors d'un peintre espagnol, qui venait de se suicider, sur son lit de mort et qui était une chose assez poignante.' Serrano 1996, p. 95.

9 Ibid., p. 19.

10 The most important of these are *Evocation (Burial of Casagemas)* (1901; Musée d'Art Moderne de la Ville de Paris) and *The Mourners* (1901; private collection). Tinterow notes that Picasso used the back of his poster design *Jardin de Paris* (pl. 35), to make a sketch related to the burial scene (Tinterow and Stein 2010, p. 38).

11 Several studies for the composition, including one in the Musée Picasso, Paris (M.P. 473), indicate that Picasso had originally considered portraying himself in the role of artist.

12 Palau i Fabre 1980, p. 277; Dr Jullien's name and address, 12 rue de la chaussée d'Antin (not far from Saint-Lazare), appears in one of Picasso's early address books (APP).

13 'Cree que el arte emana de la tristeza y del dolor. Estamos de acuerdo. Que la tristeza se presta a la meditación y que el dolor está en el fondo de la vida.' Sabartés 1953, p. 75, first pub. in English in Sabartés 1949, p. 65.

14 'Elle aussi par un grand geste désesperé etend les bras vides en avant et on voit ses mains, des bonnes mains solides d'ouvrière.' Van Gogh, letter to his sister Willemien, 19 September 1889; Vincent van Gogh Letters, vol. 5, letter 804.

15 See also Peter Read in this catalogue, pp. 164-71.

16 Picasso later told Daix that the show had gone very well. Daix and Boudaille 1967, p. 154. Vollard, however, claimed to have been disappointed both with the sales and the critical reception. Vollard 1936, pp. 219-20.

17 Sabartés 1949, p. 80, reported that Picasso and Mañach had become increasingly at odds and that the disagreements had to do with money. For further discussion and the speculation that sexual tension existed between them, see Richardson 1991, p. 231.

18 Jean-Paul Crespelle, *La vie quotidienne à Montmartre au temps de Picasso, 1900-1910*, Paris: Hachette, 1978, p. 219.

19 'luxuriante *Nature morte* [...] un éclatant, bruyant, criant *14 Juillet* réunit dans les plus papillotantes couleurs tout l'excessif mouvement, toute la vie intense d'une fête populaire.' Adrien Farge, *Tableaux et Pastels de Louis Bernard-Lemaire et de Picasso* (Paris: Galerie B. Weill, 1902); see Daix and Boudaille 1967, p. 334.

20 According to Inglada, after Mañach returned in 1904, he took over the family locks and safe business in Barcelona, where he eventually married and remained for the rest of his life.

21 Vollard 1936, p. 219.

### PICASSO SYMBOLISTE

1 Picasso travelled to Paris in the company of the sculptor Juli González and the painter Josep Rocarol. On their arrival Picasso first stayed in the vicinity of González's home in Montparnasse before moving to a hotel on the left bank.

2 Weill 1933, p. 83, says that the artists, whether they sold anything or not, had to pay Mañach 25 francs per work for his hanging of the exhibition.

3 'La boutique était aux dimensions de sa propriétaire c'est-à-dire très petite et basse de plafond, les tableaux étaient disposés de la plinthe au plafond, pour augmenter la surface de l'exposition.' Serrano 1996, p. 22.

4 Palau i Fabre 1980, p. 312, provides a list of the works that appeared in the catalogue of the November 1902 show.

5 'La fougue de M. P. R. Picasso a déjà été remarquée. Il a une ardeur inlassable à tout voir, à tout traduire.Il ne s'est pas emprisonné dans une manière, un genre. Il n'a point de procédés.' Daix and Boudaille 1967, p. 334.

6 'Tous quatre, citoyens de Montmartre ! Patrie de leur désir, atmosphère de leurs travaux et de leurs ambitions, de leur art. [...] Picasso, qui peignit avant d'apprendre à lire, semble avoir reçu la mission d'exprimer avec son pinceau tout ce qui est. On dirait d'un jeune dieu qui voudrait refaire le monde. Mais c'est un dieu sombre. Les centaines de visages qu'il a peints grimacent ; pas un sourire. Son monde ne serait pas plus habitable que ses maisons lépreuses.' *Mercure de France* 156, December 1902, pp. 804, 805; trans. in Daix and Boudaille 1967, p. 335.

7 Another, less familiar review, which was signed R.M. [Roger Marx] and speaks in generalities about the four exhibitors, appeared in *Chronique des Arts et de la Curiosité. Supplément de la Gazette des Beaux-Arts*, 29 November 1902.

8 Daix and Boudaille 1967, p. 58.

9 In a letter to Max Jacob, written from Barcelona in 1903, he says that he remembered 'with disgust' ('avec degout') the Spaniards on the rue de Seine. Seckel 1994, p. 20; trans. in McCully 1981, p. 41.

10 Picasso identified the Hôtel du Maroc drawings for Zervos in annotations he made to Zervos's *Dessins de Picasso*, which was published in 1949 (APP).

11 'Così girava di museo in museo nutrendosi di buona pittura antica e moderna ; e poichè anch'io facevo lo stesso, non era raro che c'incontrassimo al Lussemburgo nella saletta degli Impressionisti, o al Louvre, dove Picasso batteva di preferenza nelle sale terrene aggirandosi come un bracco in cerca di selvaggina fra le antichità egiziane e fenície, tra le sfingi, gl'idoli di basalto, i papriri e sarcofaghi dipinti a vivi colori.' Ardengo Soffici, *Ricordi di vita artistica e letteraria*, Florence: Vallechi, 1942, pp. 365-6; trans. in McCully 1997, p. 49.

12 See Tinterow and Stein 2010, p. 86, for a recent discussion of the impact of Puvis on Picasso during the early Paris years.

13 Toulouse-Lautrec famously parodied Puvis de Chavannes's *Sacred Wood* (1884; Musée des Beaux-Arts, Lyon) in a painting (Art Institute of Chicago), in which he includes himself and his fellow students at Cormon's studio in the sacred wood.

14 *Man Carrying a Sack* was one of three drawings that accompanied an article by Picasso's great friend Carles Junyer-Vidal, 'La pintura y la escultura allende los pirineos', in the Barcelona journal *El Liberal*, 10 August 1903, in which Junyer-Vidal notes that, 'Everyone is constantly talking about Puvis de Chavannes and his name is always put alongside those of Manet, Sisley, Pissarro, Monet and Degas, among others...' ('Se habla incessantemente de Puvis de Chavannes, y su nombre se junta, casi siempre al de Manet, Sisley, Pissarro, Monet, Degas y de otros...') For further discussion of the drawing in *El Liberal*, see Vivian Endicott Barnett, *The Guggenheim Museum: Justin K. Thannhauser Collection*, New York: Solomon R. Guggenheim Museum, 1978, pp. 123-6.

15 For a broad discussion of the influence of Puvis de Chavannes on Picasso, see Richard J. Wattenmaker, *Puvis de Chavannes and The Modern Tradition*, Ontario: Art Gallery of Ontario, 1975, pp. 168-77.

16 In the autumn of 1902, just before Picasso had departed for Paris, an exhibition was held at the Palau de Belles Arts in Barcelona that included more than 1,800 works of Spanish art, including Catalan Romanesque frescoes.

17 Sabartés recalled their visit to Durrio's studio and that 'there was much talk about Gauguin, Tahiti, the poem *Noa Noa*, about Charles Morice, and a thousand other such things.' ('Se habla de Gauguin, de Tahiti, del poema *Noa-Noa*, de Charles Maurice, y de mil cosas más por el estilo.') Sabartés 1953, p. 94, first pub. in English in Sabartés 1949, p. 80. An inventory of works in Durrio's collection in 1911 (many, if not all, of which he had acquired much earlier) reveals that he owned 18 paintings, drawings, prints and wood carvings by Gauguin, as well as one painting and one drawing by Van Gogh. See Kosme María de Barañano and Javier González de Durana, 'El Escultor Francisco Durrio (1868-1940), epistolario, catálogo y notas sobre su vida y obra', *Kobie*, no. V (1988), pp. 179-80.

18 Spies 2000, p. 24, compares the *Picador* to Rodin's *Man with a Broken Nose* (1863-4).

19 He moved from a studio on Riera de Sant Joan, which he shared with Angel de Soto, to Pablo Gargallo's studio on the Carrer del Comerç, which he occupied while the sculptor was in Paris.

20. Cada nueva producción del joven artista es un paso más que conduce el principio al fin: es una muestra de la vida superior, de la vida ascendente, toda vez que Picaso no es de esos que odían la imbecilidad, la rutina, la indiferencia – fases negativas de la economía social – sin lograr sustituirlas con nuevas afirmaciones. Lejos de eso, trabaja con fe, con entusiasmo, con ahínco, ahonda cada día más sus convicciones, y sus fuerzas estallan, chocan y señalan el fin de la jornada.
'Su honradez, dentro del Arte, son pocos, poquísimos los que la tengan. La habilidad que posee es pasmosa, y si se le antojase, podría producir mucho y vender bien. Pero él se sacrifica en este sentido y no quiere complacer el público gabacho. Singular ocurrencia la esos siniquitates en embrión, que consideran el Arte como un oficio o un pasatiempo, factible a todos.
'Téngase en cuenta que la labor de Picasso no hay que compararla con nada de lo que en este país se produce, es otra cosa, !entiéndanlo bien, profanos e inteligentes! 'Picasso vuelve a París dentro de brevísimo tiempo. Allí sí que ya puede ser juzgado y discutido.' See Palau i Fabre 1980, p. 516; trans. in McCully 1981, pp. 44-5.

### LA VIE DE BOHÈME

1 Crisanto de Lasterra, *En Paris con Paco Durrio*, Bilbao: T.G.Arte, 1966, p. 62.

2 Richardson 1991, p. 295, believes Junyer-Vidal paid the 15 francs per month rent of the studio.

3 Picasso was asked to become godfather to the Canals's son Octavi and did three drawings of the child in 1904-5.

4 Jean van Dongen would come into Picasso's life once again in the late 1920s, when he assisted him with his first experiments with the decoration of ceramic pots. Later still, in the 1930s, Picasso tried to hire him away from Maillol to work as an assistant in his sculpture studio.

5 See the list of residents at the Bateau Lavoir published in Jeanine Warnod, *Le bateau lavoir*, Paris: Mayer, 1986, p. 190, which was taken from the records in *Bottin* for the years 1892-1914. Max Jacob lived at no. 7 rue Ravignan from 1907 to 1911.

6 'Je rencontrai Picasso comme je rentrais chez moi un soir d'orage. Il tenait entre ses bras un tout jeune chat qu'il m'offrit en riant, tout en m'empêchant de passer. Je ris comme lui. Il me fit visiter son atelier. [...] Je fus étonnée devant l'œuvre de Picasso. Etonnée et attirée. Le côté morbide qui s'en dégageait me gênait bien un peu, mais me charmait aussi. [...] De grandes toiles inachevées se dressaient dans l'atelier où tout respirait le travail : mais le travail dans quel désordre... grand Dieu!' Olivier 1933 pp. 25-6; unpublished version trans. in Olivier 2001, p. 139.

7 For a discussion of works by Degas for which Benedetta may have modelled, see Kendall 2010, pp. 98-102.

8   Daix and Boudaille 1967, p. 238, have identified some of the works listed in the catalogue, including at least one painting, *Enclosure at Auteuil* (1901; private collection), which had been in Weill's exhibition in June 1902. In a review, signed R.M. [Roger Marx], in *Chronique des Arts et de la Curiosité. Supplément de la Gazette des Beaux-Arts*, 5 November 1904, mention is made of 'street scenes and interiors by M. Picasso' ('des scènes de la rue et des intérieurs de M. Picasso').

9   'Je vends bien de ci, de là, quelques Picasso, dessins ou peintures, mais ne puis arriver à subvenir à ses besoins, et j'en suis navrée, car il m'en veut; ses yeux me font peur et il en abuse!! Pour tenir, il faut que j'achète un peu à tous, avec un seul, cela ne serait pas possible; comment le lui faire comprendre?' Weill 1933, p. 85.

10  See McCully 1981, p. 41.

11  Ricard Viñes noted in his diary on 12 November 1904 that, at Picasso's request, he and his brother Pepe had gone to his studio, where they found him not only in need of money but 'extremely thin' ('molt escanyat'). He added that they gave him 30 francs in exchange for two Barcelona drawings, one of a country dance, *La jota* (1903; private collection) and the other of a beggar, *El loco* (1903-4; Solomon R. Guggenheim Museum, New York). Bernardó 2006, p. 228.

12  'A cette époque Picasso travaillait à une eau-forte maintenant célèbre : un homme et une femme sont assis devant une table chez le marchand de vins et de ce couple famélique se dégage une intense expression de misère et d'alcoolisme, d'un réalisme effrayant.' Olivier 1933, p. 26; trans. in Olivier 2001, p. 139.

13  Prior to this the only prints he had done were one engraving, *Picador*, in 1899 and a woodcut of a *Torero* in 1900.

14  Brigitte Baer, in Geiser/Baer 1990, p. 19, notes that several proofs were signed and dedicated to some of Picasso's friends and collectors, including the one he sent to Junyent, which is dated September 1904, and others to Canovas [Casanovas?], December 1904, Mlle Gatti, 1905, [Charles] Dullin, 1905, Ricciotto Canudo, and Guillaume Apollinaire, 24 March 1905. Baer also notes that Clovis Sagot later handled the sale of *The Frugal Repast*, and that the copies were printed according to demand. After the plate was steel-faced in 1913, Vollard issued a further edition, which was printed by Louis Fort.

15  '[gracias por] el aguafuerte porqué está muy bien hecho, me parece que en Paris venderéis muchos. Aquí es mas difícil, ya sabéis el arte que aquí prefiesen, sin embargo ensayaré de vender alguno. Os felicite también por la venta que me anuncias, algo es algo, y eso prueba que no todo ha de ser amargura. Todavía no hé entregado el aguafuerte à vuestro padre, lo haré à la primera ocasión.' Letter from Sebastià Junyent to Picasso, 26 December 1904 (APP).

16  Picasso wrote Jacint Reventós on [22] February 1905, '[...] in a few days I'm going to have a small exhibition.

God willing people will like it and I'll sell all I'm sending. Charles Morice is in charge of organizing it.' ('[...] dentro de unos días haré una pequeña exposición Dios quiera que guste mucho a la gente y venda todo lo que mando – Charles Maurice es quien se ha ocupado de organizarla.') See Palau i Fabre 1980, p. 516; trans. in McCully 1981, p. 51.

17  Gustave Serrurier-Bovy was an Art Nouveau architect and furniture designer, who had worked with René Dulong on the Pavillon Bleu restaurant at the Exposition Universelle. Serrurier, who was Belgian, had design showrooms for his furniture in Liège, Brussels, The Hague and Paris.

18  Postcard from Charles Morice to Picasso, 18 February 1905 (APP).

19  Exhib. cat. *'On est ce que l'on garde!': Les Archives de Picasso*, Paris: Musée Picasso, 2003, p. 188.

20  Degas did a number of compositions featuring Harlequin and other characters from the *commedia dell'arte*, many of which were inspired by the ballet based on Florian's *Les Jumeaux de Bergame*. See Theodore Reff, 'Harlequins, saltimbanques, clowns, and fools', *Artforum*, October 1971, pp. 39, 41 and n. 75.

21  *Mardi Gras* (1888; Pushkin Museum, Moscow). There are several other related Harlequins, including a large oil on canvas, *Harlequin* (1888-90; National Gallery of Art, Washington).

22  Palau i Fabre 1980, p. 396.

23  According to Tinterow, the painting was removed from the stretcher, and the canvas hung on the wall of the Lapin Agile, where it remained until 1912, at which time Frédé sold it to the dealer Alfred Flechtheim (Tinterow and Stein 2010, p. 70, where the photograph is also reproduced).

24  Sainsère wrote Picasso on 5 March 1905: 'Your exhibition is extremely interesting and I very much enjoyed seeing it. I would very much like to have your woman with a crow.' ('Votre exposition est tout à fait intéressant et j'ai très grand plaisir à la voir. J'aurais bien voulu avoir votre femme au corbeau.') And again, on 11 April 1905: 'I saw again with great pleasure your woman with a crow, which is so strange: be so good as to let me know how much I owe you.' ('J'ai revu avec grand plaisir votre si curieuse femme au corbeau: soyez assez aimable pour me dire ce que je vous dois.') (APP). Of the two versions Picasso painted of the *Woman with a Crow*, the first of which is in the Toledo Museum of Art, Ohio, Sainsère acquired the second, now in a private collection in New York. Daix and Boudaille 1967, pp. 255, 341, suggest that the Rue Ravignan painting may well have been the work known as *Rue Lepic* (1901; private collection), which is also titled *Rue Ravignan*.

25  On 13 February 1905, Picasso received a note from Suzanne Bloch, who was in Brussels, saying that she was flattered that her portrait would be in the exhibition (APP). The work is now in the Museu de Arte, São Paulo.

26  *Paysage de Montjuich (Espagne)* is likely the same work that was exhibited as *Montjuich* in the Vollard Show; see 'The 1901 Vollard Show', note 19.

27  'Les arlequins vivent sous les oripeaux quand la peinture recueille, réchauffe ou blanchit ses couleurs pour dire la force et la durée des passions, quand les lignes limitées par le maillot se courbent, se coupent ou s'élancent....
    'Les sœurs adolescentes, foulant en équilibre les grosses boules des saltimbanques, commandent à ces sphères le mouvement rayonnant des mondes. Ces adolescentes ont, impubères, les inquiétudes de l'innocence, les animaux leur apprennent le mystère religieux. Des arlequins accompagnent la gloire des femmes, ils leur ressemblent, ni mâles ni femelles.
    'La couleur a des matités de fresques, les lignes sont fermes. Mais placés à la limite de la vie, les animaux sont humains et les sexes indécis....' 'Les Jeunes: Picasso, peintre', *La Plume* 15 May 1905; trans. in McCully 1981, p. 52.

28  See Harriet Stratis, 'Beneath the surface: Redon's methods and materials', in exhib. cat. *Odilon Redon: Prince of Dreams 1840-1916*, Chicago: Art Institute of Chicago, 1994, p. 372.

29  'Vois-tu le personnage maigre et sauvage
    La cendre de ses pères lui sortait en barbe grisonnante
    Il portait ainsi toute son hérédité au visage
    Il semblait rêver à l'avenir
    En tournant machinalement un orgue de Barbarie
    Dont la lente voix se lamentait merveilleusement
    Les glouglous les couacs et les sourds gémissements'
    From 'Un fantôme de nuées', *Calligrammes* (1917), in Guillaume Apollinaire, *Œuvres poétiques*, ed. Marcel Adéma and Michel Décaudin, Paris: Pléiade, 1965; trans. in Roger Shattuck, *Selected Writings of Guillaume Apollinaire*, New York: New Directions, 1971, p. 161.

**'ALL FIELDS OF KNOWLEDGE': PICASSO'S ART AND THE INTELLECTUAL ENVIRONMENT OF HIS EARLY YEARS IN PARIS**

1   'Picasso, vêtu de ses "bleus" impeccables, peignait, la pipe aux dents, avec une méticuleuse attentive.' Raynal 1922, p. 44.

2   'On ne saurait imaginer quelle époque de ferveur ardente et contenue signifient dans l'art de Picasso les œuvres de la manière bleue. Je lui en ai vu peindre plusieurs. Il semblait tellement pénétré de son action qu'il paraissait comme s'incarner dans les sujets qu'il peignait. Armé, parfois, de petits bouts de pinceau, il avait l'air de tirer les lignes du carton ou de la toile comme avec une pince, et tout le dessin suivait docilement sa main; on eût dit qu'il le tenait en laisse. La rapidité avec laquelle il exécutait ses compositions, même les plus compliquées, témoignait chez lui d'une sorte d'état de transes d'autant plus inconscient qu'il semblait découvrir lui-même le monde nouveau que sa main réalisait.' Maurice Raynal, *Picasso*, Geneva: Skira, 1953, p. 28 (a version in English was published

the same year). Raynal was the son of a government minister. Pierre MacOrlan remembered him as a close and devoted friend of Alfred Jarry, and, from his hotel window overlooking the Bateau Lavoir, often watched Raynal, of melancholy demeanour, going in to visit Picasso. See MacOrlan 1955, pp. 178-9.

3   'Toutes les matières de la connaissance seront plus ou moins consultées, peut-être au hasard mais toujours en esprit, jamais à la lettre. Tour à tour poésie, littérature, philosophie, science, seront interrogées beaucoup plus sur le secret de leurs intentions que sur les réalisations obtenues. Aussi la poésie demeura certainement pour eux le symbole de l'imagination.' Maurice Raynal, *Peinture moderne*, Geneva: Skira, 1953, p. 90.

4   Read 1997.

5   'Enlève ta barbe […] Ote ton binocle, mets un monocle. Ne reste pas un employé. Vis comme un poète.' Picasso quoted by Max Jacob in June 1920, recorded in M. Martin du Gard, *Les Mémorables*, vol. 1, Paris: Flammarion, 1957, p. 105.

6   André Salmon, *Max Jacob poète peintre mystique et homme de qualité*, Paris: René Girard, 1927, p. 28.

7   André Warnod, *Fils de Montmartre Souvenirs*, Paris: Fayard, 1955, p. 159.

8   See Jeffrey Weiss, 'Bohemian Nostalgia: Picasso in Villon's Paris', in McCully 1997, pp. 196-209.

9   Jehan Rictus, *Les Soliloques du pauvre, édition revue, corrigée et augmentée de poèmes inédits*. Illustrations by A. Steinlen. Paris: P. Sevin et E. Rey, 1903. See Jehan Rictus, *Les Soliloques du pauvre*, ed. Denis Delaplace, Paris: Editions Classiques Garnier, 2009, which contains some of Steinlen's illustrations.

10  R.M. [Roger Marx], 'Petites expositions. A la Galerie Weill', *La Chronique des Arts et de la Curiosité. Supplément de la Gazette des Beaux-Arts*, 5 November 1904, p. 279. Louis Vauxcelles noted at the same exhibition that Picasso was showing 'a dozen curious studies of proletarian life in the suburbs, in which I sometimes thought I found a memory of Alexandre Steinlen.' ('une douzaine d'études curieuses de la vie prolétarienne des faubourgs, où j'ai cru trouver parfois un ressouvenir d'Alexandre Steinlen.') L. Vauxcelles, 'Notes d'art. Exposition Raoul Dufy, Picasso, Girieud et Clary-Baroux', *Gil Blas*, 9 November 1904, p. 1.

11  'décor médiéval'. MacOrlan 1955, p. 182.

12  'd'un délabrement, d'un dénuement tels, que je me demande à la réflexion si ce n'était pas un peu étudié.' Jules Romains, *Les Hommes de bonne volonté*, vol. XII, *Les Créateurs*, Paris: Flammarion, 1932, p. 164. Romains visited the Bateau Lavoir in around 1908.

13  Richardson 1991, chapter 21, 'The Apollinaire Period', pp. 327-49; Peter Read, *Picasso and Apollinaire The Persistence of Memory*, Berkeley, Los Angeles & London: University of California Press, 2008.

14  'Ils se trouvèrent immédiatement frères en cet amour de la liberté qui les animaient tous deux.' Raynal 1922, pp. 39-40.

15  'l'enfant chéri du Montparnasse d'alors et considéré à très juste titre comme le grand poète de l'époque et l'espoir de la Poésie, bien autant que sinon plus que Guillaume.' Jacob 1956, pp. 94-5. Max Jacob's memoirs were written in 1936-7 and were published with prints by Picasso in 1956.

16  'Tu me sacras Poète à la fin du banquet'.

17  'Picasso que nous rencontrons n'a pas exposé, il a sans doute d'excellentes raisons, nous regrettons cependant de ne point voir ici ses arlequins visionnaires, ses enfants prophétiques, ses fleurs pantelantes, ses mères douloureuses. Volland [sic] et Sagot plus heureux exposent quelques-unes de ses toiles poignantes entre toutes. Les peintres et les poètes ont le devoir de descendre rue Laffitte. On connaît trop le boulevard et pas assez la rue Laffitte, si proche, où il y a dix toiles de Picasso, qui sont l'apport le plus neuf de la peinture depuis dix ans, et chez Durand-Ruel un Greco incomparable que Madrid n'a pas su retenir.' André Salmon, 'Au Salon d'automne', *La Revue littéraire de Paris et de Champagne*, no. 32, November 1905, p. 490.

18  'Arthur Rimbaud' was in 1907 included in Salmon's best collection, *Féeries*. Rimbaud's *Œuvres*, including *Poésies*, *Illuminations* and *Une Saison en enfer* had been published by the Mercure de France in 1898, other poems appeared in *La Revue littéraire de Paris et de Champagne* in 1905, but his famous 'Lettre du Voyant' was published only in October 1912.

19  Young incomers 'enrichissent le patrimoine spirituel de leur nouvelle nation comme le chocolat et le café, par exemple, ont étendu le domaine du goût.' Guillaume Apollinaire, 'Giovanni Moroni', in Apollinaire, *Œuvres en prose*, vol. I, ed. Michel Décaudin, Paris: Pléiade, 1977, p. 320.

20  'l'Acropole Cubiste'. Jacob 1956, p. 25.

21  'Il poursuivait cet idéal de perfection dans le dessin qui a été le but de sa vie […] "Je ne sais pas si je suis un grand peintre, mais je suis un grand dessinateur."' Ibid., p. 95.

22  Daix and Israël 2003. Picasso himself stated that Olivier Sainsère, a Counsellor of State who started collecting his works in 1901 and later frequented the Bateau Lavoir, helped protect him from police harassment. See Daix and Boudaille 1967, p. 159.

23  'appel douloureux à toute la pitié humaine […] un profond et désespérant amour de l'humanité.' Olivier 1933, p. 27; trans. in Olivier 2001, p. 139.

24  Salmon's sympathetic history of the anarchist movement in France, dated 1957, was recently republished in a handsome illustrated edition, with a Preface by Jacqueline Gojard: André Salmon, *La Terreur noire*, Montreuil: L'Echappée, 2008.

25  Jacqueline Gojard, 'Mécislas Golberg et André Salmon: Du symbolisme expirant à l'école de la rue Ravignan', in Coquio 1994, pp. 335-46.

26  'Une quarantaine de personnes, plus ou moins groupées par tables, mais voisinant d'une table à l'autre. La fumée et la rumeur d'une salle ordinaire. Mais – pour être juste – une atmosphère beaucoup plus excitante. […] Des têtes de tous les âges et de tous les styles. Des costumes d'une élégance ou d'une étrangeté fort inégales. […] Peu de femmes.' Paul Fort, 'Grand nez, grands yeux, grosses moustaches.' Jules Romains, *Les Hommes de bonne volonté*, vol. IV, *Eros de Paris*, Paris: Flammarion, 1932, chapter XXII, 'Réunion à la Closerie. – Songes de Moréas', pp. 233-50. Jules Romains confirmed his own visits to the *Vers et Prose* evenings in his *Souvenirs et confidences d'un écrivain*, Paris: Fayard, 1958, p. 33.

27  Other artists who participated over the years included Severini, Modigliani, Derain, Charles Guérin and Othon Friesz. Rilke and Stefan Georg also attended. See Fort 1944, pp. 85-6.

28  'Tout cela, c'est du sentiment.' Henri Mahaut, *Picasso*, Paris: Crès, 1930, pp. 7, 9. In a café near the Trocadéro in Paris, when the poet Jean Royère got carried away with theorizing about Cézanne, Picasso put his gun on the table and warned, 'One more word and I'll shoot!' ('Encore un mot et je tire!') Jacob 1956, p. 69.

29  André Salmon in conversation with Roland Penrose, recorded in Elizabeth Cowling, *Visiting Picasso: The Notebooks and Letters of Roland Penrose*, London: Thames and Hudson, 2006, p. 156.

30  'le principe gréco-latin'. See letters by Moréas dated 13 September 1891 and 1899, addressed to newspapers, in Robert A. Jouanny (ed.), *Cent soixante-treize lettres de Jean Moréas à Raymond de La Tailhède et à divers correspondants*, Paris: Minard, 1968, pp. 148, 152.

31  'Monsieur Picasso est un homme très bien.' Raynal 1922, p. 37.

32  'Moréas affectait de mépriser les peintres.' André Salmon, *Propos d'atelier*, Paris: Crès, 1922, p. 264.

33  'Dites-moua. Picasso, est-ce que Vélasquez avait du talent?' Olivier 1933, p. 48; trans. in Olivier 2001, p. 171.

34  'Un soir, Moréas répéta pendant une heure à intervalles réguliers: "Don Pablo Picasso de Ségovie!" avec son sublime croassement. Picasso prit violemment sa casquette et me dit: "Bamanos!" ce qui signifie en Espagnol, paraît-il, "Allons-nous-en!" et qu'Apollinaire traduisait "Barrons-nous!"' Jacob 1956, p. 94.

35  'le Poète parfait'. Guillaume Apollinaire, 'Jean Moréas', *Revue de la vie mondaine*, 10 May 1910, in Apollinaire, *Œuvres en prose complètes*, vol. II, ed. Pierre Caizergues and Michel Décaudin, Paris: Pléiade, pp. 1031-4.

36  Golberg praised Moréas for creating a post-Symbolist aesthetic which was 'Greek in expression and contemporary in content […] wisdom couched in well chosen words and well made phrases' ('Cette nouvelle forme, grecque par l'expression et contemporaine par le fond […] la sagesse commentée par des mots justes et en phrases bien faites.') Mécislas Golberg, *Deux poètes: Henri de Régnier et Jean Moréas*, Paris: Editions de La Plume, 1904, pp. 22, 28. The cultural and political significance of neoclassicism in France and Catalonia is documented and explored by Marilyn McCully in her

essay 'Mediterranean Classicism and Sculpture in the Early Twentieth Century', in Elizabeth Cowling and Jennifer Mundy (eds.), exhib. cat. *On Classic Ground: Picasso, Léger, de Chirico and the New Classicism 1910-1930*, London: Tate Gallery, 1990, pp. 324-32.

37 Fort 1944, p. 97. Fort also claimed that they would meet Marie Laurencin, Braque, Derain and Utrillo at the Au Téléphone café.

38 'les bons dîners de Fernande Olivier'. Fort 1944, p. 101. According to Salmon, 'Picasso enjoyed Paul Fort's company; he showed infinite respect towards Moréas.' ('Picasso goûtait la compagnie de Paul Fort; il témoignait infiniment de considération à Moréas.') Salmon 2004, p. 228.

39 Fort 1944, p. 104, recalled 'le charmant cœur de Marguerite, sa fine et douloureuse poésie, et ses larges yeux verts, et ses longs cheveux d'or' ('The charming heart of Marguerite, her refined and sorrowful poetry, and her big green eyes, and her long golden hair'). That description is confirmed by Gillot's portrait in Marie Laurencin's 1909 painting *Guillaume Apollinaire and His Friends* (Centre Pompidou, Paris, Musée national d'art moderne), where she appears third from the left. This may have been painted after Fort took his wife and daughter to live in the countryside in Senlis. Marguerite left him there and returned temporarily to Paris. Fort 1944, p. 105.

40 Olivier 2001, p. 187.

41 Picasso also caricatured himself as a mischievous monkey with a paintbrush behind his ear, in an ink drawing dated 1 January 1903 (Museu Picasso, Barcelona). Other works by Picasso featuring apes and monkeys included his Paris oil painting *Clown with a Monkey* (1901; private collection) showing the monkey dressed like a little man, holding the clown's hand, like a toddler with a parent, and *The Monkey* (1905; Baltimore Museum of Art. The Cone Collection), an ink drawing of a seated ape on a pale blue, marbled watercolour background. In 1951 he made his sculpture *Baboon and Young* using found objects including two toy motor-cars.

42 'Son naturalisme amoureux de précision se double de ce mysticisme qui en Espagne gît au fond des âmes les moins religieuses.' G. Apollinaire, 'Picasso, peintre et dessinateur', *La Revue immoraliste*, April 1905, in Guillaume Apollinaire, *Œuvres en prose complètes*, vol. II, p. 78.

43 'L'enfant rapproche du père la femme que Picasso voulait glorieuse et immaculée. [...] Noël! Elles enfantèrent de futurs acrobates parmi les singes familiers, les chevaux blancs et les chiens comme les ours.' G. Apollinaire, 'Les Jeunes. Picasso, peintre', *La Plume*, 15 May 1905, in G. Apollinaire, *Œuvres en prose complètes*, vol. II, p. 21. See Guillaume Apollinaire, *The Cubist Painters*, trans. with commentary by P. Read, Berkeley, Los Angeles: University of California Press, 2004, p. 34.

44 Fernande Olivier found the frequent visits frightening (Olivier 2001, p. 202). Max Jacob recalled Manolo and

Picasso teasing the lions through the bars of their cages, like orang-outangs taunting lions from the safety of a tree (Jacob 1956, p. 68).

45 Joseph Deniker, *Recherches anatomiques et embryologiques sur les singes anthropoïdes. Fœtus de gorille et de gibbon comparés aux fœtus humains et aux anthropoïdes jeunes et adultes*, Paris: C. Reinwald, 1886. Deniker's observations confirmed T. H. Huxley's controversial findings on anatomical similarities between human beings and primates in his *Evidence as to Man's Place in Nature* (1863), translated as *De la place de l'homme dans la nature* (1868).

46 Salmon 1912, p. 42. The roses in the wallpaper may have been added at the same time.

47 'Les roses? D'après une image de première communion offerte par une gosse de la place Ravignan.' André Salmon, 'La Jeunesse de Picasso', *Les Nouvelles littéraires*, 11 July 1931, p. 8. In this article, Salmon states that Picasso and his friends were at the Azon restaurant, rue des Trois-Frères, when he suddenly rushed off to finish the painting.

48 Richardson 1991, p. 340.

49 See Salmon 2009, pp. 66-73.

50 'un affreux petit personnage séduisant, un atroce et gracieux petit criminel, un franc ami du mal et peut-être innocent, au cas, pas impossible, que tout est écrit là-haut, en lettres de feu, de toute éternité.' André Salmon, 'Véritable clé d'un domaine imaginaire', Postface in Salmon 2009, pp. 265-317 (p. 305). Salmon's 'key' to his novel was written in 1953 and published in 2009.

51 Salmon 1912, p. 42.

52 Salmon 2009, pp. 72-3.

53 'A peu près l'apparence de l'artiste lui-même aux heures de travail'. Salmon 1912, p. 42.

54 'Plus les peuples sont civilisés, plus ils sont mélangés entre eux dans certaines limites territoriales.' Joseph Deniker, *Les Races et les peuples de la terre. Eléments d'anthropologie et d'ethnographie*, Paris: Schleicher frères, 1900, p. 4. The book contains 176 illustrations and two maps.

55 Christopher Green, *Picasso: Architecture and Vertigo*, New Haven & London: Yale University Press, 2005 (especially chapter 3, 'Looking for Difference: the *Demoiselles d'Avignon* again').

56 Georges Deniker, born in 1889, was also a sculptor, dubbed by Apollinaire 'the youngest cubist in France'. See Guillaume Apollinaire, *Correspondance avec les artistes 1903-1918*, ed. Laurence Campa and Peter Read, Paris: Gallimard, 2009, pp. 705-9.

57 Anne Baldassari has suggested that these photographs provided models for *Les Demoiselles d'Avignon* and other works. See Anne Baldassari, exhib. cat. *Picasso and Photography: The Dark Mirror*, Houston: Museum of Fine Arts / Paris: Flammarion, 1997.

58 See Sophie Dulucq, 'L'Afrique noire, laboratoire d'anthropologie sociale d'un libertaire', in Coquio 1994, pp. 233-42.

## THE WIDENING OF PICASSO'S CIRCLE

1 'Max Jacob, Apollinaire venaient chaque jour et Max, si spirituel, si amusant, si plein de vie, de dynamisme, était le dispensateur de nos jeux. Picasso et Guillaume pouvaient rire toute une soirée des propos, des inventions, des chansons, des jeux de physionomie de Max. L'atelier qui se remplissait peu à peu retentissait de nos rires.' Olivier 1988, p. 193; trans. with additional unpublished sentence in Olivier 2001, pp. 164-5.

2 Richardson 1991, p. 349, says that the head was modelled in clay in Durrio's studio; Spies 2000, p. 394, however, claims that the original was done in wax.

3 Olivier 2001, p. 170.

4 'Durrio était tout petit, tout rond, curieux, d'un tempérament solide, original, artiste, sincère, amoureux de l'art. Un vrai cœur humain. [...] Il avait été un grand ami de Gauguin au temps où ils habitaient tous deux rue de la Grande-Chaumière avant le départ de Gauguin pour Tahiti.' Olivier 1933, p. 28; trans. with additional unpublished material in Olivier 2001, p. 163.

5 'il partageait les frais avec Etchevarria, Pichot et Anglada qui étaient plus fortunés.' Olivier 1933, p. 29 ; trans. in Olivier 2001, p. 163.

6 Olivier 2001, p. 170.

7 Raynal was also a friend of Jacob and Apollinaire, with whom he signed a card from Honfleur to Picasso, dated 4 August 1905 (APP). Raynal's *Picasso* appeared in 1921 (Munich: Delphin Verlag).

8 Olivier 2001, p. 172.

9 'l'acte pur de peindre'. Maurice Denis, *Du symbolisme au classicisme: Théories*, ed. Olivier Revault d'Allonnes, Paris: Hermann, 1964, p. 110.

10 Weill 1933, pp. 118-21.

11 His interview was published in the Dutch newspaper *Nieuwe Rotterdamsche Courant*, 31 May 1905. Mata Hari's debut performance was held at the Musée Guimet on 13 March 1905.

12 Picasso later told Palau that Fernande did not accompany him to Holland, because she was a married woman and she had obligations (Palau i Fabre 1980, p. 417). However, he went on to say that the name of her husband, from whom she was estranged, was Gaston Labaume, but this is the name of a sculptor who lived at the Bateau Lavoir and was married to someone else. The name of Fernande's husband was, in fact, Paul Percheron.

13 Daix and Boudaille 1967, p. 274.

14 'Moi, je n'avais pas d'argent. Il en fallait bien un peu pour le voyage. Max Jacob n'en avait pas non plus. Il est allé chez la concierge. Il est revenu avec vingt francs. J'avais une sacoche [...] j'y ai mis des couleurs. Les pinceaux n'y tenaient pas ; j'ai cassé les manches et je suis parti.' Ibid.

15 A postcard from Picasso to Apollinaire with a drawing of a Dutch girl is postmarked Amsterdam, 29 June 1905. Pierre Caizergues and Hélène Seckel (eds.), *Picasso/Apollinaire correspondance*, Paris: Gallimard/ Réunion des Musées nationaux, 1992, p. 30 no. 4.

16 Madeline 2006, p. 18, states, mistakenly, that Picasso attended the retrospective exhibition of Van Gogh that was held in the summer at the Stedelijk Museum in Amsterdam. A card Schilperoort wrote to him from Schoorl on 10 July 1905 establishes that Picasso was back in Paris before the exhibition opened (APP).

17 I am indebted to Gerrit Valk's study 'Le séjour de Picasso aux Pays-Bas en 1905', which he generously made available to me some years ago.

18 Others believe that Dieuwertje de Geus, who was remembered as a tall, thin woman, was not the model; see Hofhuis 1973.

19 According to Pierre Cabanne, Picasso told Paco Durrio, when he made him a gift of La Belle Hollandaise, that 'the most beautiful women's breasts are the ones that give the most milk.' ('Les plus beaux seins de femme, dit Pablo, sont ceux qui donnent le plus de lait.') Pierre Cabanne, Le siècle de Picasso I. La naissance du cubisme (1881-1912), Paris: Denoël, 1992, p. 267; trans. in Pierre Cabanne, Pablo Picasso: His Life and Times, New York: Morrow, 1977, p. 103.

20 Karl Baedeker, Belgium and Holland, Leipzig: Baedeker, 1905, p. 397.

21 'aux tailles de cuirassiers'. Olivier 1933, p. 43; trans. in Olivier 2001, p. 168.

22 The sons of the owner of the café where Picasso had worked in Schoorldam recalled that the locals remembered Picasso returning to Paris with a giant painting under his arm. Hofhuis 1973.

23 Olivier 2001, p. 162.

24 In a letter to Picasso of 24 January 1908, André Level advises the artist that he will come by the studio to take measurements of the painting (APP).

25 Richardson 1991, p. 414.

26 For a discussion of the relationship with Le Nain, see E.A. Carmean, Jr., Picasso: The Saltimbanques (Washington, National Gallery of Art, 1980), p. 23.

27 See Richardson 1991, p. 385.

28 Charles Morice referred to the Matisse painting as 'la question du Salon' in Mercure de France, 15 April 1906.

29 Theodore Reff, 'Themes of Love and Death in Picasso's Early Work', in Roland Penrose and John Golding (eds.), Picasso in Retrospect, New York: Harper & Row, 1980, p. 31.

30 Picasso revived the subject later in his career. Harlequins and Pierrots feature in his work from 1908 through the 1920s, and in his late graphic work, especially in the Suite 347, the travelling performers made a final appearance in several compositions.

31 Vollard gave Picasso a show, which opened in late December 1910, in his rue Laffitte gallery.

32 See Peter Read in this catalogue, pp. 159-60. These exhibits were previously unrecorded.

33 Olivier 2001, p. 169.

34 In a letter of 15 February 1905 (APP) Sagot had asked Picasso to bring him several works, including 'Harlequin on a red background' (probably Seated Harlequin, 1905; Museum Berggruen, Berlin) and 'Harlequin with

a dog' (Boy with a Dog, 1905; State Hermitage Museum, St Petersburg).

35 '[Sagot] vint un jour à l'atelier, il choisit trois études d'un assez grand format, deux gouaches faites en Hollande lors d'un séjour là-bas [...] et la fillette nue à la corbeille de fleurs, peinture à l'huile grandeur nature. [...] Pablo n'accepta pas le marché. Comme la situation ne s'améliorait pas, il prévint Sagot qu'il les lui laisserait pour le prix qu'il en avait offert. Mais Sagot, paraît-il avait réfléchi et n'en donnait plus que 400 francs je crois [...]' See Olivier 1988, p. 209; original manuscript (with different sums of money etc.) trans. in Olivier 2001, p. 168.

36 'C'était inespéré.' Olivier 1988, p. 211; original manuscript trans. in Olivier 2001, p. 178.

37 Stein 1933, p. 43.

38 Ibid., p. 50. Gertrude was at work on the story of Melanctha for her Three Lives.

39 Ibid., p. 53.

40 John Elderfield cited in Tinterow and Stein 2010, p. 112, n. 9.

41 According to Lucy Belloli in Tinterow and Stein 2010, p. 114.

42 Stein 1933, p. 53.

43 Ibid., p. 52. The Cones' collection is now in the Baltimore Museum of Art.

44 Ibid., p. 53.

45 'un temps, nous dinions le jeudi soir chez Matisse, Picasso, Salmon, Apollinaire et moi. Je crois que c'est chez Matisse que Picasso vit la statuaire nègre, ou tout au moins, qu'il en fut frappé pour la première fois.' Max Jacob, 'Souvenirs sur Picasso contés par Max Jacob', Cahiers d'Art II, no. 6, 1927, p. 202; trans. in McCully 1981, p. 55.

**EATING FIRE**

1 Picasso gave this painting to Van Dongen, in exchange for a landscape by the Dutch artist. See Hélène Seckel-Klein, Picasso Collectionneur, Paris: Réunion des Musées nationaux, 1998, pp. 230-3.

2 Vollard wrote Picasso on 4 May 1906, saying that he would visit his studio on Sunday (6 May) at 10 a.m, and he asks him to have everything ready to show him (APP). See Rabinow 2006, p. 388, no. 148.

3 'Tout là-haut, dans un air d'une pureté incroyable, au dessus des nuages, entourés des habitants aimables, hospitaliés, désintéressés, presque tous contrebandiers, nous avons [...] trouvé avec une paix sereine ce qui peut être le bonheur. [...] aucun nuage ne vint mettre la discorde entre Picasso et moi, puisque n'ayant plus de sujet de jalousie, son inquiétude avait disparue.' See Olivier 1988, pp. 214-16; original manuscript trans. in Olivier 2001, p. 183.

4 See Richardson 1991, p. 442.

5 Letter from Picasso to Casanovas, July 1906 (Casanovas Archives, Barcelona).

6 See Woman Combing her Hair (Georges Pellequer collection, Paris), repr. in McCully 1997, p. 339.

7 Anne Baldassari, in Picasso et les maîtres, Paris: Réunion des Musées nationaux, 2009, pp. 112-13, compares the Self-Portrait with a Palette to Cézanne's Self-Portrait with a Palette (1884; Bührle Foundation, Zurich).

8 Vollard made further purchases from Picasso, including 6 oils in November 1906 and more than 23 paintings and drawings from February to December 1907. Rabinow 2006, p. 388.

9 Richardson 1991, p. 442, n. 17.

10 See Marilyn McCully, 'Small figure: Picasso's first wood carvings and the story of Mémène's little doll', in exhib. cat. Picasso: Small figure. The collection in context, Málaga: Museo Picasso Málaga, 2007, pp. 17-41.

11 See 'The Widening of Picasso's Circle', note 45.

12 'me ha alegrado recibir carta tuya no sabes lo que me pudo complacer el saber que estas trabajando desde hace meses a un cuadro grande este cuadro ya sera diferente de los que yo conozco...' Letter from Iturrino to Picasso, 3 July 1907 (APP).

13 Penrose 1958, p. 126.

14 Gertrude Stein, Picasso, Paris: Floury, 1938, p. 64.

15 For the different accounts and versions of Braque's statement, see Hélène Seckel, 'Anthology of Early Commentary on Les Demoiselles d'Avignon', in Les Demoiselles d'Avignon: Studies in Modern Art 3, New York: Museum of Modern Art, 1994, pp. 228-9.

# SHORT TITLES

**ABBREVIATIONS**

APP: Archives Picasso, Paris

F: Jacob-Baart de la Faille, *The Works of Vincent van Gogh: His paintings and drawings*, new ed., Amsterdam: Meulenhoff International, 1970

**SHORT TITLES**

Bernard 1994: Emile Bernard, *Propos sur l'art*, 2 vols. Paris: Séguier, 1994

Bernardó 2006: Màrius Bernardó (ed.), *Ricard Viñes: El pianista de les avantguardes*, Barcelona: Fundació Caixa de Catalunya, 2006

Bernheim Jeune 1901: *Exposition d'œuvres de Vincent van Gogh*, Paris: Galerie Bernheim Jeune, 1901

Coquio 1994: Catherine Coquio (ed.), *Mécislas Golberg (1869-1907) Passant de la pensée. Une anthropologie politique et poétique du début du siècle*, Paris: Maisonneuve et Larose, 1994

Coquiot 1914: Gustave Coquiot, *Cubistes Futuristes Passéistes*, Paris: Ollendorff, 1914

Daix and Boudaille 1967: Pierre Daix and Georges Boudaille, *Picasso, The Blue and Rose Periods, A Catalogue Raisonné, 1900-1906*, Greenwich, Ct.: New York Graphic Society, 1967

Daix and Israël 2003: Pierre Daix and Armand Israël, *Pablo Picasso: Dossiers de la Préfecture de Police 1901-1940*, Paris: Editions des catalogues raisonnés / Moudon: Acatos, 2003

Fort 1944: Paul Fort, *Mes Mémoires: Toute la vie d'un poète 1872-1943*, Paris: Flammarion, 1944

Geiser/Baer 1990: Bernhard Geiser, revised by Brigitte Baer, *Picasso peintre-graveur*, vol. 1, Berne: Kornfeld, 1990

Hofhuis 1973: A.J. Hofhuis, 'Picasso was ook in Schoorldam', *Alkmaarse Courant*, 25 April 1973

Jacob 1927: Max Jacob, 'Souvenirs sur Picasso contés par Max Jacob', *Cahiers d'Art* no. 6, 1927

Jacob 1956: Max Jacob, *Chronique des temps héroïques*, Paris: Louis Broder, 1956

Kendall 2010: Richard Kendall, 'Neighbors in Montmartre', in exhib. cat., *Picasso Looks at Degas*, Williamstown, Mass.: Sterling and Francine Clark Institute, 2010, pp. 61-103.

McCully 1981: Marilyn McCully, *A Picasso Anthology*, London: Arts Council of Great Britain, 1981

McCully 1997: Marilyn McCully (ed.), exhib. cat. *Picasso: The Early Years, 1892-1906*, Washington: National Gallery of Art, 1997

MacOrlan 1955: Pierre MacOrlan, *Le Mémorial du Petit Jour*, Paris: Gallimard, 1955

Madeline 2006: Laurence Madeline, *Van Gogh-Picasso*, Paris: La Martinière, 2006

Malraux 1974: André Malraux, *La tête d'obsidienne*, Paris: Gallimard, 1974

Malraux 1994: André Malraux, *Picasso's Mask*, trans. June Guicharnaud with Jacques Guicharnaud from *La tête d'obsidienne*, New York: Da Capo, 1994

Ocaña 1995: Maria Teresa Ocaña, exhib. cat. *Picasso i els 4 Gats*, Barcelona: Museu Picasso / Lunwerg, 1995

Ocaña 1997: Maria Teresa Ocaña, exhib. cat. *Picasso: La Formació d'un geni, 1890-1904*, Barcelona: Museu Picasso / Lunwerg, 1997

Olivier 1933: Fernande Olivier, *Picasso et ses amis*, Paris: Stock, 1933

Olivier 1988: Fernande Olivier, *Souvenirs intimes*, Paris: Calmann-Lévy, 1988

Olivier 2001: Fernande Olivier, *Loving Picasso: The Private Journal of Fernande Olivier*, trans. Christine Baker and Michael Raeburn, foreword and notes by Marilyn McCully, epilogue by John Richardson, New York: Abrams, 2001

Palau i Fabre 1980: Josep Palau i Fabre, *Picasso Vivo (1881-1907)*, Barcelona: Polígrafa, 1980

Parmelin 1965: Hélène Parmelin, *Picasso: Le Peintre et son modèle*, Paris: Cercle d'Art, 1965; English ed. *Picasso: The Artist and his Model*, New York: Abrams, 1965

Penrose 1958: Roland Penrose, *Picasso: His Life and Work*, London: Gollancz, 1958

Rabinow 2006: Rebecca A. Rabinow (ed.), exhib. cat. *Cézanne to Picasso: Ambroise Vollard, Patron of the Avant-Garde*, New York: The Metropolitan Museum of Art / New Haven & London: Yale University Press, 2006

Raynal 1922: Maurice Raynal, *Picasso*, Paris: Crès, 1922

Read 1997: Peter Read, 'Au Rendez-vous des poètes', in McCully 1997, pp. 210-23

Richardson 1991: John Richardson with the collaboration of Marilyn McCully, *A Life of Picasso, I. 1881-1906*, New York: Random House, 1991

Sabartés 1949: Jaime Sabartés, *Picasso: An Intimate Portrait*, London: W.H. Allen, 1949

Sabartés 1953: Jaime Sabartés, *Picasso: retratos y recuerdos*, Madrid: Afrodisio Aguado, 1953

Salmon 1912: André Salmon, *La Jeune peinture française*, Paris: Société des Trente / Albert Messein, 1912

Salmon 2004: André Salmon, *Souvenirs sans fin, 1903-1940*, new ed. with Preface by Pierre Combescot, Paris: Gallimard, 2004

Salmon 2009: André Salmon, *La Négresse du Sacré-Cœur*, Preface by Jacqueline Gojard, unpublished Postface by the author, Paris: Gallimard, 2009

Seckel 1994: Hélène Seckel, exhib. cat. *Max Jacob et Picasso*, Paris: Réunion des Musées nationaux, 1994

Serrano 1996: Véronique Serrano, exhib. cat. *Pierre Girieud et l'expérience de la modernité 1900-1912*, Marseille: Musée Cantini, 1996

Spies 2000: Werner Spies in collaboration with Christine Piot, *Picasso: The Sculptures*, Ostfildern/Stuttgart: Hatje-Cantz, 2000

Stein 1933: Gertrude Stein, *The Autobiography of Alice B. Toklas*, New York: Vintage, 1961 (originally published New York: Harcourt Brace, 1933)

Tinterow and Stein 2010: Gary Tinterow and Susan Alyson Stein (eds.), exhib. cat. *Picasso in The Metropolitan Museum of Art*, New York: The Metropolitan Museum of Art / New Haven & London: Yale University Press, 2010

Van Gogh Letters 2009: *Vincent Van Gogh – The Letters: The Complete Illustrated and Annotated Edition*, ed. Leo Jansen, Hans Luijten and Nienke Bakker, 6 vols., Amsterdam: Van Gogh Museum, 2009

Vollard 1936: Ambroise Vollard, *Recollections of a Picture Dealer*, London: Constable, 1936

Weill 1933: Berthe Weill, *Pan! Dans l'Œil: Ou trente ans dans les coulisses de la peinture contemporaine 1900-1930*, Paris: Lipschutz, 1933

Zemel 1980: Carol M. Zemel, *The Formation of a Legend: Van Gogh Criticism, 1890-1920*. Ann Arbor: UMI Research Press, 1980

# CHRONOLOGY
## ISABEL CENDOYA

### 1881

25 OCTOBER: Pablo Ruiz Picasso (1881-1973) is born in Málaga. He studies drawing and painting with his father and at art schools in La Coruña, Barcelona and Madrid.

### 1889

6 MAY–31 OCTOBER: Exposition Universelle in Paris, for which the emblematic Eiffel Tower is erected.

MID-SEPTEMBER: Santiago Rusiñol (1861-1931) arrives in Paris, where he stays for long periods until September 1892. His letters and reports are published in Barcelona in *La Vanguardia*, whose correspondent Miquel Utrillo (1862-1934) has been living in Paris since 1868.

6 OCTOBER: The impresario Josep Oller i Roca (1839-1922), whose origins are Catalan, and Charles Zidler found the cabaret Le Moulin Rouge, on boulevard de Clichy, with Le Jardin de Paris, near the Champs Elysées, as its 'summer outpost'.

### 1890

29 JULY: Death of Vincent van Gogh (b. 1853) in Auvers-sur-Oise.

END OCTOBER: Ramon Casas (1866-1932) arrives in Paris with Rusiñol. He contributes illustrations to Rusiñol's reports in *La Vanguardia*, which are published together under the title *Desde el Molino*, referring to the Moulin de la Galette, where they live above the dancehall.

Pere Romeu (1862-1908) moves to Paris in 1893; Ramon Pichot (1872-1925) in summer 1895; Francisco Iturrino (1864-1924) in 1895; Joaquim Sunyer (1874-1956) in summer 1896; Isidre Nonell (1873-1911) and Ricard Canals (1876-1931) in February 1897; Marià Pidelaserra (1877-1946), Pere Ysern (1875-1946) and Emili Fontbona (1879-1938) arrive in April 1899; Juli González (1876-1942) in September or October 1899; Paco Durrio (Francisco Durrio de Madrón, 1868-1940) moves into the Bateau Lavoir, 13, rue Ravignan, in 1901; and Pablo Gargallo (1881-1934) arrives in 1903.

### 1891

27 JANUARY: Miquel Utrillo recognizes his paternity of Maurice (Utrillo) (1883-1955), son of Suzanne Valadon (Marie Clémentine, 1865-1938).

### 1895

21 SEPTEMBER: Picasso arrives with his family in Barcelona.

### 1899

FEBRUARY: First issue of the Barcelona journal *Quatre Gats*, edited by Pere Romeu (15 issues are published).

JUNE: In Barcelona Miquel Utrillo and Ramon Casas found the journal *Pèl & Ploma*, which includes reports on events in Paris and notices of French art and publications (100 issues are published until December 1903).

JUNE–JULY: 'Exposition de tableaux, esquisses & dessins de Puvis de Chavannes' at the Galerie Durand-Ruel, 16, rue Laffitte. *Pèl & Ploma* (no. 6, 8 July) publishes a review of the exhibition.

23 DECEMBER: *Pèl & Ploma* (no. 30) invites entries for a poster competition to celebrate the Carnival of 1900. Picasso submits a design showing a Pierrot and his companion toasting the New Year, which the journal commends as 'original and well executed' (no. 32, 6 January 1900).

### 1900

FEBRUARY: Picasso's first large exhibition, principally of portraits of local artists and writers done in mixed media on paper, is held at the tavern Els Quatre Gats in Barcelona. Reports of the show appear in *La Veu de Catalunya* (1 February, late edition), *La Vanguardia* (3 February) and *Diario de Barcelona* (7 February).

FEBRUARY: Exhibition in Paris of 'Peintures, dessins, pastels de Ramon Pichot, Sunyer, Nonell, Ricard Canals, Rusiñol, Durrio le céramiste...' at the Galerie Hessel, 13, rue Laffitte.

24 FEBRUARY: Names of artists accepted in the Spanish section of the Exposition Universelle in Paris appear in *La Vanguardia* (Barcelona); among them is Pablo Ruiz [Picasso], who submits 'oil paintings'. The work that is finally selected is *Last Moments*. Other Spanish artists included were José María Sert (1874-1945), Miquel Blay (1866-1936), Mariano Fortuny (1871-1949), Ramon Casas and Eliseu Meifrèn (1857-1940). Artists whose work was rejected included Ricard Canals, Ignacio Zuloaga (1870-1945) and Laureà Barrau (1864-1957).

15 APRIL: Opening of the Exposition Universelle (the exhibition closes 12 November).

1 JUNE–NOVEMBER: Exhibition of 150 works by Auguste Rodin (1840-1917) in the Pavillon de l'Alma, Paris. On most days the sculptor is present to show his works to visitors. A review by Ramon Casas appears in *Pèl & Ploma* (1 August), and another by Manuel Rodríguez Codolà (1888-1945) in *La Vanguardia* (30 August). Picasso draws a portrait of Rodin on a page of sketches of bullfighters and Paris entertainers.

18 JUNE: André Derain (1880-1954) and Maurice de Vlaminck (1876-1958), who both live in the suburb of Chatou, meet on a train. They become firm friends.

19 JULY: Line 1 (Porte Maillot–Porte de Vincennes) of the Paris Metro opens after two years of construction. The Metro entrances are designed by Hector Guimard (1867-1942).

27 SEPTEMBER: *Catalunya artística* reports that among those who plan to leave for Paris are 'the notable artists Ruiz Picasso and [Carles] Casagemas [1881-1901], who have been named artistic correspondents for this newspaper. We look forward with much pleasure to their contributions.'

LATE OCTOBER: Picasso and Casagemas arrive in Paris just before Picasso's 19th birthday. They spend a couple of nights in Montparnasse, at 8, rue Campagne-Première, then in the Hôtel du Nouvel Hippodrome; they move on to Nonell's studio at 49, rue Gabrielle, in Montmartre, which he had recently vacated. Some days later they are joined by their friend Manuel Pallarès (1876-1974). Three artist's models, Germaine Gargallo (Laure Florentin, 1881-1948), her sister Antoinette (later Fornerod, d. 1972) and Odette (Louise Lenoir, b. 1881), move in with them. Picasso decorates the walls of the studio with a *Temptation of St Anthony*.

25 OCTOBER: Picasso and Casagemas write Ramon Reventós (1881-1924) back in Barcelona:
*'Now we have a model. Tomorrow we'll light the stove and we'll have to work furiously for we're already thinking about the painting we're going to send to the next Salon. Also we're painting for exhibitions in Barcelona and Madrid. [...] The Boulevard de Clichy is full of places like Le Néant, Le Ciel, L'Enfer, La Fin du Monde, Les 4 Z'Arts, Le Cabaret des Arts, Le Cabaret de Bruant and a lot more which don't have the least bit of charm but make lots of money. A 'Quatre Gats' here would be a mine of gold and muscles. [...] The Moulin de la Galette has lost all its character and l'idem Rouge costs 3 francs to enter and some days 5. The theatres too. The cheapest seats in the cheapest theatres cost one franc. [...] Soon the Exposition*

*will close and we still haven't seen more than the painting section.'*

19 NOVEMBER: In another letter to Reventós, Casagemas remarks:
*'We are now waiting for a man [Pere Mañach] who buys more paintings from us than God. [...] At the moment, I am still painting Montmartre landscapes that are unbelievably successful.'*

Mañach gives Picasso a contract for 150 francs a month and sells three bullfight pastels to Berthe Weill (1865-1951).

Picasso paints *Le Moulin de la Galette.*

22 NOVEMBER–15 DECEMBER: Claude Monet (1840-1926) exhibits 26 paintings at Galerie Durand-Ruel, including his first *Waterlily* canvases.

1 DECEMBER: *Pèl & Ploma* (no. 65) publishes an article by Utrillo on Santiago Rusiñol, illustrated with a portrait by Picasso.

5–25 DECEMBER: 16th Exposition des Artistes Indépendants. Among those who participate are Jean Puy (1876-1960), Emile Schuffenecker (1851-1934), Armand Séguin (1869-1903) and Paul Signac (1863-1935).

During the year the Ecole des Beaux-Arts in Paris is open to female students for the first time.

LATE DECEMBER: Picasso and Casagemas return to Barcelona for Christmas; they go on to Málaga, arriving on 1 January 1901.

## 1901

JANUARY: Picasso and Casagemas spend ten days in Málaga, after which Casagemas travels alone to Barcelona, before returning to Paris; Picasso goes to Madrid. This is the last time that they see each other.

15 JANUARY: Joaquim Cabot i Rovira (1861-1951) publishes an article in *Pèl & Ploma* about Auguste Rodin, whose *Bust of Falguière* is exhibited in January at the Cercle Artístic de Sant Lluc in Barcelona.

MID-JANUARY–EARLY MAY: Picasso lives in Madrid, where he collaborates with Francisco de Asís Soler (d. 1903) on the journal *Arte Joven* (5 issues, 10 March– 1 June 1901), contributing drawings used for the covers and illustrations. He shows *Figura (Woman in Blue)* at the Exposición Nacional de Bellas Artes in Madrid.

17 FEBRUARY: Suicide in Paris of Carles Casagemas in the Hippodrome café, 128, boulevard de Clichy. Witnesses include the sculptor Manolo (Manuel Martínez Hugué, 1872-1945), the collector Alexandre Riera, and the critic Frederic Pujulà i Vallès (1877-1963) as well as Pallarès, Germaine and Odette. A drawing of Casagemas by Picasso, who is still in Madrid, accompanies an obituary in *Catalunya Artística* (28 February). Casagemas's death is evoked by Picasso in a series of paintings later in the year.

15–31 MARCH: 71 works by Vincent Van Gogh are shown in Paris at Galerie Bernheim Jeune, 8, rue Laffitte. On a visit to the exhibition, Derain introduces his friend Vlaminck to Henri Matisse (1869-1954).

4 APRIL: First number of *L'Assiette au Beurre* appears, with a cover by Théophile-Alexandre Steinlen (1859-1923) (593 issues are published until 1912). This illustrated journal is the most serious of the many 'humorous' periodicals published in Paris, with a strong political bias.

20 APRIL–21 MAY: 17th Salon des Indépendants includes works by Pierre Bonnard (1867-1947), Paul Cézanne (1839-1906), James Ensor (1860-1949), Albert Marquet (1875-1947), Matisse (exhibiting there for the first time), Puy, Henri Rousseau (called le Douanier, 1844-1910), Ker-Xavier Roussel (1867-1944) and Louis Valtat (1869-1952).

22 APRIL–30 JUNE: 11th Salon of the Société Nationale des Beaux-Arts in the Grand Palais includes works by Eugène-Anatole Carrière (1849-1906), Kees van Dongen (1877-1968), Jacques Villon (1875-1963) and Anders Leonard Zorn (1860-1920), in addition to Maurice Denis (1870-1943), whose *Hommage à Cézanne* shows the Nabis – himself, Bonnard, Roussel and Paul Sérusier (1864-1927) – contemplating a Cézanne still life, while Jean-Edouard Vuillard (1868-1940) is looking at a work by Odilon Redon (1840-1916).

22 APRIL–31 OCTOBER: 119th Salon des Artistes Français includes works by Raoul Dufy (1877-1953), Othon Friesz (1879-1949), Gaston Lachaise (1882-1935), Francis Picabia (1879-1953) and Georges Rouault (1871-1958).

END MAY: After about ten days in Barcelona, Picasso returns to Paris in the company of Antoni Jaumandreu Bonsoms, bringing with him some Spanish paintings and drawings. Miquel Utrillo writes in *Pèl & Ploma* (no. 77, June 1901):
*'Paris, that city so often criticized for its frantic pace, has attracted [Picasso] once more, but he is not going with the idea of conquering it, as was his dream on his first trip, but rather with the desire to gain knowledge in a*

*place where, undoubtedly, all the arts have flourished so exuberantly [...] Picasso, who is not yet 20 years old, has already been favourably supported in Paris [...] and has inspired his French friends to call him the "Petit Goya".'*

25 MAY–14 JUNE: Exhibition at Sala Parés, Carrer Petritxol, 5, Barcelona, with drawings by Picasso and Casas.

EARLY JUNE: Picasso and Mañach move into the studio that Casagemas had occupied at 130*ter*, boulevard de Clichy.

10–22 JUNE: Emile Bernard (1868-1941) exhibition at Galerie Vollard, 6, rue Laffitte.

11 JUNE–JULY: Yvette Guilbert appears at the Olympia, on boulevard des Capucines; she has a return engagement there in October.

17–30 JUNE: Exhibition of 3 of Picasso's works in a show organized by the periodical *Art et littérature* at Galerie La Bodinière, 18, rue Saint-Lazare. An expanded version of the exhibition, including 9 of his works, is shown at Villa Désiré, Dinard (19 August–30 September).

BEFORE 24 JUNE: Picasso meets the writer Max Jacob (1876-1944), who comes to his studio. Later, Picasso visits Jacob in the poet's apartment at 13, quai aux Fleurs, where he admires his collection of *Images d'Epinal* and lithographs by Honoré Daumier (1808-1879).

24 JUNE: Opening at the Galerie Vollard of the exhibition 'Iturrino et Picasso'. Picasso shows 64 paintings, including a self-portrait and portraits of Iturrino, Mañach, Ambroise Vollard (1868-1939) and Gustave Coquiot (1865-1926), and an unspecified number of drawings. The show runs until 14 July. The catalogue introduction is by Coquiot, who had already previewed the show in an article, ' La vie artistique, Pablo Ruiz Picasso', in *Le Journal* (17 June).

10 JULY: Pere Coll publishes a review of the show in *La Veu de Catalunya*:
*'Picasso is very young (19 years old) and there must be hardly anyone who could have done what he has done at this age. He has very great qualities, but he also has great faults. [...] It is a shame that a boy like this, who could do well, wants to do peculiar things. They tell me that this is what he likes, but I do not believe it. I would rather believe that they had pushed him in that direction. [...] The man who has done the drawings and sketches in colour which are shown here could achieve a great deal, but it is a big mistake to think that he can master every kind of subject.'*

SEPTEMBER: François Charles writes in *L'Ermitage* about the exhibition:
*'As for M. Picasso, who I am told is extremely young, he makes his debut with such brilliance that I am a little uneasy about his future [...] There is no doubt that he is gifted, but for his own good I would advise him not to paint one canvas a day.'*

9 SEPTEMBER: Death of Henri de Toulouse-Lautrec (b. 1864) at the Château Malromé.

14 SEPTEMBER: Drawings by Picasso (signed 'Ruiz') are published in *Le Frou-Frou* (no. 48); others are published in 1902 and 1903. He also contributes illustrations to other French journals, including *Gil Blas Illustré* and *Le Journal pour tous*, to *El Liberal* and *Pèl & Ploma* in Barcelona and to *Arlequín* in Madrid.

END SEPTEMBER: The Japanese actress Sada Yacco (1871-1946), who had performed in Loïe Fuller's pavilion at the Exposition Universelle, performs at the Théâtre de l'Athénée.

LATE SUMMER–EARLY AUTUMN: With the permission of Doctor Louis Jullien, Picasso gains admission to the Saint-Lazare prison, where the female inmates provide subjects for his paintings.

OCTOBER: The poet Jaime Sabartés (1881-1968) arrives in Paris, where he lives in the quartier Latin. Picasso's portrait of him (*Le Bock*) inaugurates the painter's Blue Period.

Sabartés and Picasso visit Paco Durrio, the Basque sculptor and friend of Paul Gauguin (1848-1903), in the Bateau Lavoir. Through Durrio, Picasso meets the artists Pierre Girieud (1876-1948) and Fabien Launay (Fabien Vieillard, 1877–1904) at the café Chez Azon, 12, rue Ravignan.

19 OCTOBER: Alberto Santos-Dumont (1873–1932) gains notoriety as the first person to fly from Saint-Cloud to the Eiffel Tower and back in a dirigible in less than 30 minutes. The episode was commemorated shortly afterwards by Ramon Pichot in a painting on the walls of the Montmartre cabaret Le Zut, 28, rue Ravignan, where Picasso also painted another *Temptation of St Anthony*.

2-31 DECEMBER: Inaugural exhibition organized by Mañach at Galerie Berthe Weill, 25, rue Victor-Massé. Durrio, Aristide Maillol (1861-1944), Girieud and Launay are among the artists included. The catalogue introduction is by Gustave Coquiot.

DECEMBER: Picasso asks his father to send money so that he can return to Barcelona.

## 1902

EARLY JANUARY: Picasso returns to Barcelona, where he works in a studio on Carrer Nou de la Rambla, which he shares with Angel Fernández de Soto (1882-1937) and Josep Rocarol (1882-1961).

Picasso's first sculpture, *Seated Woman*, is realized in clay in the studio of Emili Fontbona in Barcelona. It is later cast in bronze.

29 MARCH–15 MAY: The 18th Salon des Indépendants in Paris features works by Toulouse-Lautrec and Cézanne. Matisse also shows 6 paintings.

1–15 APRIL: Although he is absent from Paris, 15 paintings and pastels by Picasso are exhibited in a group show organized by Mañach at Galerie Berthe Weill. In the preface to the catalogue Adrien Farge writes:
*'Picasso is all nerve, all verve, all impetuosity. [...] he constructs brilliant, solid works which delight the eyes of those who have a taste for dazzling painting in colours that are sometimes crudely brutal, sometimes intentionally unusual.'*

Félicien Fagus later writes about Picasso's work in the exhibition in *La Revue Blanche* (1 September):
*'Picasso, who only lately was positively revelling in colour, now focuses his strength on energy. [...] All of this is conveyed in vivid but matt flat tints enclosed by carefully worked out, prominently marked outlines: this simplification strongly supports the impression of stained glass that is suggested by the essence of these canvases.'*

13 JULY: Picasso writes Max Jacob, asking him to send a contribution to *Pèl & Ploma*. Nothing is published.

25 SEPTEMBER: Opening of Exposició d'Art Antic in the Palau de Belles Arts in Barcelona, featuring Catalan Romanesque and Gothic art, and also works by Francisco de Zurbarán (1598-1664) and El Greco (1541-1614), among others.

29 SEPTEMBER: Death of Emile Zola (b. 1840) in Paris.

19 OCTOBER: Picasso's departure for Paris in the company of Juli González and Josep Rocarol is reported in the newspaper *El Liberal*. He first stays in Montparnasse and, afterwards, at the Hôtel du Maroc, 57, rue de Seine. Later he moves to Max Jacob's room at 150, boulevard Voltaire.

Coquiot commissions from Picasso a series of drawings of performers for an album (which is never completed). Among those portrayed are the music hall singer Berthe Bresina, Anna Thibaud (Marie-Louise Thibaudot, 1867-1936) and Jane Avril (Jeanne Richepin, 1868-1943).

15 NOVEMBER–15 DECEMBER: Pichot, Girieud, Launay and Picasso (who shows 8 works) participate in a group exhibition at the Galerie Berthe Weill. Thilda Harlor writes in the catalogue preface:
*'Two Frenchmen, two Spaniards, all four are inspired by the same scorn for the conventional. Each vision is quite personal. They paint or draw with gusto. They sacrifice nothing to a desire to please. And, if, at times, they reveal some uncertainty, it is not from catering to this or that opinion, but because they are themselves still searching. And one of their charms is that they find it natural to admit it. [...] The ardour of M. P.R. Picasso has already been noted. He has a tireless passion to see everything, to express everything. He is not bound by one manner, one genre. He has no set method.'*

Charles Morice reviews the exhibition in *Mercure de France* (15 December):
*'... Picasso, who painted before he learned to read, seems to have been assigned the mission of expressing with his brush everything there is. One could talk of a young god who wishes to remake the world. But it is a sombre god. [...] Beings who scarcely belong to either sex, "ordinary demons", with despairing eyes, heads bowed, brow blackened with desperate or criminal thoughts... After all, would one really hope that this painting will regain its health? Is not this child with a terrible precocity destined to consecrate with a masterpiece his negative view of life, that sickness from which he suffers more than anyone else?'*

DECEMBER–JANUARY 1903: Picasso does drawings after Pierre Puvis de Chavannes (1824-1898) in the Panthéon.

## 1903

MID-JANUARY: Picasso returns to Barcelona, where he remains for 15 months. The work done during this time constitutes the greater part of what came to be referred to as his 'Blue Period'.

8 MAY: Death of Paul Gauguin at Atuona in the Marquesas Islands.

SPRING: Picasso commemorates the death of Casagemas for the last time in the painting *La Vie*.

10 AUGUST: *El Liberal* publishes an article by Carles Junyer-Vidal (1881-1962) on Manuel Rodríguez Codolà's (1888-1945) book *La pintura en la Exposición Universal de París de 1900*, with illustrations by Picasso after Rodin, Puvis de Chavannes and Carrière.

31 OCTOBER–6 DECEMBER: 1st Salon d'Automne, founded by Matisse and Marquet to rival the official Salons. Félix Vallotton (1865-1925), Vuillard and Bonnard take part, and 12 works by Gauguin are shown, establishing the practice of featuring the work of a single artist.

4-28 NOVEMBER: Gauguin retrospective exhibition with 50 paintings and 27 drawings at Galerie Vollard.

NOVEMBER–DECEMBER: Steinlen exhibition at 32, place Saint-Georges, Paris.

## 1904

21 FEBRUARY–24 MARCH: 20th Salon des Indépendants features Cézanne.

24 FEBRUARY: André Level (1880-1954) founds La Peau de l'Ours, a syndicate which buys the work of young artists, speculating on their future success. Purchases within the first month include 3 Matisses.

24 MARCH: In anticipation of Picasso's departure from Barcelona, a long article by Carles Junyer-Vidal, 'Picasso y su obra', is published in *El Liberal*.

8-18 APRIL: Exhibition at Bernheim Jeune of works by Bonnard, Denis, Maillol, Roussel, Vallotton and Vuillard.

12 APRIL: Picasso's departure for Paris with Sebastià Junyer-Vidal (1878-1966) is reported in *El Liberal*. They move into the studio left vacant by Paco Durrio in the Bateau Lavoir in Montmartre; Picasso remains there until autumn 1909.

12 APRIL–14 JULY: Exhibition of French Primitives (14th-16th centuries) at the Louvre and the Bibliothèque Nationale.

17 APRIL–30 JUNE: 14th Salon of the Société Nationale des Beaux-Arts.

20 APRIL–15 MAY: Othon Friesz exhibition at the Galerie des Collectionneurs.

1 MAY: Opening of 122nd Salon des Artistes Français.

MAY–JUNE: Picasso is included, together with Girieud, Launay (who had recently died) and Georges Dufrenoy (1870-1943), in an accrochage at the Galerie du XXème siècle, which Clovis Sagot (c. 1854-1913) had opened at 46, rue Laffitte the previous year.

MAY: Vollard starts to employ Emile Delétang to photograph works passing through the gallery. Later Delétang performs the same function for Daniel-Henry Kahnweiler (1884-1979). Many of his photographs are still extant.

1-18 JUNE: Exhibition of 46 works by Matisse at Galerie Vollard, his first one-man show.

AUGUST: Fernande Olivier (Amélie Lang, 1881-1966) visits Picasso's studio for the first time, where she sees *The Frugal Repast*, his first major print.

OCTOBER–NOVEMBER: Ivan Morosov (1871-1921), Leo (1872-1947) and Gertrude Stein (1874-1946) and Sergei Ivanovich Shchukin (1854-1936), who would soon become major collectors of Picasso, start to purchase work from Vollard: Camille Pissarro (1830-1903), Pierre-Auguste Renoir (1841-1919), Denis, Cézanne, Gauguin.

15 OCTOBER–15 NOVEMBER: 2nd Salon d'Automne. It includes an homage to Renoir; a room devoted to Cézanne (33 paintings); 13 paintings by Matisse; and early works by Robert Delaunay (1885-1941).

24 OCTOBER–20 NOVEMBER: Group exhibition at Galerie Berthe Weill with works by Picasso (more than 12 paintings and drawings), Charbonnier, Adolphe Clary-Baroux (1865-1933), Dufy, Girieud, Picabia and Gaston Thiesson (1882-1920). The catalogue preface includes a poem and text by Maurice Le Sieutre (1879-1975).

15-25 NOVEMBER: Large exhibition (133 works) of Kees van Dongen at Galerie Vollard.

22 NOVEMBER–10 DECEMBER: Maurice Denis retrospective exhibition at Galerie Druet, rue du Faubourg-Saint-Honoré, which is followed by exhibitions of Signac and Henri-Edmond Cross (Henri-Edmond-Joseph Delacroix, 1856-1910).

## 1905

The bande à Picasso frequents the Cirque Médrano and Le Lapin Agile, successor to Le Zut, at 22, rue des Saules.

Frédé, the proprietor, commissions Picasso to do a work for his establishment. In 1906 Eugène Marsan (1882-1936) writes about the painting in the preface to his essay *Au Pays des Firmans* (published under the pseudonym Sandricourt):
'… If you are tempted to think me paradoxical, I would ask you to observe the eloquent décor of this café which is frequented only, for I discount the curious, by the young men who pay with poverty for the leisure of their unlimited dreaming. […]
'With his finger, M. Sandricourt pointed out to me a compelling picture done in colours that were flat, as if burnt. He remarked of it: "This Harlequin and Columbine are hungry (notice the eyes), but they don't have twenty sous and, not being able to eat, they drink. They are not looking at each other at all; but I can tell that they care for each other. The young artist who painted that in two hours will become a genius, if Paris does not destroy him."
'I objected, for I had at once recognized the hand that had fitted the yellow, red, green lozenges of their tights to the thin bodies of Harlequin and Columbine.
'"The painter of this Harlequin," I said, "Monsieur, already has a reputation and tomorrow… He is an Andalusian, and one who paints, as only a Spaniard could, the look and the rags. You might call him, to help you remember, the Callot of the saltimbanques, but you'd do better to remember his name: Picasso."'

10-25 FEBRUARY: Exhibition of 61 works by Picabia at the Galerie Haussmann, 67, boulevard Haussmann.

MID-FEBRUARY: Meeting of Picasso and the poet Guillaume Apollinaire (Wilhelm de Kostrowitzky, 1880-1918) in a bar near Saint-Lazare station. Manolo introduces Picasso to André Salmon (1881-1969) the following week.

25 FEBRUARY–6 MARCH: Exhibition at the Galeries Serrurier, 37, boulevard Haussmann, of Albert Trachsel (1863-1929), Auguste Gérardin (b. 1849) and Picasso, who shows 34 paintings, drawings and prints, and an unidentified sketchbook. Charles Morice writes in the preface to the catalogue:
'He was not twenty years old and already he had this amazing certainty of line, of colour harmonies, of composition, which many artists still strive for after years of work. A miracle which nothing can explain. One could believe that in another life, with many years and works, this child with the insistent and sure eye had already learned everything…'

Morice also contributes a review of the show to *Mercure de France*:

'...These new works that [Picasso] is showing at the Galeries Serrurier herald a radiant transformation of his talent. [...] But today the poses are simpler, the groups are not so shabby, the canvas is lighter. [...] For what was especially disappointing in the first works of Picasso, though they were already stamped with a powerful personality, was that he apparently relished the melancholy without sympathizing with it. His sensibility has deepened. Let us note also that his technique has improved and strengthened: the structures are more solid than a short time ago and also simpler.'

Apollinaire publishes an article in *La Revue immoraliste* (April) about the exhibition:
'It is said that Picasso's work reveals a precocious disenchantment.
'I think it is the opposite.
'Everything enchants him and his undeniable talent seems to me at the disposal of a fantasy which blends exactly the delightful and horrible, the wretched and refined [...]
'Under the bright rags of his slender saltimbanques, you discern real youths of the masses, fickle, cunning, clever, poor and deceitful.
'His mothers clench their thin hands just as young mothers of the common people have often done and his nudes are granted the escutcheon of fleece which traditional painters scorn, and which is the shield of Western modesty.'

Apollinaire returns to the discussion of Picasso's work in an article in *La Plume* (15 May), which was reprinted in 1913 in his *Méditations esthétiques*:
'There are children who have wandered around without ever learning the catechism. They stop and the rain stops: "Look! There are people in those buildings and their clothes are poor and ragged." [...] These women who are no longer loved have memories. [...]
'The harlequins live in faded finery where painting brings its colours together, warms or whitens them, to express the strength and durability of passion, where lines following the shape of the costume curve, cross or leap upwards.
'Fatherhood transfigures the harlequin in a square bedroom, while his wife washes in cold water and admires herself as slender and skinny as her puppet husband. [...]
'Picasso's love of fluid, changing, incisive lines has produced almost unique examples of linear drypoint engravings in which he has in no way altered the general appearance of the world. [...]
'His persistent pursuit of beauty then changed everything in Art.'

25 FEBRUARY–25 MARCH: Group exhibition at Galerie Berthe Weill, including works by Dufy, Toulouse-Lautrec and Van Dongen.

24 MARCH–30 APRIL: 21st Salon des Indépendants, which includes retrospectives of Seurat and Van Gogh. Derain and Vlaminck meet Signac at the exhibition.

MARCH: Paul Fort (1872-1960) publishes the first issue of *Vers et Prose*.

6–29 APRIL: Group exhibition at Galerie Berthe Weill, including works by Charles Camoin (1879-1965), Henri-Charles Manguin (1874-1949), Marquet and Matisse.

15 APRIL–30 JUNE: 15th Salon of the Société Nationale des Beaux-Arts.

22 APRIL: Opening of 6th Venice Biennale, for which Zuloaga has requested Picasso's *Acrobat and Young Harlequin* for the Spanish section. The work is hung for only a few days before being returned to the artist.

1 MAY: Opening of 123rd Salon des Artistes Français, which includes works by Picabia.

JUNE: While touring Spain with Rodin, Zuloaga discovers El Greco's *Apocalyptic Vision* in a collection in Córdoba. He acquires it and later installs it in his Paris studio, where Picasso often sees the painting.

LATE JUNE: Picasso travels to north Holland, stopping in Amsterdam to change trains. He spends two weeks in and around Schoorl, before returning to Paris before 10 July.

LATE JUNE–EARLY SEPTEMBER: Derain is in Collioure with Matisse. Matisse paints his portrait and Derain does three portraits of Matisse.

SUMMER: Picasso completes his large composition *Family of Saltimbanques*, for which he has made many studies over the previous months.

AUGUST: Apollinaire spends his vacation in Amsterdam.

3 SEPTEMBER: Fernande Olivier moves in with Picasso in the Bateau Lavoir. Apart from a few weeks of separation, they are together until 1912.

18 OCTOBER–25 NOVEMBER: 3rd Salon d'Automne, featuring retrospectives of Carrière, Jean-Auguste-Dominique Ingres (1780-1867) and Edouard Manet (1832-1883), and a room devoted to Cézanne. Works by the Nabis and Douanier Rousseau are also included. Louis Vauxcelles (1870-1945) refers to the room with paintings by Matisse and his followers as 'La cage aux fauves'.

21 OCTOBER–20 NOVEMBER: Group exhibition at Galerie Berthe Weill, featuring works by Camoin, Derain, Vlaminck, Dufy, Manguin, Marquet and Matisse.

NOVEMBER: 10 works by Picasso are exhibited simultaneously on rue Laffitte at Galerie Vollard and Sagot's Galerie du XXème siècle. Around this time Picasso is introduced to Gertrude and Leo Stein by Henri-Pierre Roché (1879-1959). She begins posing in the Bateau Lavoir studio for her portrait, which is completed at the end of the following summer.

23 NOVEMBER: Derain sells 89 paintings and 80 drawings to Vollard, who becomes his dealer. Derain meets Picasso around this time.

DECEMBER: Apollinaire publishes his poem 'Salomé' in *Vers et Prose*. Around the same time, Picasso produces his print *Salomé*.

## 1906

Picasso rediscovers Iberian sculpture in a display at the Louvre, featuring archaic works found in recent excavations in Osuna and Cerro de los Santos in Andalusia.

JANUARY: Eugeni d'Ors (1882-1954) begins publishing his 'Glosari' in *La Veu de Catalunya*, as the paper's artistic correspondent in Paris.

28 FEBRUARY–15 MARCH: Exhibition of 53 works by Odilon Redon at Galerie Durand-Ruel.

19 MARCH–17 APRIL: Exhibition of 58 paintings and a group of watercolours, lithographs and woodcuts by Matisse at Galerie Druet.

20 MARCH–30 APRIL: 22nd Salon des Indépendants. Georges Braque (1882-1963) shows 7 works, and Matisse exhibits his *Bonheur de vivre*. Picasso meets Matisse either at the Druet exhibition or at the Indépendants.

15 APRIL–30 JUNE: 16th Salon of the Société Nationale des Beaux-Arts.

21 APRIL: Rodin's *Thinker* is unveiled in the place du Panthéon.

EARLY MAY: Vollard buys 27 works for 2,000 francs from Picasso, enabling him and Fernande to spend the summer in Spain.

21 MAY: Picasso and Fernande arrive in Barcelona. After visiting family and friends, they travel to Gósol in the Pyrenees, near the border with Andorra. They return to Paris in August.

AUTUMN: Derain, who is now in constant touch with Picasso and the Bateau-Lavoir group, rents a studio at 22, rue Tourlaque.

6 OCTOBER–15 NOVEMBER: 4th Salon d'Automne includes a special exhibition of 10 works by Cézanne and a large retrospective of Gauguin (240 works). The Salon also includes a large exhibition of Russian art organized by Serge Diaghilev (1872-1929).

23 OCTOBER: Death of Cézanne in Aix-en-Provence.

12 NOVEMBER: Santos-Dumont flies his plane 220 metres at Bagatelle (his first attempt on 23 October had achieved 60 metres), the first flight in Europe. The first flight by the Wright Brothers' (Wilbur, 1867–1912, and Orville, 1871–1948) had been made on 17 December 1903.

16 NOVEMBER: Vollard buys 6 paintings by Picasso for 1,000 francs; the following 13 February he buys a further group of paintings and drawings for 2,500 francs.

## 1907

6 JANUARY: Manet's *Olympia* is hung in the Louvre at the urging of Monet.

14 JANUARY–10 FEBRUARY: Group exhibition at Galerie Berthe Weill, including works by Robert Delaunay and Jean Metzinger (1883-1956).

21 JANUARY–2 FEBRUARY: Exhibition of 80 works by Paul Signac at Galerie Bernheim Jeune.

1–15 FEBRUARY: Exhibition of 76 works by Francis Picabia at the Galerie Haussmann.

MARCH: Louis Géry Pieret (1884-after 1938) steals two Iberian heads from the Louvre, which he sells to Picasso. Picasso returns them at the time of the theft of the *Mona Lisa* in 1911. Not long after this Picasso is encouraged by Derain to visit the Ethnographic museum at the Trocadéro, where he studies tribal art. Derain has been acquiring African pieces, including a Fang mask bought from Vlaminck.

11 MARCH: Sale of 53 works by Odilon Redon at the Hôtel Drouot, 9, rue Drouot.

20 MARCH–30 APRIL: 23rd Salon des Indépendants includes a commemorative exhibition for Cézanne as well as 6 fauve landscapes by Braque, who makes Picasso's acquaintance before the Salon closes.

MARCH: Picasso asks Wilhelm Uhde (1874-1947) to come to his studio to see his latest work, which includes studies for *Les Demoiselles d'Avignon*. On 28 April Gertrude and Leo Stein also visit the studio.

MAY: Apollinaire meets Marie Laurencin (1885-1956) at Sagot's Galerie du XXème siècle.

17–29 JUNE: Exhibition of 79 Cézanne watercolours at Galerie Bernheim Jeune.

11 JULY: Daniel-Henry Kahnweiler, who arrived in Paris on 22 February, opens his gallery at 28, rue Vignon. Some weeks later he visits Picasso and buys 3 gouaches.

24 AUGUST: Fernande Olivier writes Gertrude Stein that she and Picasso are going to separate the following month. They are back together again by late autumn.

SUMMER–END OCTOBER: Exhibition of more than 200 drawings by Rodin at Galerie Bernheim Jeune.

AUTUMN: Max Jacob moves to a studio at 7, rue Ravignan, next door to the Bateau Lavoir, where he stays until 1911.

1–22 OCTOBER: 5th Salon d'Automne, which features 48 paintings by Cézanne, Rousseau's *Snake-Charmer* (one of his exotic paintings inspired by walks in the Jardin des Plantes), and Derain's *Bathers*. Apollinaire publishes a series of articles on the Salon, attacking the organizer, Frantz Jourdain (1847-1935), and praising the work of his friends Rousseau and Vlaminck.

25 OCTOBER–14 NOVEMBER: Kahnweiler exhibits paintings by Girieud and stoneware by Durrio.

1 NOVEMBER: Death of Alfred Jarry (b. 1873).

NOVEMBER: Apollinaire takes Braque to Picasso's Bateau Lavoir studio, and this marks the beginning of the close association and friendship between the two painters. Braque is astounded by the *Demoiselles d'Avignon*.

# LIST OF WORKS

**IBERIAN**
*Head of a Man*
Cerro de los Santos (Albacete), 3rd century BC
Limestone, 20 x 17.5 x 13 cm
Musée du Louvre, Paris (on deposit at Musée d'Archéologie
nationale, Saint-Germain-en-Laye)
Pl. 96

**POLYNESIAN**
*Tiki*
Marquesas Islands (French Polynesia), 19th century
Wood, h: 72 cm
Private collection
Pl. 92 (not in exhibition)

**PIERRE BONNARD (1867 – 1947)**
*Nude with Black Stockings*
1900
Oil on canvas, 59 x 43 cm
Private collection
Pl. 24 (not in exhibition)

**RICARD CANALS LLAMBÍ (1876 – 1931)**
*At the Bullfight* (Fernande and Benedetta)
1904
Oil on canvas, 157 x 256.3 cm
Private collection, Barcelona
Pl. 73 (Barcelona only)

**RAMON CASAS CARBÓ (1866 – 1932)**
*Dance at the Moulin de la Galette*
1890
Oil on canvas, 100 x 81.4 cm
Museu Cau Ferrat, Sitges
Pl. 2 (Barcelona only)

**PAUL CÉZANNE (1839 – 1906)**
*Bathers*
c. 1890
Oil on canvas, 28 x 44 cm
Musée d'Orsay, Paris (on deposit at Musée Granet,
Aix-en-Provence)
Pl. 108

*Ginger Jar, Sugar Bowl and Apples*
1890-3
Oil on canvas, 36 x 46 cm
Musée de l'Orangerie, Paris
Pl. 19 (not in exhibition)

**HONORÉ DAUMIER (1808 – 1879)**
*Crispin and Scapin*
1863-4
Oil on canvas, 60.5 x 82 cm
Musée d'Orsay, Paris
Pl. 80

**ANDRÉ DERAIN (1880 – 1954)**
*Portrait of Matisse in his Studio*
1905
Oil on canvas, 93 x 52.5 cm
Musée Matisse, Nice
Pl. 93 (Barcelona only)

**PACO (FRANCISCO) DURRIO DE MADRÓN
(1868 – 1940)**
*Anthropomorphic Pot*
1900-5
Glazed stoneware, 37.8 x 23.5
Musée d'Orsay, Paris
Pl. 88

*Head of a Youth* or *Head of an Inca*
First third of 20th century
Glazed stoneware, 30.6 x 16.5 x 18.7 cm
Museo de Bellas Artes de Bilbao
Pl. 97

**HENRI EVENEPOEL (1872 – 1899)**
*The Spaniard in Paris (Portrait of Francisco Iturrino)*
1899
Oil on canvas, 217 x 152 cm
Museum voor Schone Kunsten, Ghent
Pl. 13

**DÉMÉTRIUS (DEMETRIOS) GALANIS
(1880 – 1966)**
*Paris, Summer*
Reproduced in *L'Assiette au Beurre*, 24 August 1907
Private collection, London
Not illustrated

**PAUL GAUGUIN (1848 – 1903)**
*The Arlésienne (Madame Ginoux)*
1888
White and coloured chalks and charcoal on paper,
56.1 x 49.2 cm
Fine Arts Museums of San Francisco. Memorial gift from
Dr. T. Edward and Tullah Hanley, Bradford, Pa.
Pl. 49 (Barcelona only)

*Tehura*
1891–3
Painted and gilded pua wood, 22.2 x 7.8 x 12.6 cm
Musée d'Orsay, Paris
Pl. 98

*Portrait of a Young Woman (Vaïte Goupil)*
1896
Oil on canvas, 75 x 65 cm
Ordrupgaard, Copenhagen
Pl. 69 (Amsterdam only)

**XAVIER GOSÉ I ROVIRA (1876 – 1915)**
*Foreign Adventurers*
Cover of *L'Assiette au Beurre*, 4 July 1903
Private collection, London
Pl. 28

**JUAN GRIS (JOSÉ VICTORIANO GONZÁLEZ PÉREZ)
(1887-1927)**
*Aeroplanes*
Cover of *L'Assiette au Beurre*, 24 November 1908
Private collection, London
Pl. 31

**PAUL IRIBE (1883 – 1935)**
*Woman Artist*
Caricature from his 'Esthètes' issue of *L'Assiette au Beurre*,
25 April 1903
Private collection, London
Pl. 30

**HENRI MATISSE (1869 – 1954)**
*Standing Nude*
1907
Oil on canvas, 92.1 x 64.8 cm
Tate, London. Purchased 1960
Pl. 91 (Barcelona only)

**PABLO RUIZ PICASSO (1881 – 1973)**
*Picasso and Manuel Pallarès in Paris*
Paris, 1900
Pen and ink on paper, 8.8 x 11.1 cm
Museu Picasso, Barcelona
Pl. 1

*Leaving the Exposition Universelle*
Paris, 1900
Charcoal, coloured crayons and pencil on paper,
47.6 x 62 cm
Private collection, Switzerland. Courtesy of
E & R Cyzer Gallery, London
Pl. 3

*House and Street in Paris*
Paris, 1900
Pastel on paper, 59 x 12.6 cm
Private collection
Pl. 4 (Barcelona only)

*The Embrace*
Paris, 1900
Pastel on paper, 59 x 35 cm
Museu Picasso, Barcelona
Pl. 5

*In the Dressing Room*
Paris, 1900
Pastel on paper, 47.5 x 52.5 cm
Museu Picasso, Barcelona
Pl. 7

*Le Moulin de la Galette*
Paris, 1900
Oil on canvas, 88.2 x 115.5 cm
Solomon R. Guggenheim Museum, New York
Thannhauser Collection, Gift, Justin K. Thannhauser, 1978
Pl. 8

*French Can-Can*
Paris, 1900
Oil on canvas, 46 x 61 cm
Hiroshima Museum of Art
Pl. 38 (not in exhibition)

*Waiting (Margot)*
Paris, 1901
Oil on cardboard, 68.5 x 56 cm
Museu Picasso, Barcelona
Pl. 12

*Picasso and Jaumandreu Bonsoms Arriving in Paris*
Paris, 1901
Coloured pencils on paper, 33 x 38 cm
Staatliche Museen zu Berlin, Nationalgalerie, Museum
Berggruen, Berlin
Pl. 14 (Amsterdam only)

*Woman at a Café*
Paris, 1901
Oil on paper pasted on panel, 53.5 x 35 cm
Museum Boijmans Van Beuningen, Rotterdam
Pl. 15

*Dinner in a Restaurant*
Paris, 1901
Pastel and watercolour on paper, 28.5 x 39 cm
Pl. 17 (Barcelona only)

*Still Life*
Paris, 1901
Oil on canvas, 61 x 82 cm
Museu Picasso, Barcelona
Pl. 18

*Flowers*
Paris, 1901
Oil on canvas, 65.1 x 48.9 cm
Tate, London
Pl. 20

*Dwarf-Dancer (La Nana)*
Paris, 1901
Oil on cardboard, 105 x 60 cm
Museu Picasso, Barcelona
Pl. 21

*Le Divan Japonais*
Paris, 1901
Gouache and watercolour on paper, 39 x 53 cm
Collection Gabriele and Horst Siedle, Germany
Pl. 22

*Nude with Red Stockings*
Paris, 1901
Oil on cardboard, 67 x 51.5 cm
Musée des Beaux-Arts de Lyon
Pl. 23 (not in exhibition)

*Madwoman with Cats*
Paris, 1901
Oil on cardboard, 45.1 x 40.8 cm
The Art Institute of Chicago, Amy McCormick Memorial
Collection
Pl. 25

*Lures for Men*
Paris, 1901
Reproduced in *Le Frou-Frou*, 31 August 1901
Private collection, London
Pl. 26

*Catcalls and Capers*
Paris, 1901
Reproduced in *Le Frou-Frou*, 14 September 1901
Private collection, London
Pl. 27

*Jardin de Paris*
Paris, 1901
Ink and watercolour on paper, 64.8 x 49.5 cm
The Metropolitan Museum of Art, New York. Gift of
Raymonde Paul, in memory of her brother, C. Michael Paul,
1982
Pl. 35 (Barcelona only)

*Café-Concert Singer* (Yvette Guilbert)
Paris, 1901
Charcoal and coloured pencils on paper, 21 x 12.5 cm
Museu Picasso, Barcelona
Pl. 39

*Sada Yacco*
Paris, 1901
Pastel and ink on paper, 37.1 x 25.5 cm
Collection Pieter and Olga Dreesmann, Brussels
Pl. 40

*Blue Roofs*
Paris, 1901
Oil on cardboard, 39 x 57.7 cm
The Ashmolean Museum, Oxford. Bequeathed by Frank
Hindley Smith, 1939
Pl. 45

*Children in a Park*
Paris, 1901
Oil on cardboard, 32 x 47 cm
Private collection, Rotterdam (on loan to Van Gogh Museum)
Pl. 46

*The Fourteenth of July*
Paris, 1901
Oil on cardboard mounted on canvas, 48 x 62.9 cm
Solomon R. Guggenheim Museum, New York. Thannhauser
Collection, Gift, Justin K. Thannhauser, 1978
Pl. 47

*The Diners*
Paris, 1901
Oil on cardboard, 47 x 62.2 cm
Museum of Art, Rhode Island School of Design, Providence.
Bequest of George Metcalf
Pl. 50

*Woman with Jewelled Collar*
Paris, 1901
Oil on canvas, 65.3 x 54.5 cm
Pinacoteca Giovanni e Marella Agnelli, Turin
Pl. 52 (not in exhibition)

*Head of the Dead Casagemas*
Paris, 1901
Oil on cardboard, 52 x 34 cm
Private collection, Courtesy of Fundación Almine y Bernard
Ruiz-Picasso para el Arte
Pl. 54 (Amsterdam only)

*Self-Portrait*
Paris, 1901
Oil on canvas, 81 x 60 cm
Musée national Picasso, Paris
Pl. 55 (not in exhibition)

*The Blue Room (Le Tub)*
Paris, 1901
Oil on canvas, 50.5 x 61.6 cm
The Phillips Collection, Washington DC
Pl. 56 (Amsterdam only)

*Head of the Dead Casagemas*
Paris, 1901
Oil on panel, 27 x 35 cm
Musée national Picasso, Paris
Pl. 57 (not in exhibition)

*Casagemas in his Coffin*
Paris, 1901
Oil on cardboard, 72.5 x 58 cm
Private collection. Courtesy of James Roundell
Pl. 58

*Melancholy Woman*
Paris, 1901
Oil on canvas, 100 x 69.2 cm
Detroit Institute of Arts. Bequest of Robert H. Tannahill
Pl. 59 (Amsterdam only)

*Women at the Prison Fountain*
Paris, 1901
Oil on canvas, 81 x 65 cm
Private collection
Pl. 60 (not in exhibition)

*Woman with a Cap*
Paris, 1901
Oil on canvas, 41 x 33 cm
Museu Picasso, Barcelona
Pl. 83

*Study of a Head Looking Upwards*
Paris, 1902
Conté crayon on paper, 31.2 x 24.3 cm
Museu Picasso, Barcelona
Pl. 64

*Head of a Boy*
Paris, 1902
Conté crayon and charcoal on paper, 31.2 x 23.5 cm
Museu Picasso, Barcelona
Pl. 65

*The Golden Age*
Paris, 1902
Pen and sepia ink and wash on paper, 26 x 40 cm
Museu Picasso, Barcelona
Pl. 66

*Man Carrying a Sack (after Puvis de Chavannes)*
Paris, 1902
Graphite pencil on paper, 31.2 x 23.5
Museu Picasso, Barcelona
Pl. 68

*Picasso and Sebastià Junyer Vidal Travel to Paris*
*1. Picasso and Junyer Depart by Train; 2. Picasso and
Junyer Arrive at the Border; 3. Picasso and Junyer Arrive in
Montauban 4. Picasso and Junyer Arrive in Paris; 6. Junyer
Visits Durand-Ruel*
Paris, 1904
Pen and ink and coloured pencils on paper, five sketches,
each 22 x 16 cm
Museu Picasso, Barcelona
Pl. 71 (Barcelona only)

**Poor Couple**
Paris, 1904
Oil on canvas, 100 x 80.5 cm
Merzbacher Kunststiftung
Pl. 72 (Amsterdam only)

**The Frugal Repast**
Paris, 1904
Etching with drypoint on paper, 46.2 x 37.8 cm (plate size)
Collection Pieter and Olga Dreesmann, Brussels
Pl. 76 (Amsterdam only)

**Portrait of Benedetta Canals**
Paris, 1905
Oil and charcoal on canvas, 90 x 69.5 cm
Museu Picasso, Barcelona
Pl. 75

**Young Acrobat and Monkey** (Invitation to Max Jacob)
Paris, 1905
Pen and ink and watercolour on paper, 21.6 x 12.7 cm
Collection Pieter and Olga Dreesmann, Brussels
Pl. 77

**Harlequin Applying Make-up**
Paris, 1905
Gouache on cardboard, 69 x 53.5 cm
Marina Picasso Collection
Pl. 78 (not in exhibition)

**Jester on Horseback**
Paris, 1905
Oil on cardboard, 100 x 69.2 cm
Virginia Museum of Fine Arts. Collection of Mr and Mrs Paul Mellon, Richmond, Va.
Pl. 79

**Hurdy-Gurdy Man and Young Harlequin**
Paris, 1905
Gouache on cardboard, 100.5 x 70.5 cm
Kunsthaus Zurich
Pl. 82

**Harlequin's Family with an Ape**
Paris, 1905
Gouache, watercolour, pastel and Indian ink on cardboard, 104 x 75 cm
Konstmuseum, Gothenburg
Pl. 84 (not in exhibition)

**Family of Saltimbanques ('Pour Fernande')**
Paris, 1905
Ink, charcoal and watercolour on paper, 16.5 x 12.5 cm
Collection Gabriele and Horst Siedle, Germany
Pl. 85

**Boy with a Pipe**
Paris, 1905
Oil on canvas, 100 x 81.3 cm
Private collection
Pl. 86 (not in exhibition)

**Head of a Jester**
Paris, 1905
Bronze, 41.5 x 37 x 22.8 cm
Collection Fondation Pierre Gianadda, Martigny
Pl. 87

**Three Dutch Girls**
Schoorl, 1905
Gouache on paper, 77 x 67 cm
Centre Pompidou, Paris, Musée national d'art moderne
Pl. 89 (Amsterdam only)

**Self-Portrait with a Palette**
Paris, 1906
Oil on canvas, 91.9 x 73.3 cm
Philadelphia Museum of Art. A. E. Gallatin Collection
Pl. 94

**Boy on a Horse**
Paris, 1906
Oil on canvas, 50.5 x 31 cm
Private collection
Pl. 95

**La Coiffure**
Paris, 1906
Oil on canvas, 174.9 x 99.7 cm
The Metropolitan Museum of Art, New York. Wolfe Fund, 1951; acquired from The Museum of Modern Art, New York, Anonymous Gift
Pl. 99 (Amsterdam only)

**Nude Combing her Hair**
Paris, 1906
Oil on canvas, 105.4 x 81.3 cm
Kimbell Art Museum, Fort Worth, Texas
Pl. 100

**Woman Combing her Hair**
Paris, 1906
Bronze, 42.2 x 26 x 31.8 cm
Museum Ludwig, Cologne
Pl. 101

**Woman Combing her Hair**
Paris, 1906
Pencil and charcoal on paper, 55.8 x 40.7 cm
Sainsbury Centre for Visual Arts, University of East Anglia, Robert and Lisa Sainsbury Collection, Norwich
Pl. 102 (Amsterdam only)

**Nude Woman on a Red Background**
Paris, 1906
Oil on canvas, 81 x 54 cm
Musée de l'Orangerie, Paris
Pl. 103 (Barcelona only)

**Head of a Woman (Fernande Olivier)**
Paris, 1906
Bronze, 35.7 x 24.8 x 24.4 cm
Museu Picasso, Barcelona
Pl. 104

**Study for Woman with her Head Bent**
Paris, 1906
Pencil on paper, 31.5 x 48 cm
Staatsgalerie Stuttgart
Pl. 106 (Barcelona only)

**Female Nude with Arms Raised**
Paris, 1907
Gouache on paper, 63 x 46.5 cm
Sainsbury Centre for Visual Arts, University of East Anglia, Robert and Lisa Sainsbury Collection, Norwich
Pl. 90 (Amsterdam only)

**Doll**
Paris, 1907
Carved wood, brass pins, traces of oil and gesso, 23.5 x 5.5 x 5.5 cm
Art Gallery of Ontario, Toronto
Pl. 107

**Study for Les Demoiselles d'Avignon**
Paris, 1907
Pencil and pastel on paper, 47.6 x 63.7 cm
Stadt Basel (on deposit in Kunstsammlung Basel)
Pl. 109 (Amsterdam only)

**Nude with Raised Arms**
Paris, 1907
Pastel, black chalk and pencil on paper, 24 x 19 cm
Collection François Odermatt, Montreal
Pl. 112

**Carafe, Bowl and Lemon**
Paris, 1907
Oil on panel, 63.5 x 49.5 cm
Fondation Beyeler, Basel-Riehen
Pl. 113

**Standing Nude**
Paris, 1908
Oil on wood panel, 67 x 26.7 cm
Private collection
Pl. 110 (Barcelona only)

**Standing Nude with Upraised Arms**
Paris, 1908
Oil on wood panel, 67 x 25.5 cm
Private collection
Pl. 111 (Barcelona only)

**PIERRE PUVIS DE CHAVANNES (1824 – 1898)**
*Charity*
1894
Oil on canvas, 91.4 x 71 cm
Mildred Lane Kemper Art Museum, Washington University, St Louis
Pl. 67

**ODILON REDON (1840 – 1916)**
*Woman and Child*
c. 1898
Pastel on paper, 59.5 x 43.6 cm
Van Gogh Museum, Amsterdam
Pl. 81 (Barcelona only)

**AUGUSTE RODIN (1840 – 1917)**
*She who was Once the Helmet-Maker's Beautiful Wife*
1883
Bronze, 50.5 x 31 x 23 cm
Private collection. The Edelweiss Trust
Pl. 70

**THÉOPHILE-ALEXANDRE STEINLEN (1859 – 1923)**
*The Embrace*
1895
Oil on cardboard, 65 x 50 cm
Association des Amis du Petit Palais, Geneva
Pl. 6

*White Slavery* (censored version)
1899
Colour lithographic poster, 80.5 x 60 cm
Musée d'Ixelles, Brussels
Pl. 32 (Barcelona only)

**JOAQUIM SUNYER I DE MIRÓ (1874 – 1956)**
*At the Cirque Médrano* or *The Box*
1905
Pastel on paper, 31 x 48 cm
Collection Eusebi Isern Dalmau
Pl. 74 (Barcelona only)

**HENRI DE TOULOUSE-LAUTREC (1864 – 1901)**
*The Drinker* or *Hangover* (Suzanne Valadon)
1889
Black ink and crayon on paper, 49 x 63 cm
Musée Toulouse-Lautrec, Albi
Pl. 16 (Barcelona only)

*Red-Haired Girl in a White Blouse*
1889
Oil on canvas, 60.5 x 50.3 cm
Museo Thyssen-Bornemisza, Madrid
Pl. 105 (Barcelona only)

*Divan Japonais*
1893
Colour lithographic poster, 82 x 57.5 cm
Van Gogh Museum, Amsterdam
(Vincent van Gogh Foundation)
Pl. 34 (Amsterdam only)

*Jane Avril*
1893
Colour lithographic poster, 124 x 91.5 cm
Musée d'Ixelles, Brussels
Pl. 36 (Barcelona only)

*May Milton*
1895
Colour lithographic poster, 79 x 60 cm
Musée d'Ixelles, Brussels
Pl. 33

*Mademoiselle Eglantine's Troupe*
1896
Colour lithographic poster, 61.7 x 78.9 cm
Musée d'Ixelles, Brussels
Pl. 37 (Barcelona only)

**KEES VAN DONGEN (1877 – 1968)**
*Short Story for Children Small and Large*
Cover of *L'Assiette au Beurre*, 26 October 1901
Private collection
Pl. 29

**VINCENT VAN GOGH (1853 – 1890)**
*Worn Out*
The Hague, 1882
Pencil on watercolour paper, 50.4 x 31.6 cm
Van Gogh Museum, Amsterdam
(Vincent van Gogh Foundation)
Pl. 53 (Barcelona only)

*The Hill of Montmartre with Stone Quarry*
Paris, 1886
Oil on canvas, 32 x 41 cm
Van Gogh Museum, Amsterdam
(Vincent van Gogh Foundation)
Pl. 10 (Barcelona only)

*The Bridge of Courbevoie*
Paris, 1887
Oil on canvas, 32 x 40 cm
Van Gogh Museum, Amsterdam
(Vincent van Gogh Foundation)
Pl. 9 (Barcelona only)

*Montmartre: Mills and Vegetable Gardens*
Paris, 1887
Oil on canvas, 44.8 x 81 cm
Van Gogh Museum, Amsterdam
(Vincent van Gogh Foundation)
Pl. 11 (Barcelona only)

*Courtesan (after Eisen)*
Paris, 1887
Oil on canvas, 105.5 x 60.5 cm
Van Gogh Museum, Amsterdam
(Vincent van Gogh Foundation)
Pl. 41 (Barcelona only)

*The Boulevard de Clichy*
Paris, 1887
Oil on canvas, 46.5 x 55 cm
Van Gogh Museum, Amsterdam
(Vincent van Gogh Foundation)
Pl. 48 (Barcelona only)

*Café Table with Absinthe*
Paris, 1887
Oil on canvas, 46.2 x 33.3 cm
Van Gogh Museum, Amsterdam
(Vincent van Gogh Foundation)
Pl. 51 (Barcelona only)

*Self-Portrait as Painter*
Paris, 1888
Oil on canvas, 65.2 x 50.2 cm
Van Gogh Museum, Amsterdam
(Vincent van Gogh Foundation)
Pl. 42 (Barcelona only)

*Wheatfield*
Arles, 1888
Oil on canvas, 54 x 65 cm
Van Gogh Museum, Amsterdam
(Vincent van Gogh Foundation)
Pl. 43 (Barcelona only)

*An Old Woman of Arles*
Arles, 1888
Oil on canvas, 58 x 42 cm
Van Gogh Museum, Amsterdam
(Vincent van Gogh Foundation)
Pl. 61 (Barcelona only)

*Portrait of Camille Roulin*
Arles, 1888
Oil on canvas, 40.5 x 32.5 cm
Van Gogh Museum, Amsterdam
(Vincent van Gogh Foundation)
Pl. 62 (Amsterdam only)

*La Berceuse (Madame Roulin)*
Arles, 1889
Oil on canvas, 91 x 72 cm
Stedelijk Museum, Amsterdam
Pl. 44 (Amsterdam only)

*Pietà (after Delacroix)*
Saint-Rémy, 1889
Oil on canvas, 73 x 60.5 cm
Van Gogh Museum, Amsterdam
(Vincent van Gogh Foundation)
Pl. 63 (Barcelona only)

**JACQUES VILLON (GASTON DUCHAMP)**
**(1875 – 1963)**
*The Easy Life*
Cover of *L'Assiette au Beurre*, 15 February 1902
Private collection, London
Not illustrated

# INDEX

The publisher has made every effort to comply with copyright regulations, but it has not always been possible to determine the precise source of documents. Should any persons believe that an omission has been made, they are requested to inform the publisher.

# ABOUT THE AUTHORS

MARILYN McCULLY

Marilyn McCully is an internationally recognized Picasso expert, based in London. She has organized numerous international exhibitions and written widely about Picasso, his work and his background in Spain. She was the first authority to organize a comprehensive show of Picasso's unique ceramics (Royal Academy of Arts, London, and the Metropolitan Museum, New York, 1998-9), and prepared exhibitions of Picasso ceramics for Ferrara, Málaga and the 2005 Expo in Aichi, Japan. She is curator of an R.B. Kitaj exhibition to open in summer 2011 (Abbot Hall, Kendal) and is co-curator of "Three Decades of Picasso's Drawings" an exhibition to be held at the Frick Museum, New York, and the National Gallery of Art, Washington, in 2011-12. Dr McCully is currently preparing a book on Picasso's correspondence and writings, which will be translated into English for the first time.

NIENKE BAKKER

Nienke Bakker is the Curator of Exhibitions at the Van Gogh Museum. Over the last ten years, as a researcher at the museum, she has worked on various exhibitions and publications on the life and work of Vincent van Gogh. She is the co-author of *The Real Van Gogh: The Artist and His Letters* (2010), *Vincent van Gogh: The Letters. The Complete Illustrated and Annotated Edition* (2009) and *Vincent van Gogh, Painted with Words: The Letters to Emile Bernard* (2007). Her book *Van Gogh and Montmartre* will be published in 2011.

ISABEL CENDOYA

Isabel Cendoya has a degree in History of Art. She currently holds a post at the Museu Picasso in Barcelona, where she has recently coordinated the exhibitions *Forgetting Velázquez. Las Meninas*, a major Kees van Dongen retrospective and *Picasso versus Rusiñol*. She has published several articles in *Història de l'art català. Els grans museus de Catalunya* and texts in various exhibition catalogues.

PETER READ

Peter Read is a specialist in modern French literature and the visual arts. His recent publications include *Picasso and Apollinaire: The Persistence of Memory* (Berkeley, Los Angeles and London, University of California Press, 2008). He has co-edited Guillaume Apollinaire, *Correspondance avec les artistes (1903-1918)* (Paris, Gallimard, 2009); *Giacometti: Critical Essays* (Farnham, Ashgate, 2009); and *Les Dessins de Guillaume Apollinaire* (Paris, Buchet Chastel, 2008). He has also translated Apollinaire's *The Cubist Painters* (Berkeley and Los Angeles, University of California Press, 2002) and has published essays on Picasso in exhibition catalogues for Tate, London; the National Gallery of Art, Washington DC; and the Centre Pompidou, Paris. Peter Read is Professor of Modern French Literature and Visual Arts at the University of Kent, Canterbury.

MICHAEL RAEBURN

Michael Raeburn is a writer, editor, designer and producer of illustrated books and catalogues. He has edited catalogues for museums, including London's Hayward Gallery, The Sainsbury Centre, Norwich, New Walk Museum, Leicester, The Metropolitan Museum of Art, New York, the Minneapolis Museum of Art, the Denver Art Museum, Palazzo dei Diamanti, Ferrara, the Sakip Sabanci Museum, Istanbul, and the Auckland City Art Gallery. He is the author of books on art, architecture, design and music, including *The Chronicle of Opera* (rev. ed. 2007), and is currently working on a book on the American artist Joseph Glasco.